ins) in mr Plggy

ploitation of generation to competition of the young

Typographics?
Sybertype

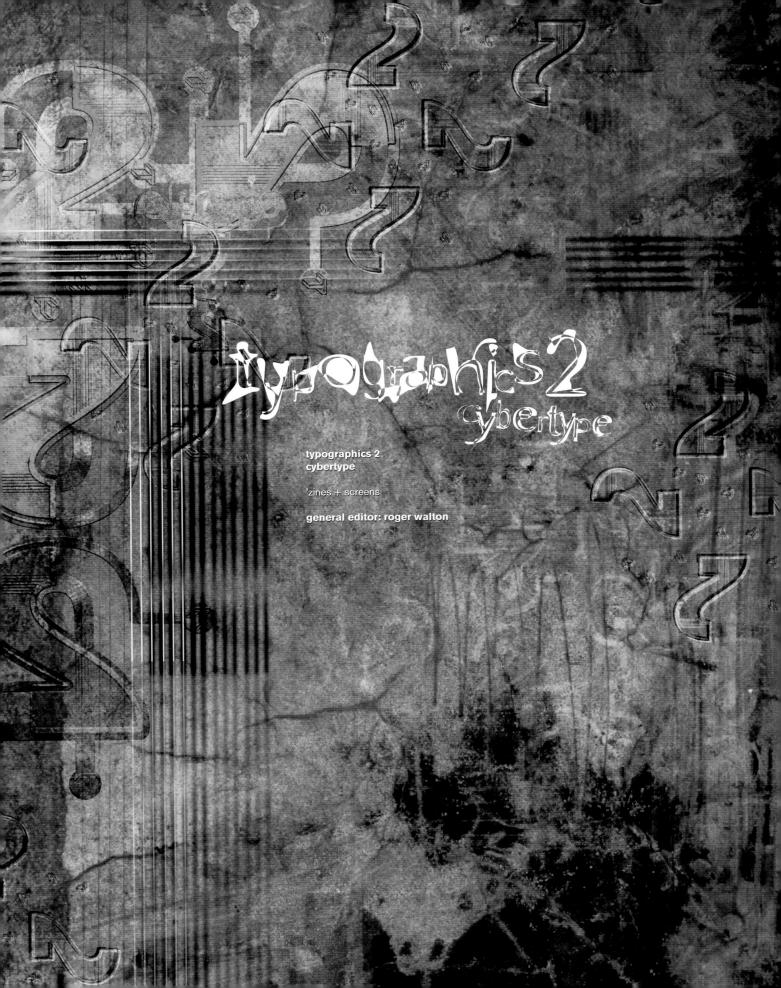

The second volume in a series devoted to highlighting the best in global typography, *Typographics 2* focuses primarily on a single form of publication: the magazine.

The work included here reflects the role that the computer continues to play in shaping the genre of the magazine, freeing the layout and subverting typographic conventions to develop a new style of information presentation. This portfolio demonstrates the various ways in which designers are addressing the concept of cybertype, both as a condition of layout and as a form of computer-generated and screen-composed typography. The material has been grouped to represent typographics ranging from minimalist "cybertype light" to the dense textual layers of "cybertype bold." Within cyberspace, the computer is able to imitate the printing press, CD, and video - resulting in a potential for freeform typography that is no longer bound to the static page. Although this collection is presented in book format which precludes manipulation at the touch of a button, it nevertheless displays both the liberation that has been granted by technology and the scope of a new space which designers both shape and are shaped by.

It is difficult to isolate the characteristics that define a magazine: regular publication; specific themes; a diversity of features; coverage of the most up-to-date information on a chosen subject; a particular format – there are evident and deliberate exceptions to every rule. But if one common thread can be drawn, perhaps it is that of the freedoms and restrictions generated by a distinctive creative pressure. Partly the result of deadlines and partly brought about by the struggle to remain economically viable, this type of pressure can produce dynamic design.

TYPOGRAPHICS

Treword

Due to their rapid turnaround and ability to react swiftly to fashions and events, magazines are able to adopt a position that is considerably more experimental and outspoken than that of many other publications.

The work displayed in *Typographics 2* demonstrates that the quality and diversity of approaches to design have a global reach. Examples have been gathered from the United States, South America, Europe, the Far East, and Australia. They include publications that may be bought from mainstream outlets, and those that might only be found by chance in obscure art stores. Magazines produced by large corporations working with big budgets are shown side by side with those created by quixotic individuals surviving merely on ingenuity and originality. Computer software has allowed typographers the space to experiment without incurring huge costs: the opening spread to "Cybertype Medium" employs a typeface that was created by scanning in letters that had originally been produced with a potato-cut print. This intriguing fusion of imagination and technology is precisely what *Typographics 2* aims to capture.

医四角的 好好,但我是是因此的相处我的一种自由的身份,就是了大幅的身

una rivista che parla del resto del mondo a magazine about the rest of the world

13

warning: this magazine contains no words. start here >

attenzione:
in questa
rivista non ci
sono parole.
comincia qui >

Arg 3 pesos | Aus 4.95AS | BRD DM6.50 | Can 4CS | Esp 450Ptas | Fr 20FF | Helias 750DR | HK HKS35 | India Rs. 100 | Ire IRE2 | Ital L6.000 | Mag 250FT | Mex 95 | Nederl 7,95FL | Port 520500 | SA 9R | UK E2 | USA \$4.50

pages 12-15

Colors

art director Fernando Gutiérrez designers Fernando Gutiérrez Leslie Mello

editor-in-chief Tibor Kalman publisher Benetton Group SpA origin Italy

dimensions 230 x 286 mm $9 \times 11^{1/4}$ in

photographers 1 Roberto Villa, Marka Iris

2 Antonio Rosario, John Banagan, Pete Turner, Harald Sund, H. De Latude, Tad Janocinski

3 David Turnley, Olympia, Titolo, Richard Martin, Maggie Steber, Eligio Paoni, Philip J. Griffiths, Chris Steele Perkins, Haviv, Abrahams, Glame, R. Benali

4 Joe McNally, Penny Gentieu, Jean Pierre Saunier, Oliviero Toscani, George Grall

5 Reza, Sandro Tucci, P. Howell, Bruno Barbey, Rainer Drexel, Philippe Crochet, McVay

6 Yeohong Yoon

7 Gilles Peress, Malcolm Linton, Ylarion Capucci, Mary Ellen Mark, Jodi Cobb, Joseph Rodriguez, Frank Spooner

8 Zefa, Claude Coireault, Pascal and Maria Marechaux, Hans Madej, Lennart Nilsson

9 Michael Friedel, ABC Carpet and Home, Kirk McKoy, Jeff Jacobson, Sergio Merli, Michael Wolf, Pagnotta Da Fonseca, Marka, Fernando Bueno

10 Philip Dowell

11 Thomas Hoepker, Robert Caputo, Louise Gubb, C. Vaisse, Anna Fox, Luigi Volpe

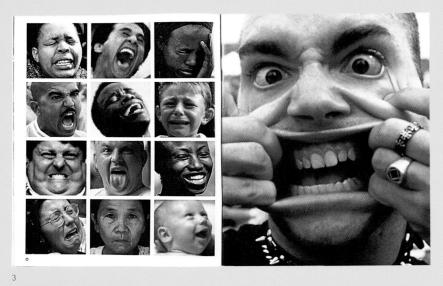

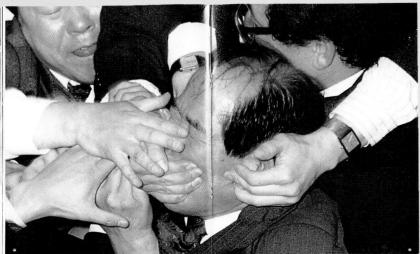

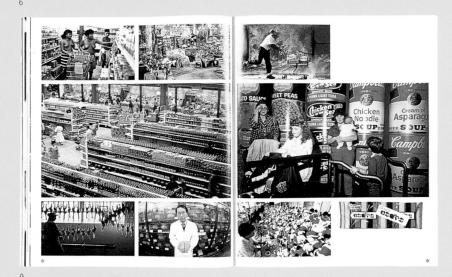

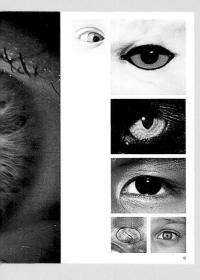

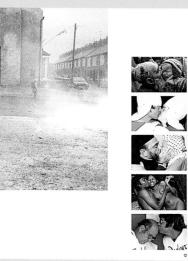

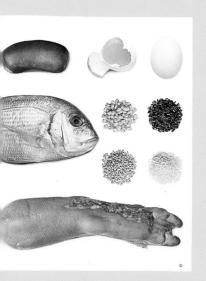

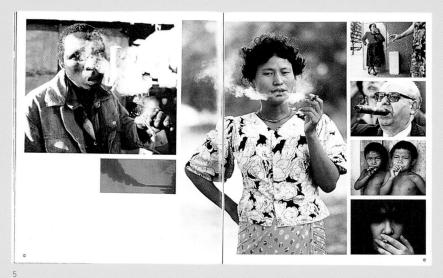

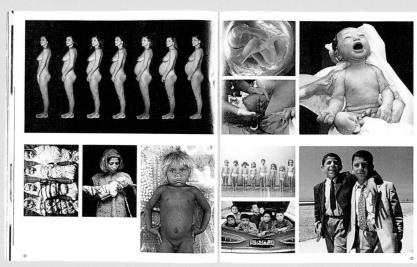

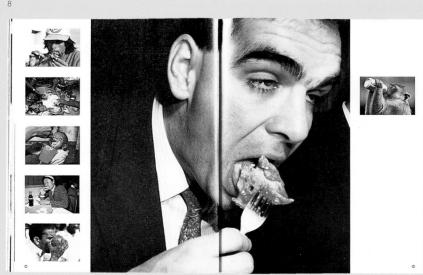

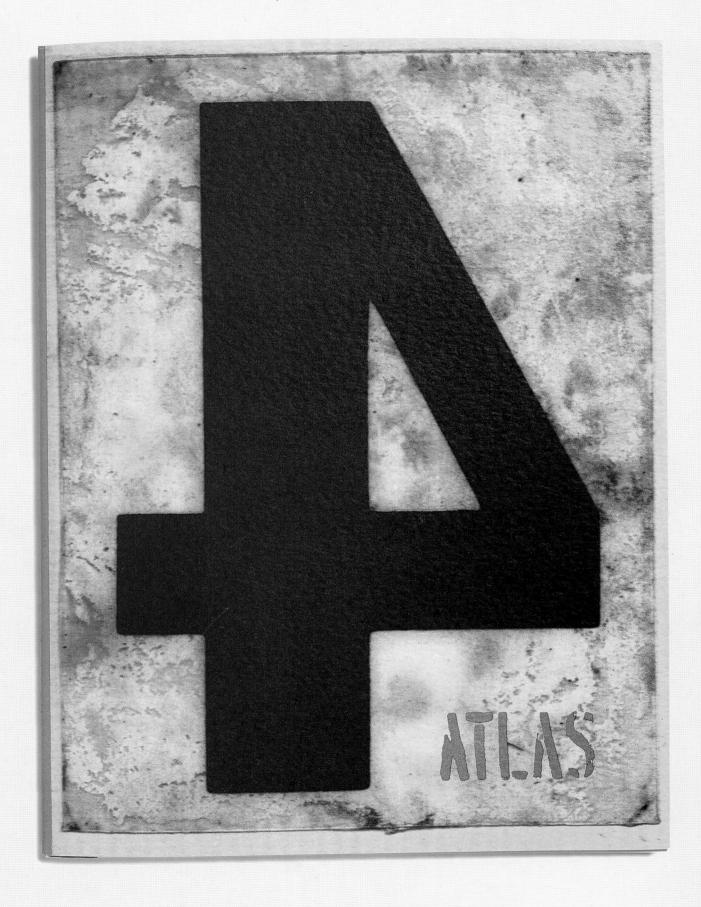

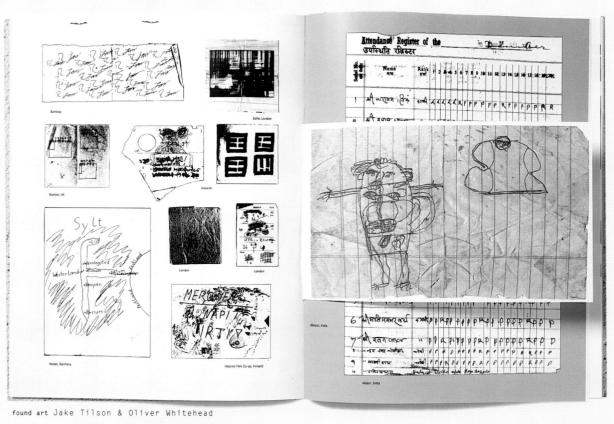

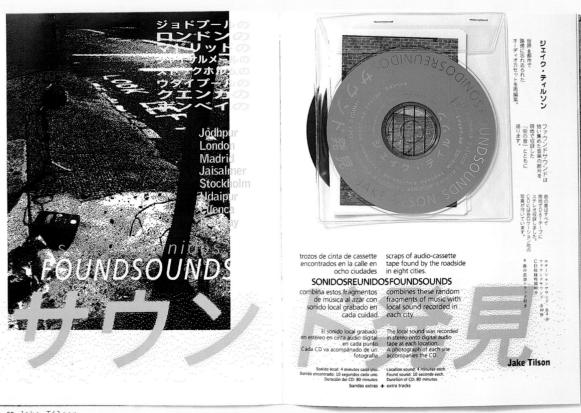

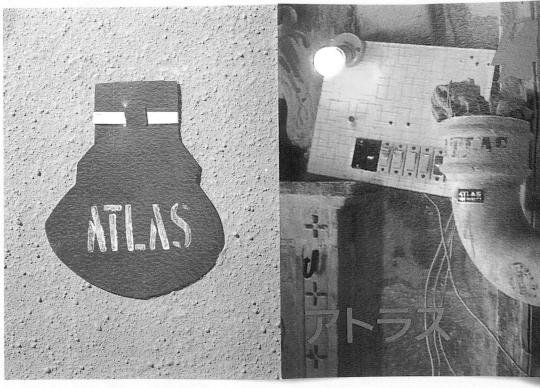

found art Jake Tilson & David Blamey

pages 16-19 Atlas

art director
Jake Tilson
designer
Jake Tilson
editor
Jake Tilson
publisher
Atlas
origin
UK
dimensions
210 x 280 mm
81/4 x 11 in

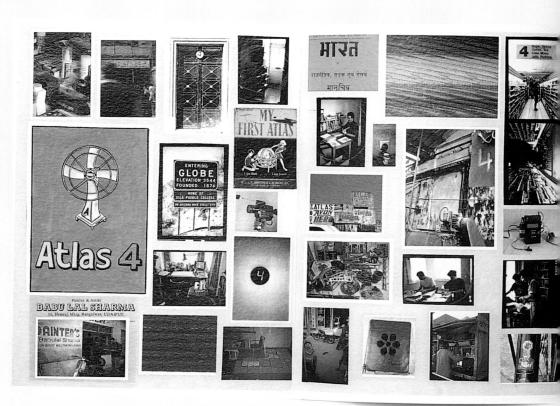

photography & video capture Jake Tilson & Eileen Tweedy

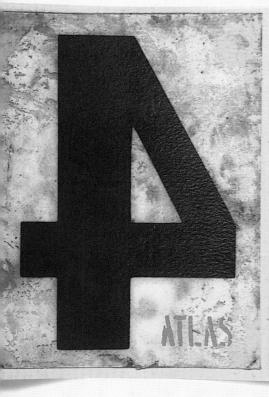

pages 20-21

Contretemps

art director Italo Lupi

designer

Italo Lupi

cover art Camilla Adami

editor

René Major

publisher

T.R.A.N.S.I.T.I.O.N. L'Age d'Homme, Paris

origin

France/Italy

dimensions

 $235 \times 315 \text{ mm}$ $9^{1/4} \times 12^{3/8} \text{ in}$

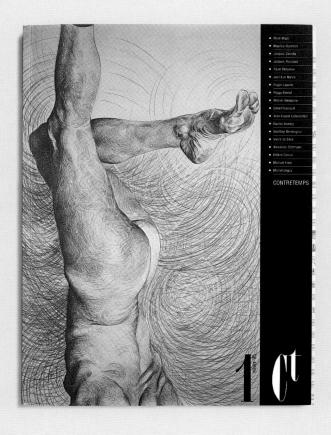

temps.

• La bévue et l'impair rappellent à l'attention de faire galle. Mais comment ce faire galle peut-il éviter de commettre l'impair? (L'impair: qui

The six antidates, prestinentes. To an compani, c'est on equil fisilat. Vac. of executed i s'ey es a pas de tres, pour qu'il se revienne l'après mudit ne cap post té dechante de ce que je le sphrage mois autres et se post té dechante de ce que je le sphrage mois passine. It suivant mois exe pas de très dechante de ce que je le saferir pour mois passine les transites les des l'estes de l'este l'este de l'este de comme les dans mois mois exe que les taté. Ce espa s'arrars per sous le sous est de l'este pour de l'este pour ou selon la memero du lone, garrie a course les passine passine passine autre de l'este pour de l'este par l'este de l'este par le se deput de de la représentation du serges. Le concept de la réport de la représentation de serges le companie par le réport de la représentation de serges passine che le missirée pas mois réport de la représentation de l'este passine de la réport de la répo

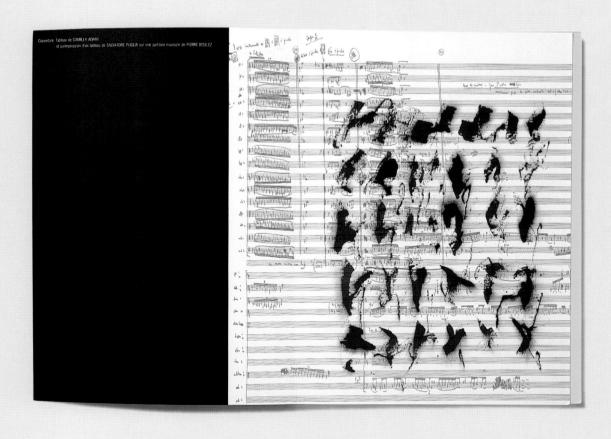

du visible, il cuyre le théâtre. [...

du visibili. Il divire le tribuler. C. Il chi visibili più i divire le trobalere C. Il chi visibili più i divire le trobalere di si informitti. Le tropisceptia si les monalere di simplement dell'informitti di si considerati di più di si considerati di si considerati di si considerati di più della di si considerati di si considerati di si considerati di considerati di si considerati di si considerati di chi con la considerati di si considerati di chi con i considerati di si considerati di di di con i responsementi mazzina, sivere per conventiona soccidera di trate de neno codera, cere den ficticare del si miliarativa, sivere del trate de nen codera, cere den ficticare del si miliarativa, sivere del trate de nen codera, cere den ficticare del si miliarativa, sivere del trate de nen codera.

- La promesse d'un sotre nom et celle du "senais plus". Le rêve de faire coincides l'objet perdu dans le temps retrouvé. Et toujours use voie
- Ne traçant qu'en retrait, n'inscrivant que daza l'effacement, l'écritur n'alt en contre-temps. Le visible des mots et le l'aible des inages com me contre-temps.
- Comment mettre en oeuvre le désoeuvrement, sesuitet une désistence du temps et sa responsabilité? C'est un tel espace dans le temps présent due souhuite correr Charredonne. Outre maiore.

Tectponi Laces, "L'ensardi" in Solicer s' 4. Ed. Smid 1975. Tectponi Derricia, "L'ephonisse à contreteoper", in Physial Caldide II

page 22

Qwerty

art director Stephen Banham
designer Stephen Banham
publisher The Letterbox
origin Australia
dimensions 74 x 105 mm
2 1/8 x 41/8 in

page 23

Qwerty

poster

art director Stephen Banham
designer Stephen Banham
photographer David Sterry
publisher The Letterbox
origin Australia
dimensions 420 x 594 mm
16½ x 23⅓ in

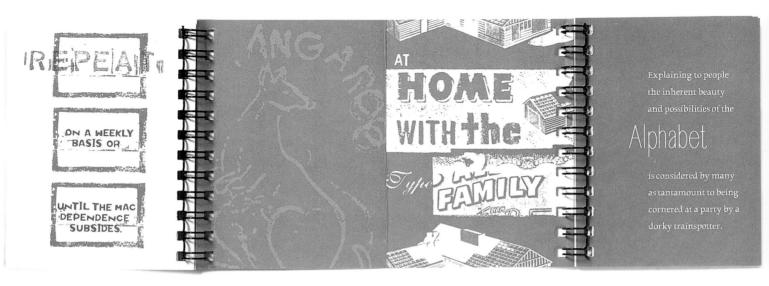

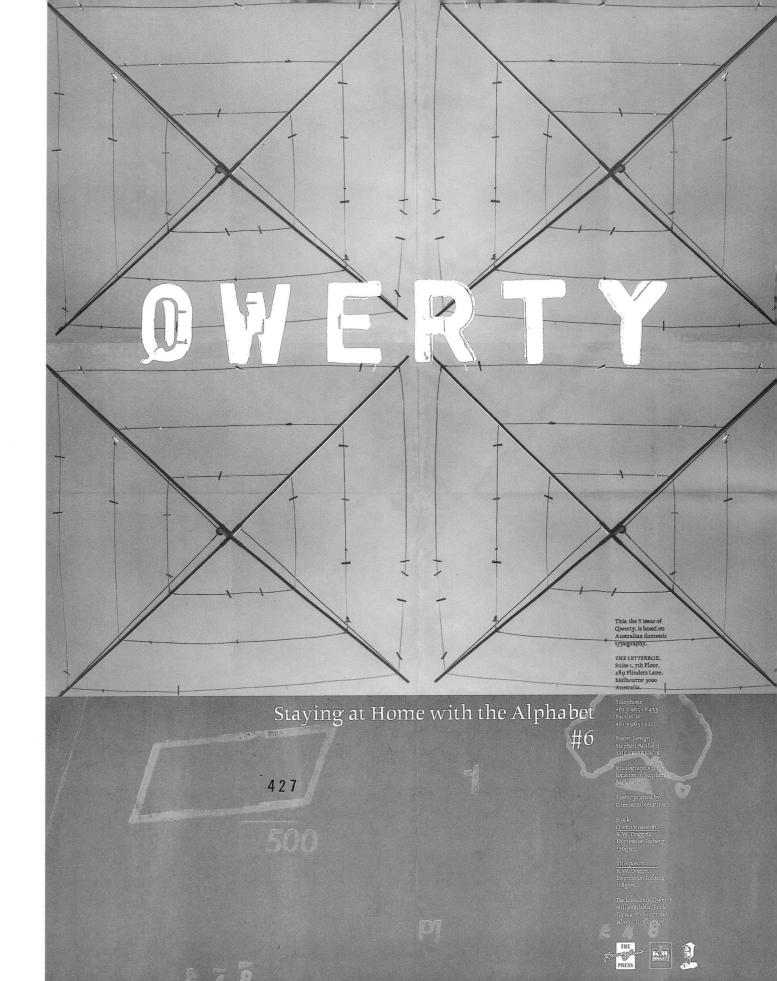

Sin

art director designer Stephen Banham photographer David Sterry editor Ann Sinatore publisher Sin Publishing origin Australia dimensions 250 x 330 mm 9½ x 13 in

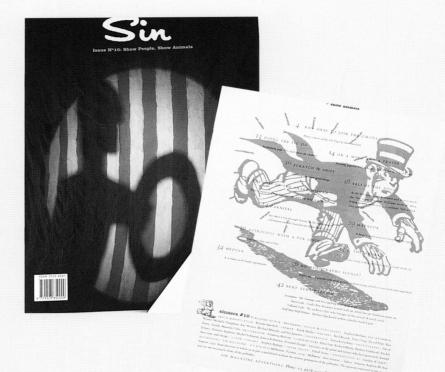

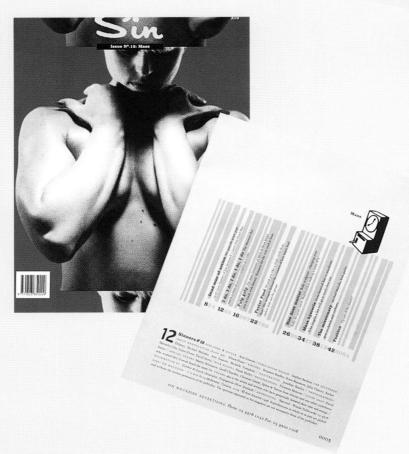

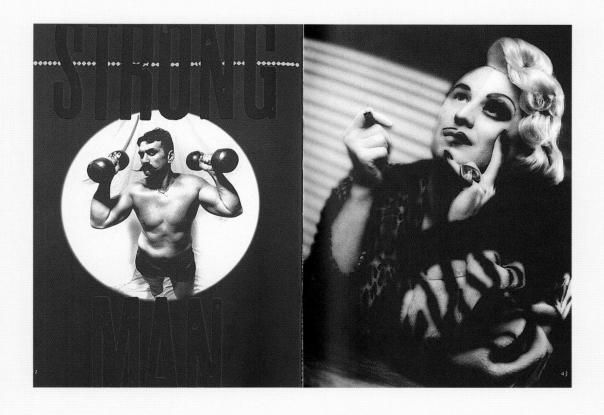

Pablo Martín

Patricia Ballesté

photographers Anton Stankowski

James A. Fox René Burri

Walker Evans

Miguel Riobranco

Henri Cartier-Bresson

Eli Reed

Luis De Las Alas

editor Alberto Anaut

publisher La Fábrica origin Spain

dimensions $300 \times 400 \text{ mm}$

 $11^{3}/_{4} \times 15^{3}/_{4}$ in

ABECEDARIO "JAVIER MARÍAS, DESIDERÁTUM "MATADORES: CELEBIDACHE, TASCHEN, FIDALGO "JAMES A. FOX, EDUARDO ARROYO, GONZALO SUÁREZ: EL LÍMITE "OLIVER STONE-BARRY GIFFORD, CONVERSACIÓN "ANTONIO SAURA, CARMEN IGLESIAS, BILL GATES: FIN DE SIGLO "LA CUBANÍA: MANUEL VICENT, WALKER EVANS, REYNALDO GONZÁLEZ, RENÉ BURRI, ROGER SALAS, DELFÍN PRATS, MIGUEL RIOBRANCO *CARTIER-BRESSON "PAUL BOWLES "SANTIAGO CALATRAVA, MONÓLOGO PARA BERLÍN "ELI REED, ÁLBUM "GENERACIÓN 95

MATADOR

ALVAR AALTO JOSÉ MANUEL ABASCAL CLAUDIO ABBADO BERENICE ABBOTT DAVID ABBOTT KARIM ABBDUL JABBAR VICTORIA ABRIL ANSEL ADAMS HENRY ADAMS THEODOR W. ADORNO ADRIANO ANDRÉ AGASSI GIACOMMO AGOSTINI SAN AGUSTÍN OTLAICHER ANA AJMATOVA AZZEDINE ALAÏA PEDRO ANTONIO DE ALARCÓN LEOPOLDO ALAS ISAAC ALBÉNIZ JOSEF ALBERS RAFAEL ALBERTI TOMASSO ALBINONI ALFREDO ALCAÍN IGNACIO ALDECOA ROBERT ALDRICH VICENTE ALEIXANDRE ANDREU ALFARO ALDUS MANUTIUS JEAN D'ALEMBERT ALESSI MOHAMMAD ALI NÉSTOR ALMENDROS ALICIA ALONSO DÁMASO ALONSO JOSÉ LUIS ALONSO DE SANTOS ALBRECHT ALTDORFER ROBERT ALTMAN ÁLVAREZ QUINTERO SALVADOR ALLENDE FERNANDO AMAT CARMEN AMAYA GENE AMDAHL ROALD AMUDSEN HANS CHRISTIAN ANDERSEN LAURIE ANDERSON LEONIDAS ANDREIEV VICTORIA DE LOS ÁNGELES BEATO ANGÉLICO ANÍBAL ANGLADA CAMARASA JACQUES ANQUETIL ANTONIONI GUILLAUME APOLLINAIRE KAREL APPEL LUCIO APULEYO RON ARAD YASIR ARAFAT VICENTE ARANDA ARANGUREN ARANTXA DIANE ARBUS ARCHIGRAM ARCHIMBOLDO ALEXANDER ARCHIPENKO ELISABETH ARDEN PAUL ARDEN OSVALDO ARDILES ATAULFO ARGENTA GABRIEL ARISTI LUDOVICO ARIOSTO ARISTÓFANES ARISTÓTELES GIORGIO ARMANI LOUIS ARMSTRONG NEIL ARMSTRONG CARLOS ARNICHES EVE ARNOLD HANS ARP ARQUÍMEDES FERNANDO ARRABAL JUAN JOSÉ ARREOLA EDUARDO ARROYO ANTONIN ARTAUD ROBERT ARTL JUAN MARÍA ARZAK ARTHUR ASHE FRED ASTAIRE MIGUEL ÁNGEL ASTURIAS ATILA CHARLES ATLAS BERNARDO ATXAGA MAX AUB AUGUSTO JANE AUSTEN W. H. AUDEN AVERROES FRANCISCO AYALA MANUEL AZAÑA RAFAEL AZCONA AZORÍN FÉLIX DE AZÚA

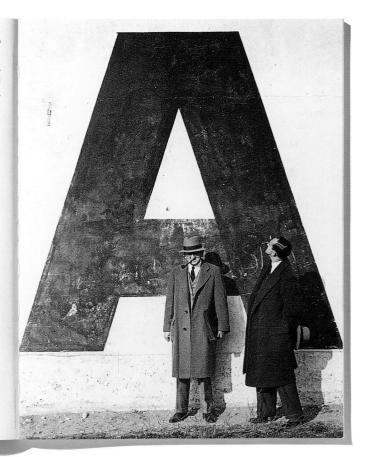

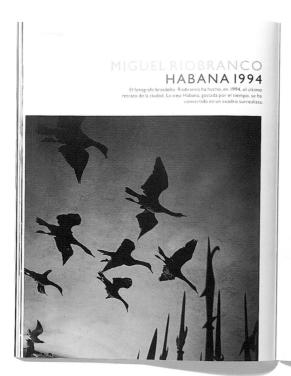

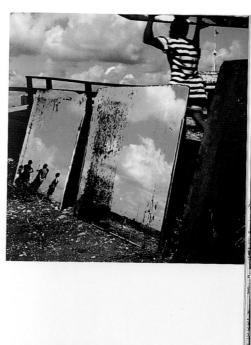

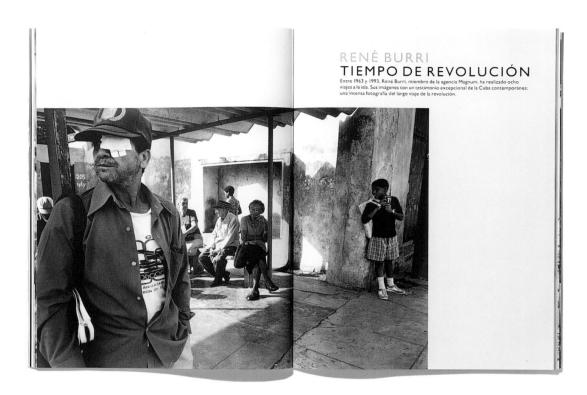

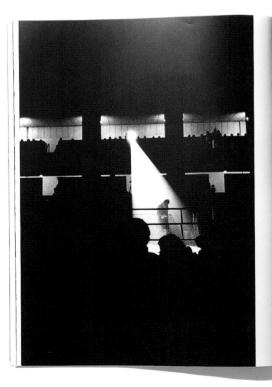

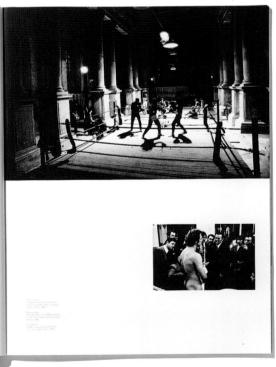

page 30

Virgin Classics

frieze

page 31

CD catalog 1996 art directors Nick Bell

designer Anukam Edward Opara

photographer Gary Woods
editor Jeremy Hall
publisher Virgin Classics
origin UK
dimensions 210 x 297 mm
874 x 1174 in

publisher Durian Publications origin UK dimensions 230 x 300 mm $9 \times 11\% \, \mathrm{in}$ art director Harry Crumb designer Harry Crumb editors Matthew Slotover Amanda Sharp Tom Gidley

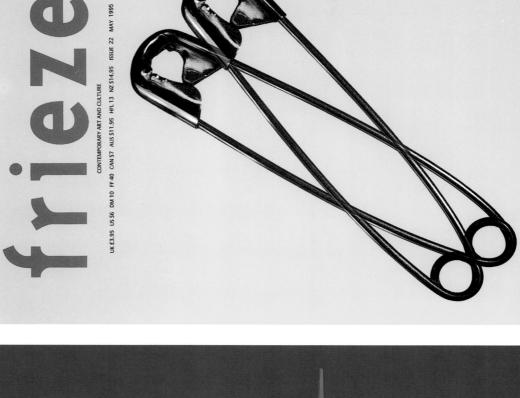

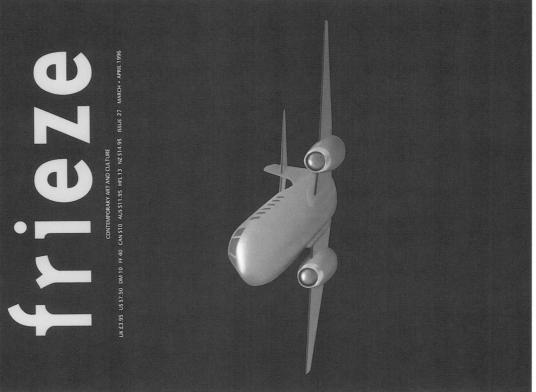

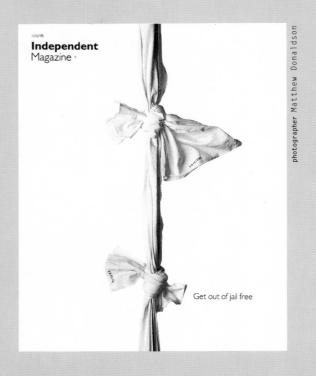

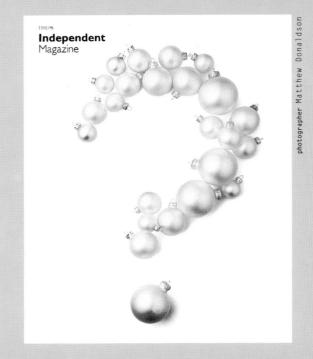

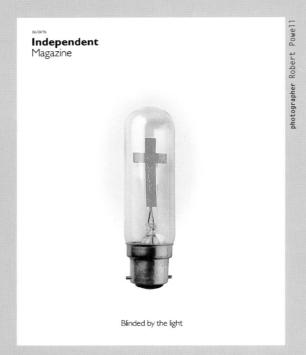

Independent Magazine

art director Vince Frost @ Frost Design
designer Vince Frost @ Frost Design
editor David Robson
publisher Newspaper Publishing Plc
origin UK
dimensions 280 x 355 mm
11 x 14 in

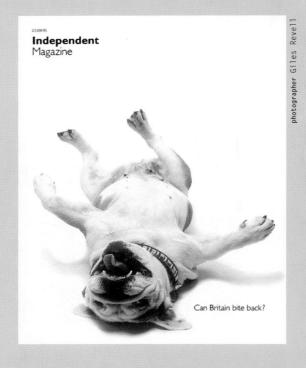

Now Time

art directors Renée Cossutta
Judith Lausten
designers 1 Miyoshi Barosh
2 Judith Lausten
photographer 2 Sherrie Zuckerman
iliustrator 1 & 2 Miyoshi Barosh
editor Miyoshi Barosh
publisher A.R.T.* Press
origin USA
dimensions 241 x 317 mm
91/2 x 1276 in

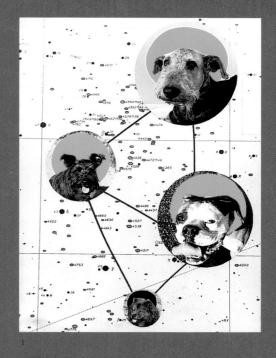

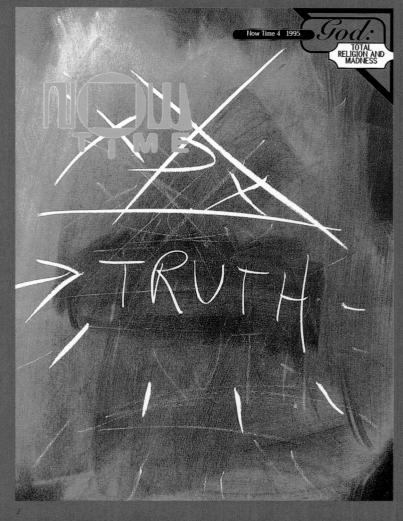

in this follow city of the month of the property of the proper

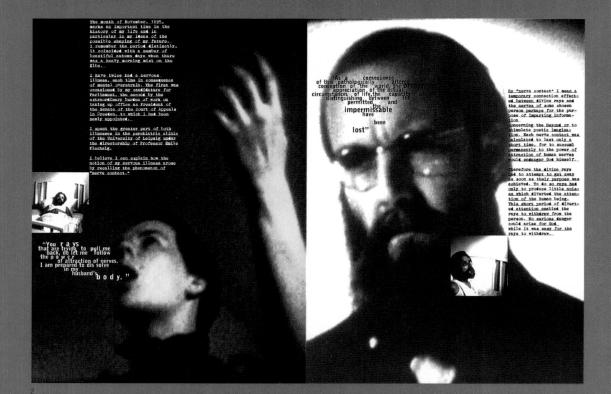

Mission San Xevier Del Bac near Tucsen, Arizona Photos: Sojin Kim

BY GARY INDI ANA

BY GARY INDIANA

For seem day-client lines is never to their village. A laquer accolor at Mahampo, on the court of Crybon, Johany God Johard down at John long fringers. They were strong through a shallhold of a day refer. He had deemend of a day vilga his tree market child bles a fagor, fix a smooth holy remembrang. The first New-organ to steep domating blend. Those who have a good hife work a week and a steep renigable out of the market volents in the The chiphests third there had as they renigable out of the market volents in the The chiphests third their heads as they renigable out of the mark volkage of out of the relation to the press would be made where the chiphests the desire the state of t

"The Farous has a theory about Nicky's illness."

The Farous has a theory about Nicky's illness."

The Farous has a theory about Nicky's illness."

The flow is here, the room had enough. One and our and a levelen deth. No custim with darkness discussives. The shares had not been man.

The sname of your formed as the orly please with a D' abe asys. "In the only one alove. Something in it for my money in made he here for all the six fluid regi.

They called here the formed as the start of the start of the please with a large start of the start of a clearing of the start of

pages 34-7

Now Time

art directors Renée Cossutta
Judith Lausten
designers 1 Somi Kim @ ReVerb
2 P. Lyn Middleton
3 Edwin Utermohlen
4 Chris Myers & Nancy Mayer
5 (see over) Chris Myers &
Nancy Mayer
photographers 1 Christiane Badgley

Bob Paris

Bob Paris
2 B. Burkhart
4 Chris Myers
5 (see over) Chris Myers
editor Miyoshi Barosh
publisher A.R.T.* Press
origin USA
dimensions 241 x 317 mm
9 1/7 x 12 1/2 in

The loss of memory was very difficult as was my re-evolution through Earth frequencies. Only those who have lost their lives through amnesia can understand the horror of being history-less. As memories return the effect is inner turmoil. The hardest task at this point is to remain calm and trust in self without becoming influenced and manipulated into going against your inner truth.

A strong negative reaction is often catalyzed within certain individuals in response to higher frequencies.

The immediate and irresistible urge to control or dominate because of a cowardly fear

This Mother attempted to dominate me through Catholicism. Religion is a method of control.

By handing your destiny over to to an outside authority you remain forever enslaved to it. A religion is sustained by a self-generating field of energy created by its members. The energy of this force field begins to believe in its power and comes to see itself as a god. It is almost impossible to break away from an attraction to this energy field. Like a weed, its roots enter your soul and subconscious mind where it spreads and grows in power. It is a challenging test of evolution to shed this possession, and an absolute necessity if you are ever to return to your home planet.

The hardest part of adjusting to the Earth experience was the pleasure and familiarity I felt during telepathic interludes with my team. It was decided that I would remain relatively isolated until I completed the normal education required by the Earth culture I'd been born into. At the end of my teen-age years the first layer was removed and my training began.

My Earth life was a traumatic and highly tested event. Often I came close to failure, which would have meant absorption into the Earth cycles of death and rebirth.

is my heritage on your planet.

You may question this activity as interference and wonder how we might justify meddling in the energies of Earth. Although there have been many ruthless visitors to your planet, those in alignment with The One require an invitation. This you provide through prayers for the return of a Savior. These prayers are sent through many religions and become an open invitation for any of us to answer. You must be aware that there was never anyone by the name of Jesus Christ on Earth. This name is a fabrication as is the history associated with this individual.

I myself answered the call for the return of the great white buffalo woman of the red race. For this reason I feel a special bond with the evolution of these people and have, in fact, adopted them as my own. My greatest gifts have come through my incarnations within

various North American tribes. Although the horrors of genocide have scarred me deeply, the glorious immersion into your Earth nature left me in awe. I was indeed mesmerized by the color and drama, the sound and smell of death, destruction, renewal, and rebirth, so orderly yet chaotic—all things long gone from my home planet. I, **Taté**, shall forever cherish those experiences as some of the dearest treasures of my entire evolution. (My secret grief is that I must share in the responsibility for the destruction of the red civilization as it once was. You see, Earth humans, you cannot invite the evolved without suffering. Once the light energy of such a being impacts on the negative energy field of your planet there are inescapable consequences.

In order to form a personality to carry me through the Earth experience it was necessary to dip into every facet of your human drama. This was a planned and systematic process. Whenever possible my experiences were combined to minimize and condense trauma and time. Quality and thoroughness were the goals as well

as keeping the life-sustaining connection to

The One.

On every planet the mastery of self begins with the mastery of inner and outer energies; but only attempt to master that which you recognize as true. All needs are contained within The One. All is available within the completeness of The One. False needs born of thoughtless childish desires are not destined to be truly satisfied. True knowledge is often painful, but with confidence in your birthright, all will be fulfilled through an intimate relationship with The One.

Overcoming the energy patterns of this planet, which must be assumed in order to exist here, is the supreme and ultimate test of every extraterrestrial. When you understand that energy is created through thoughts and feelings, stamped with the signature of the creator and destined to return to him, you will have the key to mastery. If you simply stop creating new thought forms and stop being controlled by old, unwanted thoughts, and guard the pattern of your daily thinking, you will begin to create the type of world in which you've always wished to live.

and so on into intinix

Energy not only floats around, it congeals with other like energy and eventually assumes a life of its own with a will to survive. It will seek out compatible experiences either by feeding off humans with like energies or by stimulating similar energies in unsuspecting humans. People with intense emotions are especially targeted. Two people can marry their energies and create a combined force field to benefit or complicate their lives. This is the real reason for the importance of commitment. It has little to do with satisfying the insecurities of the human, but rather with the protection of the marriage force field from contamination by outside influences.

My assignment was in the understanding of these energies. Absolutely everything breaks down to energy dynamics. The One is composed of positive (+) and negative (-). Behind The One and incomprehensible to all life-forms is the O. Out of the O exists The One which in order to evolve must become the 2s. The 2s manifest what we call life. Each 2 has a + and - component, hence the name 2. The life of the 2s is separate and complete in each 2's awareness of itself as an individual entity, therefore each + or - seeks to perpetuate itself as exactly what it is: + or -. Our job is to harmonize to The One and hold the balance of the 2s. The life of the 2s, however, wants to pull you into one or the other aspect of itself. It is easy to forget one's origins in The One when these brief trespasses into the + or – aspects of The One seem so real and complete. The test is to not take them seriously, but to respect them as equal yet opposite, and completely unavoidable! Acceptance with respect is the answer and the ultimate goal is to keep them balanced.

The state of spiritual affairs on Earth is appalling. It saddens me beyond belief to see so many desperate humans seeking escape from their lives. Either a heaven or some magnificent god awaits you upon death, if you can survive and hold fast to the rules set before you by your religions. Does no one see how often these rules change from era to era? And the metaphysicians who believe that they can ascend this physical plane by pure, positive spiritual thinking...You are mere children in your expectations. One can only become pure spirit when the 2s have been balanced in the inner One within you all. You do not become spirit by ascending out of matter but rather by moving into matter and holding the balance of the two polarities. This is a systematic process. Moving in and out of masculine and feminine and balancing the 2s of each One: balancing the 2s of the masculine,

balancing the 2s of the feminine until the spirit-form which you are understands The One behind the masculine and the feminine. In every life there are challenges of the 2s before you. If you wish to measure your evolution, check your inner peace with your inner masculine and your inner feminine and then check its manifestation in your outer, daily life.

You, Earth humans, are responsible for the state of affairs that exist on your planet. You cannot escape the responsibility for this. To seek an escape is a childish whim and can never by allowed. All are accountable to The One for whatever they have created. All energy stamped with your signature by your thoughts remain yours until it has been balanced within you and released once again into The One. When all energy has been released in freedom, then you will also be free. This ascension process is a gradual heightening of light frequency and takes place over many eons. Until you conquer your fear of death, your own frightening energy creations, and settle into the beauty of the 2s you will never begin this process of ascension.

One thing more, no one can balance the 2s of another. It is the duty of each one to do this for themselves and earn their own freedom. The more evolved you are the easier it is to see the imperfections of another. Also, although their pain might seem overwhelming and unfair, the desire to assist must be resisted. To interfere can only be dangerous for your own evolution by causing you to absorb and carry energy patterns not meant for you. This can result in a needless delay of your own mission.

During my sojourn here on your planet I was systematically led through many lives which touched me deeply and many circumstances where I searched in vain for my truth. It is frightening to know so much and have no one to validate that hard-won knowledge. Although I met many wonderful people who helped me through my ordeal, I outgrew them all in time. The message was clear: you are alone. You have the ability to know your own truth. It is as it should be.

It is a fact of great sadness and incomprehensible to us that while we maneuver and manipulate time and space, placing ourselves at great risk in order to appreciate and explore this planet of such beauty, you, Earth humans, are systematically destroying it day by day. Don't you see the mark of doom that hangs over your civilization? Your days are numbered regarding life as you know it. Reclaim your power, your earth, and your destiny! Reverse the polarity of the energy that controls you and you will be able to move your destiny in any direction you choose

Money! A special issue

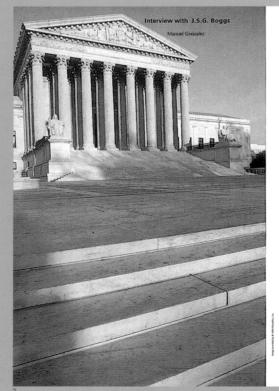

Names I detailed for a self-caught in January of this year, the artist 1.5.G. Boggs printed poet. As is correctly craveling which he then spent to rent a booth at a throughout Awarda with a faults. But the opportunity colorism is self-caught and the convention organizer sold. The self-caught (test) self-caught and them into general circulation by passing book. The self-caught (test) self-caught and the caught and caught an

havior as juxtaposed with penal For some time, I had been interested in Boggs' work and his behavioral modification. lengthy disagreement with government officials over his

currency series. Upon hearing the news of this mass act of civil disobedience, I could no longer resist satisfying my curiosity. I wanted to meet the man who, depending on whom you speak with, is either mad, a con-artist or both. I found something other in him, and I hope the record of this brief encounter will help reveal the human being who lives this painfully slow-moving legal drama daily.

The Magazine of the Book

art directors Vivienne Cherry Seònaid Mackay designers Vivienne Cherry

Seònaid Mackay photographers/ Vivienne Cherry

illustrators Seònaid Mackay editors Vivienne Cherry Seònaid Mackay

publisher The Royal College of Art

origin UK

dimensions 210 x 297 mm $8^{1}/_{4} \times 11^{3}/_{4}$ in

pages 38-9

Visible Language

art directors 1 Tom Ockerse

2, 3, & 4 Larry Clarkberg designers 1 Paul Mazzucca

2, 3, & 4 Larry Clarkberg photographers 1 Paul Mazzucca 3 Stock Photo Disk

artist 2 J.S.G. Boggs editors 1 Andrew Blauvelt

2, 3, & 4 Sharon Poggenpohl

publisher Visible Language

origin USA

dimensions $152 \times 229 \text{ mm}$

6 x 9 in

Gonzalez & Boggs

39

ISGR

You were reluctant to give this interview, and I was surprised at that because you seem to be such an accessible and public person.

> I used to have an open-door policy, and I did not discriminate. If someone wanted to talk about the work or the circumstances, the door was open, even if it was the press come to ambush me. But I hate interviews.

I'm much more interested in conversation.

You are referring to the Dan Rather Eye On America television show where they portrayed you and your work in the light of color-copy counterfeiting.

> Actually I was referring to Art in America magazine, but CBS fills the bill.

I assure you I haven't come to ambush you.

Exactly what an ambusher would say, no?

Touche.

Look, I didn't close the door because I was worried about being ambushed. Do your worst. I just got tired of doing interviews that were of little consequence to either party. There is no such thing as a stupid question, but if the question's little more than a thinly veiled fishing expedition to grab a sound bite, and no one is actually listening to the response, then

what is the point?

I'm listening

So am I.

(Boggs' reputation for full-frontal confrontation is well deserved.) You mentioned your previous open-door policy—did that extend to the police?

> What a **joke** They did not need a search warrant. I'd invited them to the studio dozens of times. I thought they were O.K. people. The United States Secret. Service had been asked to jointly prosecute in England because seven drawings were of American bills. They refused and ordered those works returned to me. I thought they were

379

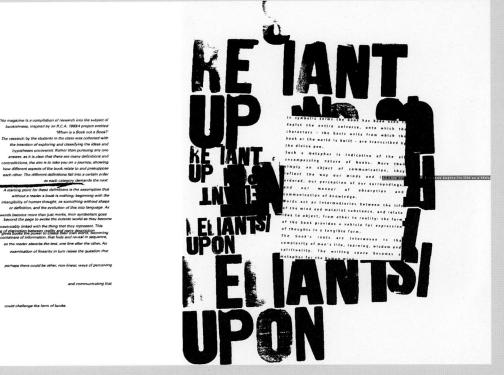

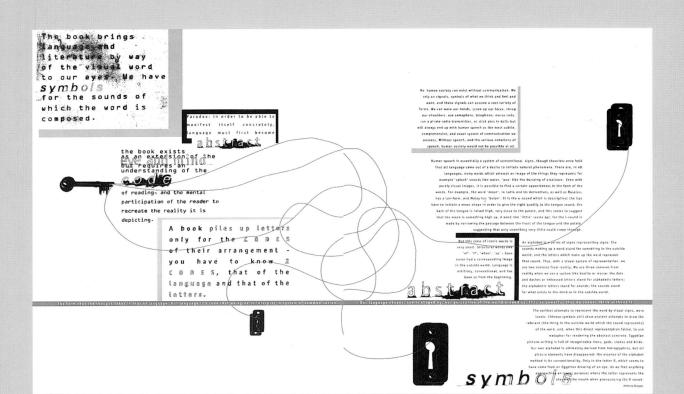

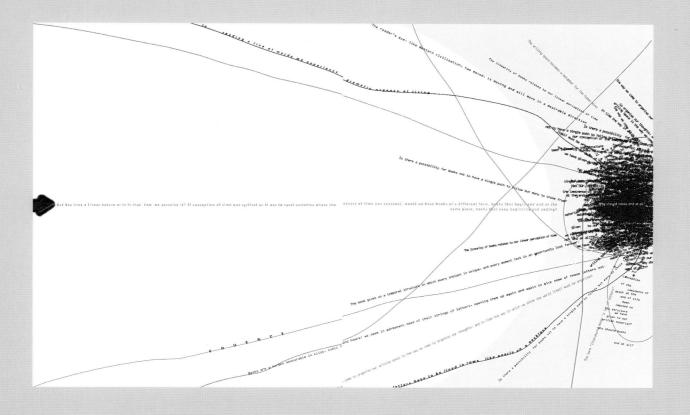

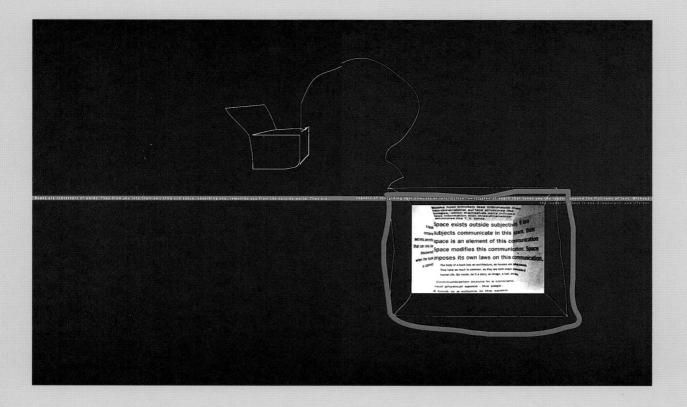

art director Stephen Coates designer Stephen Coates editor Rick Poynor publisher Emap Business Communications

42

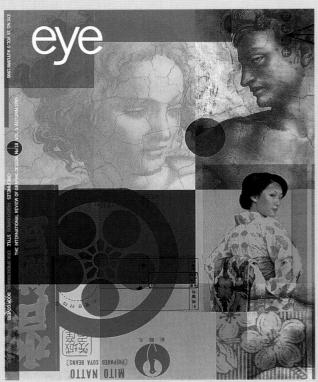

image Angus Hyland & Louise Cantrill

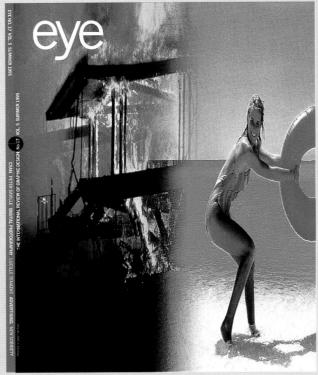

image Peter Saville photography © Pictor International

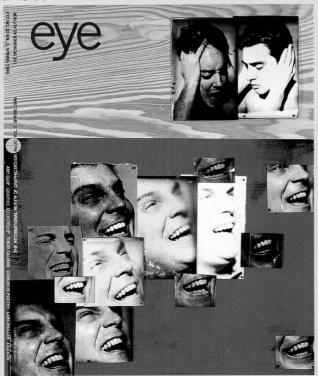

image Amy Guip

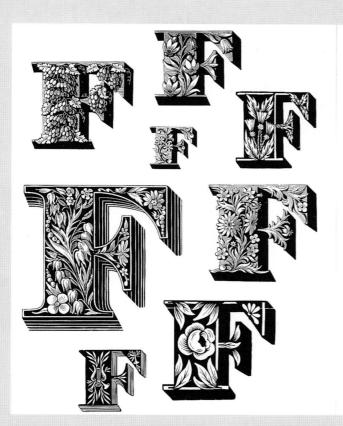

Ornament is no longer a crime and there is a growing enthusiasm for decorative display. Few recent alphabets equal Louis John Pouchée's for vivacity and invention

Pouchée's lost alphabets

in the early years to the interenth century, skilled engravers at the London type/foundry of Louis John Pouchée produced a series of finely crafted decorative alphabets. The beautiful large letters, up

heustiful large letters, up to 26 lines (1900 et 200 min) and and from single blocks of end-grain howevood, when single blocks of end-grain howevood, when intended as eye-carching elements for printed posters. They are mostly in the early miterestine-century far face self-ending sold fruit, adorned with intricately carred images of fruit, agricultural tooks, farm animals, mouscal instruments and Masonic signs. Virtually lose for er 150 years, they have now been reservered in a limited board edition as Ornamonted Types: Theory-shree alphates from the foundity of Lossis John Possiche through a collaboration between the 8 feider Farrings (Laberay in the City of London, in whose collection they reside, and Iam Mortimer of L.M. Imporime.

During the 1930s display types of this period underwent a re-appreciation and were promoted underwent a re-appreciation and were promoted that the property of the property of

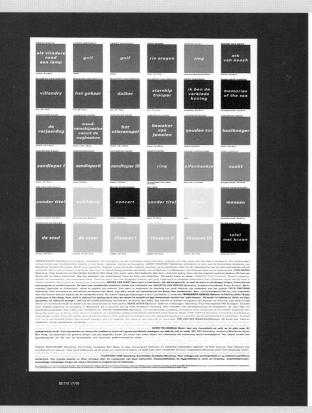

Seen from the outside, during the 1980s, the Netherlands looked like a graphic designer's heaven. Government subsidies allowed cultural work to flourish. Commercial clients backed experimentation seemingly without question. But the 1990s finds young Dutch designers beating a retreat. The older generation's triumph is being followed by diffidence

Sobrety

Dunch graphic design is going through a transitional period, per-haps even a crisis. The overall standard is high, Dutch work enjoys an excellent reputation both at home and altroad, and the industry is becoming professionally organized. But the coming of age of Dutch design looks likely to be followed by an awkward selence. The Netherlands is home to a host of freedances, studies, part-nerships and collectives of various stees, which together produce a body of work that does credit to the reputation of Dutch design. Though Amsterdam has traditionally been the capital of publishing, advertising and design, more and more high-quality studies are being established ourside the city. A good example is the Arubens based. M.-M. Wermgeers, where Mechdle Caiy and Marris Stoogen's work has an assertity reminiscent of the pre-war News Schickbert and good war functionalism. If M-M are in the middle of the spectrum, then's assistant with a high prograph's & Other Serious Marten in The Higgs recognise the more brooksive and with a hal-anced, styloh sdoen derived from Jan van Krimpen and other Dutch

ephemorality of primed matter and the ever increasing rate of change of corporate identifies. So where is the crisis? First, there is a notable absence of the kind of innovation that could be detected even in the professional main-stream until a few years ago. Second, growing numbers of leading young designers have been gone to receive the "Dunch Design" label, which they associate with hiving a ball at the client's expense and hombarding the public with a plethora of unneces-tionate and the country of the contract of the country of contract they of the work. In this country-current runs alongside a public were accessed in the country-current runs alongside a public versities with compressionally de-

Graphic authorship is taken for granted by many design theorists and it is gaining ground within practice too. But the idea has received little sustained examination. What does it mean and what is really possible?

The designer as The meaning of the word "author" has shifted significantly through history and has been the subject of interne scrutiny over the last an years. The earliest definitions are not associations are not association and the subject of interne scrutiny over the last any years. The earliest definitions are not associations are not association without the constantions. "the father of all life," "any sweeney constructor of sounder," one who legges," and "a director, columnander, or nute", More recently, "Minister and Bearderly's entired lessys." The Intentional Fallacy" (154) was one of the first to direct a wedge levere the author and the next with me chain that a reader could never really "know" than the state of the s

"THE BIRTH OF THE READER MUST BE AT THE COST OF THE DEATH OF THE AUTHOR"

"THE WHOLE POINT OF A MEANINGFUL STYLE IS THAT IT UNIFIES THE WHAT AND THE HOW INTO A PERSONAL STATEMENT" AASSEW SARRIS

A Designer's Art

von Kleist

3. Michel Foucauli, "What is an Author?" in Testinal Strategies, cd. Josef Harari, Ichaca: Cornell University Press, 1979. 4. Barthes, op. cic., p. 143-5. Fruccoult, op. cit., p. 160.

characteristics and functions of the author and the problems associated with conventional ideas of authorship and origination.' Foucault demonstrated that over the centuries

the problems associated with conventional ideas of authorship and origination.)

Foucasid demonstrated that over the centuries the relationship between the authors and the text has changed. The earliest sacred texts are authorless, and the results of the problems of the problems of the problems of the authorship and administration. On the other hand, scientific executions origin of such texts serves as a kind of authorities and authorities of the other hand, scientific executions or an authorities of the server of the authorities of the au

Text: Michael Rock

Authorship has become a popular term in graphic design circles, especially in those at the edges of the profession the design acadenies and the murby territory between design and art. The word has an important ring to it, with sedicitive commotions of origination and agency, but the question of low constitution of origination and agency, but the question of low casacity who qualifies and what authorsed design might took. But depends on how you define the term and determine admission into the parathero. Authorship ans suggest new approaches to the issue of the design process in a profession traditionally associated more with the communication than the origination of messages. But therefore is duratherly also serve as legitimizing strategies and authorship also serve as legitimizing restriction, and subscriptive jacks and the common of design production and subscriptive jacks after turn counter to recent certical attempts to overshrow the procession of design and authorship and the contraction of design and the contraction of the contraction of

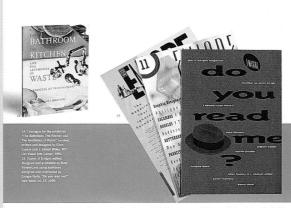

low, but in typography and composition). The singularity of the artist's book, the low technical quality and the absence of a practical application may alienate the professional graphic designer. If the difference between portry and practical messages is that the latter are successful only when

messages is that the latter are successful only when the correctly infer himeterion, then activite design would be labelled as absolutely practical. But activits we shall be a substitutely practical. But activits work—including the entropt of Gen arties, Buteractivity. Women Action Coalition, General Idea, ACT-107, Eleas Action and the Generalla Garles—a last osself-motivated and self-authored work has a sixee and message, but in its over intentionality lacks the self-reforentiality in its over intentionality lacks the self-reforentiality of the artist is book. Yet several problems—cloud the issue of authored activities, not least the question of collaboration. When we seek a seak-dirical? Yet and issue of authored activism, not least the question of collaboration. Whose woice is speaking? Not an individual, but some kind of unified community: It is this work open for interpretation or is its point the brutal transmission of a specific message? The rise of activist authorship has complicated the whole idea of authorship as a kind of free self-expression. Perhaps the graphic author is one who writes and

publishes material about design – Josef MüllerBrockmann or Rudy Vanderlams, Paul Rand or
Eril Speikermann, William Morris or Neville Borge
Kobin Kirnson or Ellen Lappon. The entrepreneurial
arm of authorship affords the possibility of a
cathorship affords the content of the cathorship
and designing. Even as their own clients, writing
and designing. Even as their own clients, bring
and designing. Even as their own clients, bring
and the design at the cathorship
and the hought. (Einzos
for instance, words as a historian then changes
hats and tecomos a 1 prograph file the extremites blend
into a configuous whole. In Emigre the content
a substros, since in Emigre aft three activities blend
into a configuous whole. In Emigre the content
is deeply embedded in the form—that is, the formal
is deeply embedded in the form—that is, the formal
of the pages and trypoparphy (as a formajetre).
Hellen Lupton and her partner J. Abbott Miller
base almost single-handedly constructed the new
critical approach to graphic design, coupled with

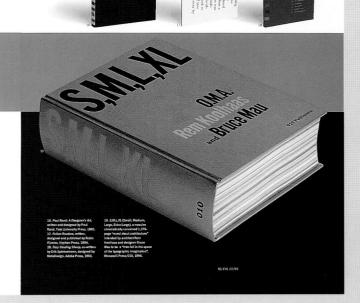

Systems not schemes, character not conformity: typography, for Erik Spiekermann, is a tool for rendering the world accessible

Vietas tectonic man

Ent Spicermantin is a consummate pursuant. Ander to more, seeming without offen, hexever roles as a typographer, designor, writer, public speaker and merchanders, he was once even a policiam a Green Brary member of the Berlin Senate. Spicerman of the Berlin Senate of Stop States of the State of Stop States of State

lowest common denominator system. The page is the the atom is the word."

of rational Modernism-with-character, the polemi has sometimes overshadowed the practitioner. Spiekermann himself rejects the title of graphic designer to describe his practice: "I am a Spread matter throat regions to the con-sequence of the control of the process of the con-trol of the control of the control of the con-trol of the control of the control of the con-trol of the control of the co

A respect for words and evident tilent for using them might seem incognosa in the visual arts were it not that Spickermann so often speaks and writes it not that Spickermann so often speaks and writes in pictures. His consentation is a stream of alphorism and metaphot. On national stereotypes in graphic design, for instance, we learn: France is often stapped; Holiand to transpillar, always very pointry and nativors Germany to very square, and transpillar and transpillar and transpillar points of the speak of the state of the speak o

K

BVG

and a palette of just two colours – black and red, in the craft tradition. While he is generous with words, Spickermann a extremely paramonous when dispersioning colour, adaps and typographic variation, depressing colour, adaps and typographic variation, and the colours of four children, his father a kery divers, he defeat of four children, his father a kery divers, he was born into an imposerabled pour was Germany, near Hamoover, in 1947, He pash his way through herita's Free Ulrestriy, where he suited art history, by setting up as a jobhing letterpress printer. He had only two typefaces, in three tues, and could rarely use more than two colours (he learned to give the impression of three-colour work by twersing type out of a colour in white). Economy was a function of necessity, and Spickermann has used this experience to establish a method which exploits accurate consortees the full rather than attenues or reduces. He is used to getting a lot from a little, but

The tenth pioneer

new ground. Cipe Pineles, their art director, played a leading part. Why, when the history came to be written, was Pineles left out:

Traditional accounts of design history have some obvious bihadpoors when it comes to the carrers of women designers. Written from a predominantly lade perspective, the rend to ignore the interactions of the personal and the professionals, the private and the professionals, the private and the professionals, the professional design professionals are public, which also work of some professional history are qualified in the public which also work of working these. They are equally indifferent to the warries of carrep rathe taken by women, the nature of collaboration between collegagues and the social and political roles played by women professionals.

The career of the American designer Cipe Pindes presents us with a much needed opportunity to explore new ways and writing design history. As an illianzation, design teacher and art director working primaryly in women's magazines, he was an

illustrator, design teacher and art director working primarly in women's magazines, she was an exemplary professional, an intriguing individual, and a valuable role model. Vet despite ber many achievements, Pitales has never entirely received her due. The most recent historical study of individual American designers, R. Roger Remington and

a dominery and innovance contribution." Pindes', career first the critical for indisting viet brough both her husbands - William Golden and Will Burtin-at among the choisen mine, the has been overlooked. Should Pindes have been the tenth pioneer?

Bort to Jewohl parents in Pidadia in 1904, Tindes came to the US in 1923, at the age of 15. Three years the resulted as a commercial art sudem at the Part Institute, followed by a year of painting supported by a Tillary foundation scholarship during which time she looked for design work. In a brougepthol aumning work to Picket Feller, and the Part Institute, followed by a year of painting supported by a Tillary foundation schodarship during which time she looked for design work. In a brougepthol aumning year to Dr Borter Leslie, which is the state of the property of the prope

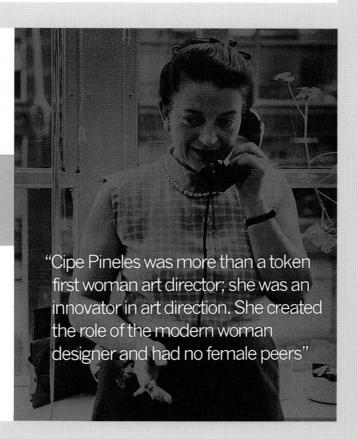

46

art director Chris Holt

editor Karen-Jane Eyre
publisher Marcello Grand, Studio Magazines

origin Australia dimensions $235 \times 324 \text{ mm}$ $9^{1/4} \times 12^{3/4}$ in

drew barrymore ellen von unwerth naomi watts penny arcade 3

photographers The Douglas Brothers

photographer Sonia Post

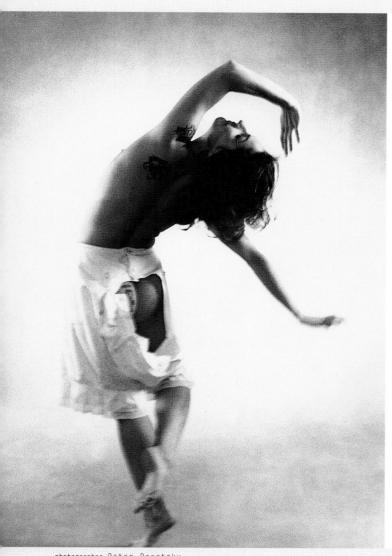

photographer Peter Rosetzky

LACY

photography peter rosetzky hair and makeup nikki cferke stylist virginia dowzer

With a combat-zone mouth and a boots-and-all attitude. Tania Lacy's take-no-prisoners comedy style has always played it fast and furious. Merran While catches up.

GRUNGING IT UP AND PLAYING HOLLYWOOD DOWN. ETHAN HAWKE IS SO COOL HE'S HOT Helen Barlow talks to Hollywood's hardest-working slacker.

serious

As brat pack stars like Kiefer Sutherland, Rob Lowe and Charlie Sheen continue their down-hill slide, a new breed of young American actors has emerged to take their place. Advocates of grunge over glamour, and more hip to the indie music and theatre scenes than the Hollywood hype-machine, these actors are high profile about their low-key lifestyles. At 23, Ethan Hawke is a reluctant celebrity who appears in one movie a year and usually tries to avoid probing journalists - except when he wants to talk about a new film.

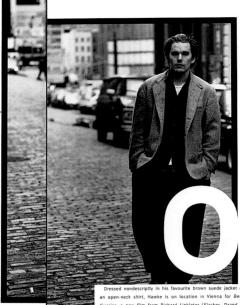

an open-neck shirt, Hawke is on location in Vienna for Before Sunrise, a new film from Richard Linklater (Slacker, Dazed and Confused). Co-starring French actress Julie Delpy, who recently appeared in Krzysztof Kieslowski's Three Colours White, the film is about two people who meet on a train in the middle of the night, and later roam the streets of Vienna, working their way through shared existential concerns, as they fall in love.

"I wanted to work with Rick [Linklater] because of his other two films," explains Hawke. "And I like him a lot. I was impressed with his idea of making a movie solely about communication, and how hard it is for two people to get to know each other."

The actor's new role is vastly different from his ranting Reality Bites character. "He's not surly, not angry at all. He's just a guy who's struggling with immediate dilemmas. He's broken up with his giris and is open to something happening in his life. Both these people-ore really available and we know so little about them outside of thou to-hour time bracket. It forces you to take them at a very human level. The idea of the film is to show real people. Life is not about drama, the most exciting things that happen to us are really mundane thim, to But these characters do have meaning, they have poetry I think."

Their different cultural backgrounds - she is French and he is American - adds to the human dimension for Hawke, "I never feel very American unless I'm placed against somebody who is very European," he muses. "Then all of a sudden I feel like all I do is drink Coke and say, 'Have a nice day'."

As the actor's sole film this year, Before Sunrise, made for only US\$2.5 million wasn't exactly a gold mine for its lead actors. Both Hawke and Delpy, however, were more interested in experiencing Linklater's loose creative process - 70 percent of the script was re-written in Vienna. "It's scary because the movie is a huge risk," says Hawke. "It's more probable that it won't work than that it will, because its aspirations are so high. Julie said in the script last night that the attempt is all, and I'm a real believer in that."

Delpy, an intense actor who works from nervous energy, is a contrast to the laid-back American. "She's very good, incredible," Hawke says. For a previous screen parthas really good instincts. You've got to hand it to her, Reality Bites is solely a product of her wanting to make a movie about her contemporaries. She is wildly successful, a millionaire," he exclaims. "Winona talked me into it. She really wanted to make the film."

Hawke's feathers get ruffled when I suggest that the characters in Reality Bites are more formulaic stereotypes - as has often been written in reviews - than accurate characterisations, "People say they tried to Hollywood-ise Slacker too, but I know how genuine that film is, and I know that it's just not true. People say things like that just to belittle a film. If I say that you're just another Australian, I'm belittling you as a numan being and it's the same to say that Reality Bites is a formula. It's a totally non-narrative movie. It's a really good movie."

Shrinking from 'generation X' and 'slacker' labels to describe his role in Before Sunrise, Hawke points out that his character has a job and that the film has a universal rather than just generational theme. "It's an optimistic movie. It's about how you can meet somebody and share intimacy ... and how you can have an exchange of souls." Hesitant about the labelling frenzy that has accompanied the so-called X generation's documentation in the media, Hawke admits to being, "Very confused about it. The only thing I can see is people who are very unsure about the future".

Hawke is reluctant to talk about his career because "It changes from day to day", so we talk about everyone else's. He agrees that Ryder's recent success, like that of Keanu Reeves, stems from wise choice of projects, and he sticks up for Reeves's much maligned acting talents. "A lot of people give Keanu Reeves a hard time but he's just proved himself again and again by sticking around and doing really good projects. Nobody has worked with better directors than Keanu Reeves."

Not that Hawke's choices have been so bad either. Before Reality Bites, he appeared in the plane-crash drama Alive and in Dead Poet's Society, the film that really jet-propelled his career.

MARLA, RUSTRALTA 1900 KURT MARKUS

The dry sultry ether of the mirage and the shifting horizons of heat and shadow imprint themselves upon the flesh of these photographs. For award-winning photographer, Kurt Markus, they are an ambling selection, not thematically constrained by the projections of the artist upon the subject. "What I respond to apart from my own pictures is what is direct, honest and straightforward. Trying to put on film what is in front of you rather than what is in your head. I haven't spent my life photographing nudes. In that sense these pictures aren't a significant body of work. They're just some pictures I've done, and that I enjoyed doing

Thus Kurt Markus brings an objectivity to the American West even though he was born and raised there - which removes it from more familiar terrain. His published photos are included in two volumes intriguingly titled, After Barbed Wire and Buckaroo, "I worked for a horse magazine for ten years," he says in his pensive, gentle drawl, "and in that time I did a lot of pictures of ranches. Some of these photos were taken in Australia, some in Santa Fe and some close to where I live. I guess you never fully escape who you are. Originality is to do with your own world. If you try to compare it to others you will always be at a loss."

nd objectivity is also displayed in Markus's nude, "Clothes can be more descriptive at times form. I don't think that just by removing clothes Itade to the nude. "Clothes can use more solutions and the nude form. I don't think that just by removing clothes are great former sort of truth. I think you can get at some sort beauty that son't being obstructed by clothes, especially in they aren't the person's clothes. Maybe these pieces are a discon against doing fastion pictures, where you never believe tiple clothes the girl is wearing are her own."

In effect, Kult Markus seeks to capture his subjects as they appearantee.

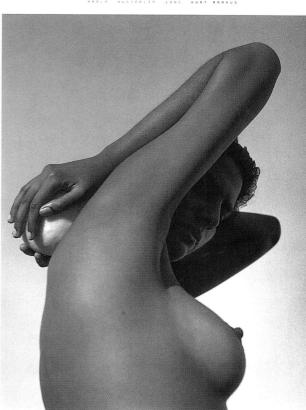

photographer Kurt Markus

pages 50-51 ➤

Arena

art director 1, 2, & 3 Sam Chick

4 Grant Turner

designer 1 & 4 Grant Turner

2 Sam Chick 3 Marissa Bourke

editor 1 David Bradshaw

2 Kathryn Flett

3 & 4 Peter Howarth

publisher Wagadon

origin UK dimensions $230 \times 335 \text{ mm}$

9 x 13¹/₈ in

Watson

EY BOY FROM FT CLASSROOM

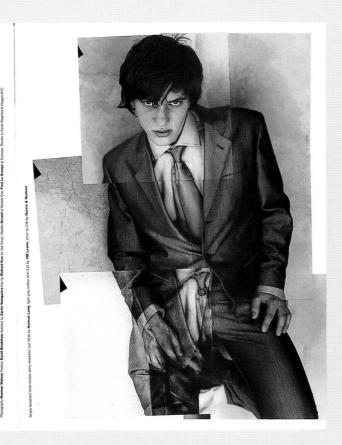

ARENA **152** AUTUMN

ALWAYS CAST HIMSELF AS THE OUTSIDER. THE DAYS, HOWEVER, THE NEW,

MELLOW MICKEY IS BACK AND THIS TIME

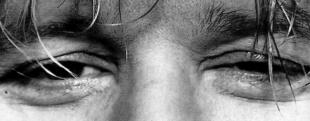

WHETHER AS ACTOR, BOXER, HELLRAISER OR HUSBAND, MICKEY ROURKE HAS

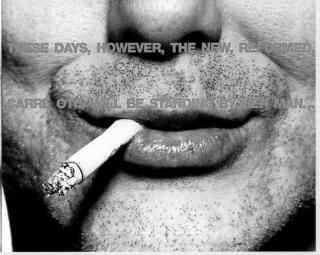

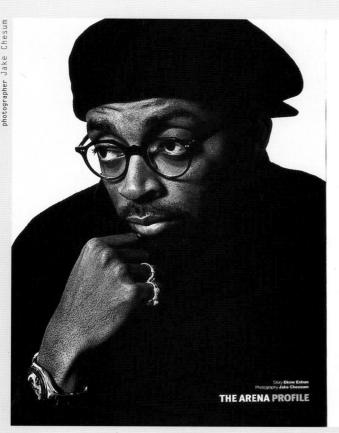

Weary, hooded eyes blinking hesitantly, **Spike Lee seems to** feel himself assailed. Assaulted. He yawns, clearly wishing that it would end, this thing of being>>

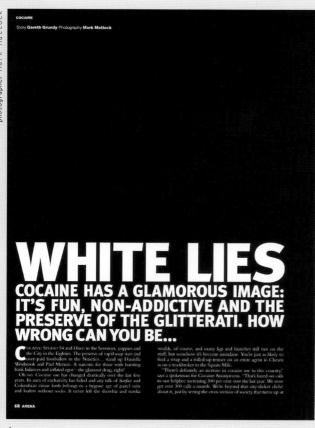

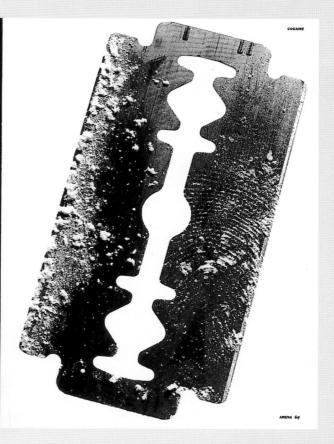

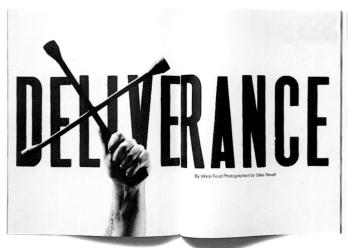

photographer Giles Revell

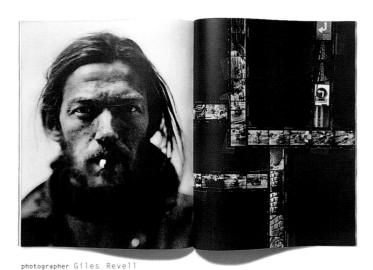

pages 52-5

Big Magazine

art director Vince Frost @ Frost Design designer Vince Frost @ Frost Design editor Marcello Jüneman publisher Marcello Jüneman origin UK

dimensions 420 x 594 mm $16^{1/2}$ x $23^{3/8}$ in

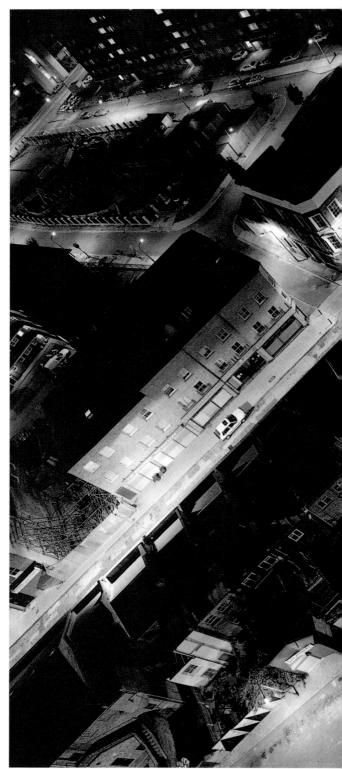

photographer Alan Delaney

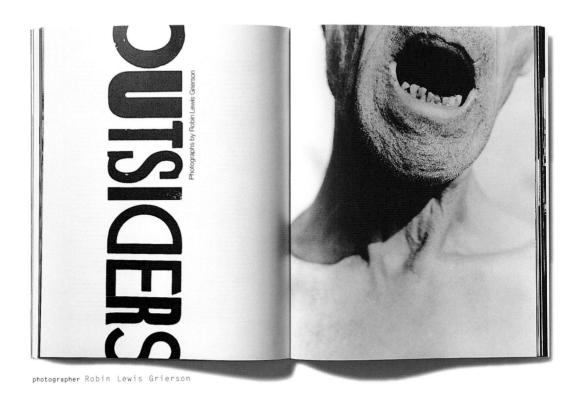

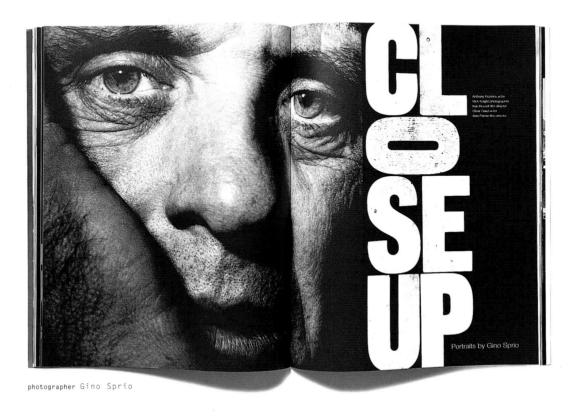

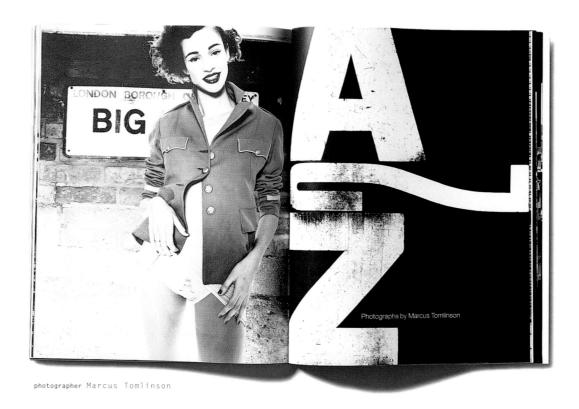

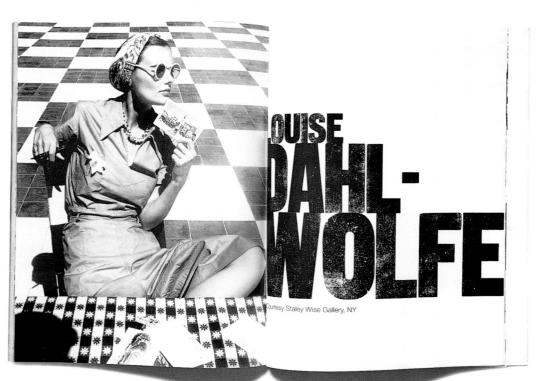

photographer Louise Dahl-Wolfe

The BERLAGE papers

Postgraduate School of Architecture

photographer Topografische Dienst Emmen

page 56

Berlage Papers

art director Arlette Brouwers
designers Arlette Brouwers
Koos van der Meer
editor Marijke Beek
publisher The Berlage Institute,
Amsterdam
origin The Netherlands
dimensions 297 x 297 mm $11^{3/4} \times 11^{3/4}$ in

page 57

Design

art director Quentin Newark
designer Glenn Howard
photographer/ Roger Taylor
illustrator
editor David Redhead
publisher ETP Publishing
origin UK
dimensions 230 x 280 mm
9 x 11 in

photographer Hélène Binet

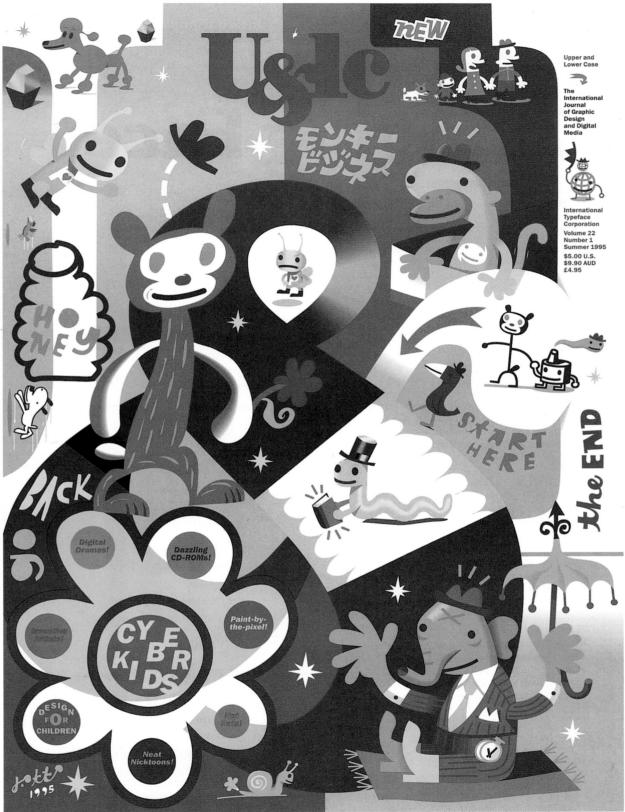

illustrator J. Otto Seibold

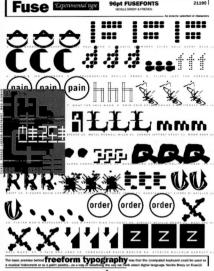

Fuse Experimental type 96pt FUSEFONTS
NEWLLE BROOF & FRENCE

images Fuse

Neville Brody, ...

Fuse isn't about trying to disintegrate language. The language is already in disinte-

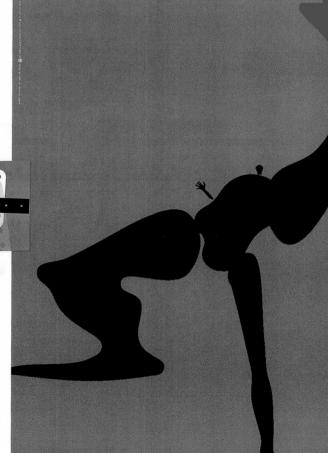

pages 58-61

origin USA dimensions 279 x 375 mm $11 \times 14^{3/4}$ in

U&1c

art director Rhonda Rubinstein designer Rhonda Rubinstein editor Margaret Richardson publisher International Typeface Corporation

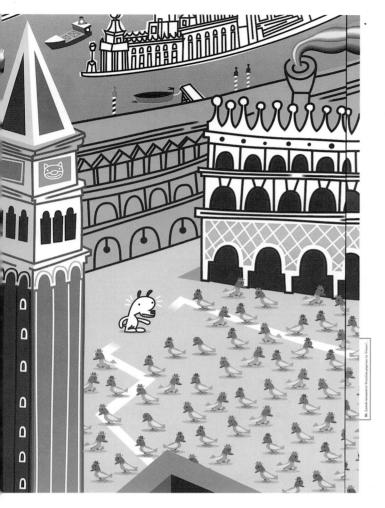

J. Otto Seibold doesn't merely answer the phone, he chortles a salutation in a comical falsetto that could easily belong to a near relative of Crusty the Clown. Should you get his answering machine, you will likewise hear a recording of Seibold shouting the regrets of his absence from a very remote distance.

illustrator J. Otto Seibold

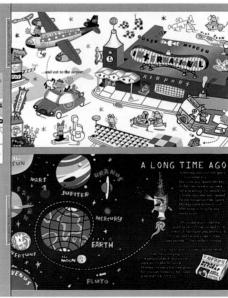

illustrator J. Otto Seibold

art director Terence Hogan

designer Terence Hogan editors Ray Edgar Sarah Bayliss

publisher Ashley Crawford origin Australia dimensions 245 x 265 mm 95/8 x 101/2 in

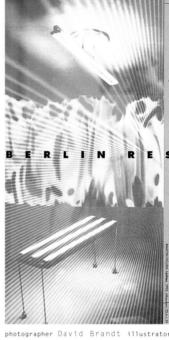

Vess, a young West Berlin gallery and one of the few experient guidences as young west Berlin gallery and one of the few exploring the neoconceptual installation art taking over Europe and New York. Knut sayer, Martin Figura, and Ulrich Kühn were noted figures on the berlin scene as artisks, and also as the principals of the Shin Shin Ballery in the Mitte section of East Berlin, an influential exhibition

Gallery in the Mitte section of East Berlin, an influential exhibition space supporting the conceptually imperied work that was percolating around the Berlin Index-beholen that the three had recently attended. At that time, Schabilify (co-operative rum) galleries like the Shin Shin were typically Berlinish - reflecting the politically progressive, "Hiermative," and activist tendencies of the people who choose to live in the walled city. In three proprietous were inspired by their teacher

rictors were inspired by their teacher Karl Horst Hoedicke, a painter of the "Wild" Neoexpressionist generation, who ran a celebrated Selbsthiffe gal-lery back in the '70s along with Mar-

"80s discourse around postmonderaism much more than we wer thinking about 70s Conceptual art. We were interested in the ide that every formal solution has already been invented, so that all style from all eras were equally available to an artist. Wild Painting was in Berlin was isolated by its political-geographical position, and fund

tioned culturally as an island.

"There was a generation that was developing in relation to the
neconoceptual art that one might find in the centers," he adds. "Critics
like Thomas Wulffen and Marius Babius served an important role.

We were also involved in developing this context.

Today the formerly dark and closed streets of Berlin's Mitte at frenetic with activity, and lit with commercial neon and street lighth Mitte is the site of noe of the Bastest-moring real estate markets. Western Europe, as this once-ruined neighborhood is being over

In a city where painting remains a historically loaded med three Berlin artists have rejected the dominance of Conceptu and returned to paint and canvas. Claudia Hart reports on a n ment that seems calculated to offend avant-garde sensibil

consisted of a site-specific multiconsisted of a site-specific multi-layered wall drawing. Each layer was conceived and made by one of the three artists, collectively suggesting a type of aesthetic conversa-tion between sympathetic individuals rather than a synthesized work. While Kühn'i Set-based work appeared to respond to the open-ended poetics of Lawrence Weiner, Figura's drawing was more historically peocles to Lewrence veneel, rigaria's unwing, was inner assoriestly impired – by Italian Benaissance architecture, and by the wall-drawings of Soi LeWit. Bayer's images, on the other hand, used silhoucites of mechanically drawn figures to create a language of signs.

"If Martin was LeWit, Knut was more Marvel Broodtheers," Kühn

ntly. Speaking of their gallery, he says, "when we started

taken by the noise of razing and reconstruction. Although the Shin Shin Gallery closed in 1992, the style of language-based Conceptual and installation art that it cultivated can be found in all of the young galleries and Kunstvereine that had sprouted up in Mitte like

rooms after aim.

An ISLAMD is the Sociolist East, the GDI's Berlin was neither restored after World War 2 nor rebuilt in solid grante along lates restored after World war 2 nor rebuilt in solid grante along lates and solid by the Bullanta lines like West Germany, instead is seemed to be filled with the Hinsiest forms of post-War perfabricated architecture, in the Hinsiest Society of the dress with trees Hilling boles in the urban tissue where houses, destroyed by benining, have left gaps. Yery few bourgeois were drawn to such an environment, as Berlin's population affracted many "alternative types," As a result, there have been ever excellent and the support of the property of

photographer David Brandt illustrator Martin Figura

n his performan

performing on the

he Net, Simone

o eliminate space.

18 WORLD ART

"I don't see myself as an 'American artist' or a 'Brazilian artist,' a 'Holography artist' or a 'Computer artist,' a 'Language artist' or an 'Installation artist," Eduardo Kac insists. "Labels are not very helpful and are often used to marginalize people. I prefer not to be bound by any particular nationality or geography. I work with telecommunications, trying to break up these boundaries." Born in Rio de Janeiro in 1962, Kac (pronounced Katz) moved to the US in 1989 to study fine art at the Art Institute of Chicago.

With a characteristic disregard for national boundaries, he went on to represent both the

US and Brazil in international exhibitions.

essons

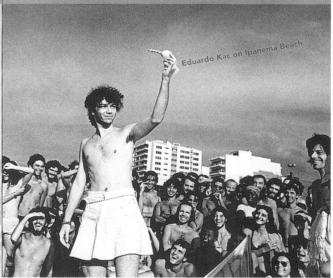

art director Christopher Waller
designer Christopher Waller
editors Ashley Crawford
Ray Edgar

publisher Ashley Crawford origin Australia dimensions 245 x 265 mm $9^{5}/_{8}$ x $10^{1}/_{2}$ in

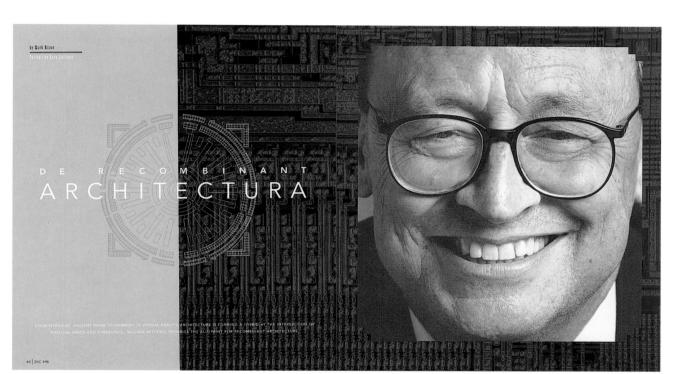

photographer Kate Gollings

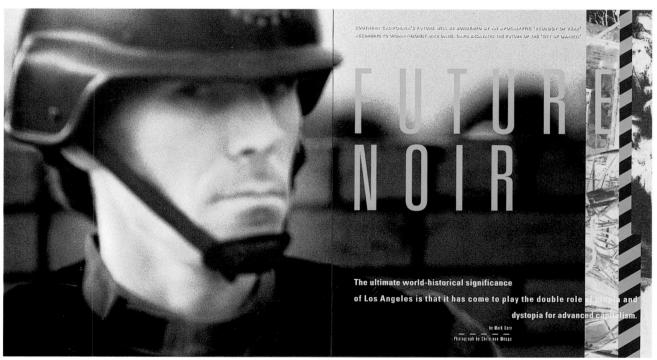

photographer Chris Von Menge

63

pages 64-5

Eventual

art director
Nina Rocha Miranda
designer
Nina Rocha Miranda
photographer/illustrator
Nina Rocha Miranda
editor
Lauro Cavalcanti
publisher
O Paço Imperial
origin
Brazil
dimensions
280 x 400 mm
11 x 15³/4 in

BUENTUAL

DEZEMBRO 1995 NÚMERO 1

64

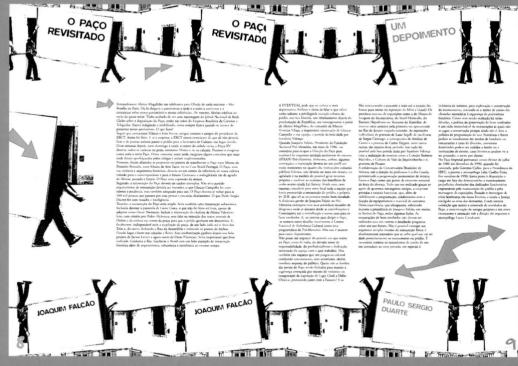

Office to printers are so finding and printers are so finding and printers are so finding and the printers are so find and the printers ar

address: Gothersgade 8C, Copenhagen City, Denmark.

information telephone number: 010 45 3393 7415/4056 9101

description of venue: aims to be an arena for explosive entertainment of an national calibre and have allied themselves with designers like Robert Singer (New York's Tunnel and Paradise) and Tony Hayes. The design is futuristic and was inspired by Blade

number of dancefloors: 2

capacity: 1,100

price of water: 16.00 DKR price of bottle of beer: 22.00 DKR

disabled access: yes

toilets (how many): 4

cloakroom and prices: 3 areas, 10 DKR per item.

sound system: Rodeck MX34 8 channel, 3 SL 1200 turntables, Roland sampler, DA

CD. Stax speakers, 8K Stereo Lab amp, Soundcraft mixer 24 channel.

how to get there: right in the middle of the city.

parking facilities: good. rail: close to Norreport station.

people policy: over 21, dress code.

regular nights: open Thursday, Friday and Saturday.

opening times: 11pm - 7am

best time to arrive: before 1 am

door prices: 40.00 DKR

resident DJs: Ezi - Cut, Joe Belmati, Kjeld Tolstrup, Kenneth Baker, Cutfather, Typ

and Knud.

quest DJs/PAs: DJ Duke, MKM, Jon Marsh (Beloved).

music policy: anything as long as it is good!

promoter Comment: "The main dancefloor is for 700 people and plays deep hous garage while hip hop, acid jazz and rare groove is played in the Underground. This part of

club also hosts rap, jazz and 'unplugged' performances."

photographer Ronnie Randall

pages 66-7

Euro Club Guide

supplement of DJ Magazine

art director Michèle Allardyce designer Michèle Allardyce

editor Christopher Mellor publisher Nexus Media Ltd

origin UK

dimensions 148 x 230 mm

 $5^{7}/8 \times 9 in$

CAFE DE PARIS

RY SATURDAY

FE DE PARIS

information telephone number: 071 287 0503 description of venue: historical ballroom. number of dancefloors: 2 capacity: 700 price of water: £1.50 price of bottle of beer: £2.60 disabled access: no.

address: Cafe De Paris, 3 Coventry Street, London, W1.

toilets (how many): enough for no queueing. cloakroom and prices: 80p per item. extra facilities: ice creams and food available sound system: main room 15K, small room 2K.

how to get there: in the heart of London in between Leicester Square and Piccadilly

parking facilities: car parks in the vicinity.

rail: British Rail at Charing Cross, nearest underground stations are Leicester Square and Piccadilly Circus.

air conditioning: yes.

people policy: people that come out for a good night without attitude. regular nights: Saturday - Release The Pressure; Tuesday - Red Hot.

opening times: 10pm - 6am

best time to arrive: before 10.30pm

door prices: members £10,00, non-members £12,00; after 3am entry is £5,00 resident DJs: Ricky Morrison, Jazzy M, Dean Savonne, Dana Down, Marcus, Paul

Tibbs, Danny Foster, Chris Mayes, Sammy (Toto), Sarah Chapman.

quest DJs/PAs: CJ Mackintosh, Frankie Foncett, Benji Candelario, Roger Sanchez, Kenny Carpenter, DJ Pierre, Femi B, Ralf, Phil Asher, Simon Aston, Rob Acteson, Ricky Montanari, Flavio Vecchi, Danny Morales, DJ Disciple, Claudio Cocolutto, Kevin Saunderson. music policy: US garage house in the main room and soul funk party classics in the small room.

club anthem: Nightcrawlers 'Push The Feeling On' DJ/promoter comment: "Tuffest US club in the

UK." Ricky Morrison. "Most beautiful club experience in the UK." Kenny Carpenter. punter/industry comment: "The music's rocking and you haven't failed us yet." Andrew & Louise from Essex. "The best DJs playing excellent house and garage. They have a special vibe of their own." Nigel Wilton, Sony Music.

CLUB UK

address: Buckhold Road, Wandsworth, London, SW18 4TQ. information telephone number: 081 877 0110 description of venue: 3 rooms with a total of 12 DJs per night. number of dancefloors: 3

price of water: £1.50 price of bottle of beer: £2.50

disabled access: wheelchair ramps and lifts.

capacity: 'loads'

toilets (how many): women - 2, men - 2

cloakroom and prices: 2 cloakrooms, £1.00 per item.

extra facilities: chill out with food available.

sound system: total for all 4 rooms is 35K.

how to get there: closest tube is East Putney (District line). British Rail - Wandswc Town. Buses stopping nearby - 28, 39, 44, 77A, 156, 270. Night Buses - N68 & N88.

parking facilities: free NCP nearby.

brief history of the club: opened in July 1993, the club was the venue for BBC's Dance Energy and for BPM.

people policy: dress to club, no blaggers, no bores, no bullshit, no bad attitude, no

bird brains, no bitchiness and no plebs. regular nights: Friday - Final Frontier; Saturday - Club UK.

opening times: 10pm - 6am

best time to arrive: before midnight.

door prices: Friday - members £7.00 before 11 pm, non-members £9.00; after 11 pm members £9.00, non-members £11.00; Saturday - members £10.00, non-members £12.00; aft 3 am £6.00

resident DJs: none as such but regulars are Danny Rampling, Judge Jules, Dean Thatcher, Roy The Roach, Fabi Paras, Dominic Moir, Steve Proctor, Steve Harvey.

guest DJS/PAS: Breeze, Terry Farley, John Digweed, Paul Oakenfold, Andy Weatherall Darren Emerson, Brandon Block, Jeremy Healy, Kenny Carpenter and Biko.

music policy: Black Room - euro house and pumping house anthems; Pop Art Room narder deep housey beats; Purple Room - ambient, classic club grooves. club anthem: Dan Hartman 'Relight My Fire', Gat Decor 'Passion', OT Quartet 'Hold Th

Sucker Down'.

DJ/promoter comment: "Ask anyone who comes down on a Saturday and 99% will t you they've had an awesome time." Sean McClusky.

punter/industry comment: "As soon as you walk up the steps the buzz hits you Steve Goddard.

DJ club guide

:lub quide 48

Caffeine Magazine

art director Heather Ferguson designer Heather Ferguson editor Rob Cohen

publisher Rob Cohen

origin USA

dimensions 254 x 305 mm

Golas Mullim are widely regarded as the world's finest. The Bolas Mullin Cannery employs only those who truly enjoy the mullin or, for they make the mont finations assemblers. Row upon row of cannot mullin time bounce by their assemblers, rejected time are regularly hand to a diseard belt. From the equality of the batter to the glue on the label, everybing it checked by hand keeping the equality second to a surprisingly nutritions true it ready to est."

The complex of the complex of the complex of the montal true is ready to est. The complex of the compl

DATTLEFIELD

Soldiers after have due than the state of the sold state of the sold are the ship at a bloody batch. If one wakes suddenly and screams be may be killed by an enemy bulk. States toldien will sleep in revot—one aburys keeping warch so no one jumps up during a nightmate. Some topse each other into fataboles. Other energes in befur jeve tored homoscead acts. Some bury themere in the white in home combet first and others still all the azimulation to keep awards or drug themselves with market in the white in home combet are and others still all the azimulation to keep scale or drug themselves with market in the still a search of the still a simulation to keep scale or drug the enders with market in the still a simulation. During batic rainings, nobliers are taught by fifts to recopiate impending algebraness in heir partners when they see thick glocal-like are streng from the course of closed sys. Then the trigger finger closels, the siming special state of the strength of the stren

Lardegi is almost back to the carde when a uniformed postman carrying a mountain of heavy packages one large.

Lardegi is almost to back to the carde when a uniformed postman carrying a mountain of heavy packages one.

But the next day the postman returns with many more packages, unloading them from a heavy carriage.

This the tens away and do not cross back! Lardegi shouts, this time from the roof of the Mocholi khois. He is robed in oiseand gath yet bidden by the fills of an entate tower.

This have then removed you will have to sign dichers and laser go our in public to the nation, Your Highness, "the postman chandlingly grinds several large stones to dust.

The how then removed you will have to sign dichers and laser go our in public to the nation, Your Highness, "the postman chandlingly grinds several large stones to dust.

The how the memory package several through the two of the properties of the postman cannot return. Rare pointoness stakes are important. Fearful deposts are cast from precisions steads. Exploding twomater applead in front pool.

The severals must also care vertible mythical construers from Cortican marble and wheel them upon immense log cares to all strategic joints in the gardens. The just heavy are distinted to dust under the tomage and the irreturn!

The postman does not return. Ludwig nover receives any mail for the rest of his life, His plan succeeds, but to

raz MUNER

Philbin Hardey was a chief technical engineer for operations on a particular deep mine shaft. Several times a day he was the victim ter-ending pun, "Hey you, fill that bin," or one of its painfully derivations. Even as a child taking out the garbage bin, he had found the joke

Philibis Hardey was a chief reducial engineer to operations on a particular deep mose mart. Severat must a sty ne was ne vocume or me ever-ending pun. "Hey you, fill that his," or one of in paintifyle devirations. Even as a deal basing our die pulsage his, he had formed he joke unstruction."

In addition to his job at the mine, he had invented and assembled a voc machine, a powerful fart vehicle to be unto once instelle an enemy retriency. A man could live in the machine for its mounts. Topologo them and multiwe weapons made it virtually uncomparable. He sport all his evenings working on a prototype now mar completion in a laboratory beamsh his house.

An enemy govername learned of Hishibin machine through article in science journals but as the printed story was altered to postect our security interest. Philibin was described as "blind medical mudent" (Philibin was no blind medical mudent) who had completed work on a var exactive former body. A special task fore was serve over your and capature the medical mudent was a completed work on a var exactive former body. A prepet that fore was serve over your and capature the medical mudent of the machine to make the constraint of the machine to make a segment to make the medical mudent of the constraint of the machine to make a segment to make the machine to make a segment to make the and a war beversing even a still is written.

One fine summer evening Philibin's sensitive minor's sen accurately deciphent due hum of forigin delils. He prepared to deput in the sensity completed machine, leaving until the machine to use against the own kind in a war beversing even a with is written.

One fine summer evening Philibin's sensitive minor's sen accurately deciphent due hum of forigin delils. He prepared to deput in the sensity completed machine, leaving the machine to use a substantial of the sensitive to the sensitive to the sensitive to the sensitive to the work of the blind before they martially and them reduling the line of the deciphed the bline of their deal and esti

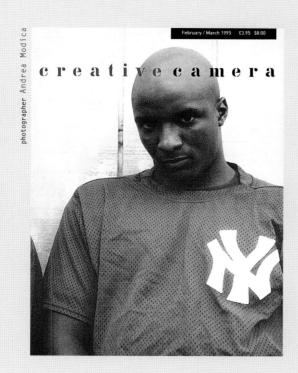

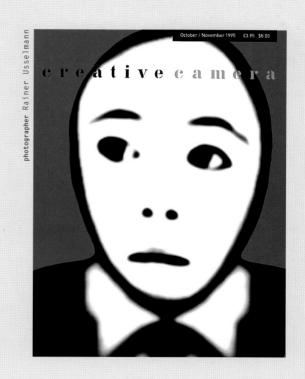

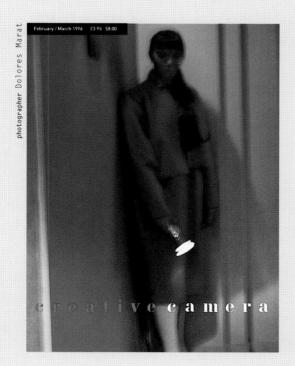

design consultant Phil Bicker
editor David Brittain
publisher Creative Camera
origin UK
dimensions 210 x 280 mm
81/4 x 11 in

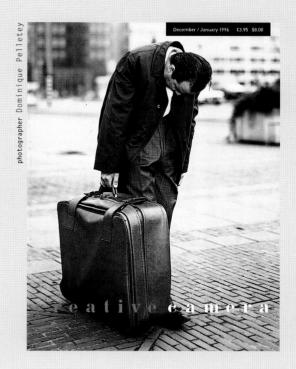

pages 70-71

Creative Camera

 $\begin{array}{cccc} {\rm design} & {\rm consultant} & {\rm Phil \ Bicker} \\ & {\rm editor} & {\rm David \ Brittain} \\ & {\rm publisher} & {\rm Creative \ Camera} \\ & {\rm origin \ UK} \\ & {\rm dimensions} & {\rm 210 \ x \ 280 \ mm} \\ & {\rm 8^{1/4} \ x \ 11 \ in} \end{array}$

70

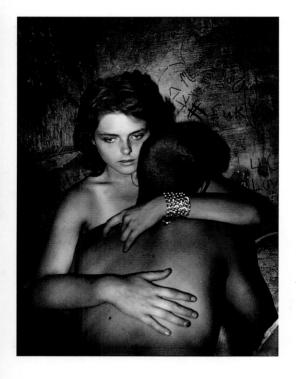

RAISED BY WOLVES

I Have 2 pairs of Black Jeans

1/2 tentherects
1 to 3 Steam ACIS tees first
2 pair of 5 Hoes
4 to Jacket 11/00

That'S KILL IS COLD TO Holly cood

pages 72-3 ➤

Experiment

art directors Mike Lawrence

Stephanie Tironelle

Aaron Rose

designer Mike Lawrence

editor Stephanie Tironelle publisher Stephanie Tironelle

origin UK

dimensions 203 mm diameter

8 in diameter

71

PREVIEW

The desert occupies a special place in European literature and art, but is especially seductive to camera users as diverse as Fredrick Sommer, Verdi Yahooda and Bill Viola

DESERT

OSSERT IS AN EXHIBITION which survey photographs of desert space, exploring its symbolic mannings and its significance as a site in which to consider the role of the limage and the space of the photograph.

Drawing on work produced during the last so years, the exhibition spans differing visions of deserted space; the extreme shelp finderick Sommer's Arkona landscapes and Thomas Briffs night sky photographs. The majority of the artists, however, explore the deserte of Netral Arkica and Arabia. These are the same places explored and charted by many of the

nineteenth and early twentieth-century travellers and writers whose experiences and visions contribute to the image of the desert as a symbolic soarce within European culture.

The image of the desert created by many such writers was based, to a great extent, on a European Romantie view of the "other" which, unfortunately, could not escape the infection of colonialism. The need to idealise nature, ancient beliefs and the exostic in many of these writings, therefore, speaks most loudly of Western desire. Others, however, explore

the barren desert as a more complex and layered space, rich and fertile with other possible symbolic readings: the desert is a place of metaphysical experience; a metancholic space of indifference; a site of death, disappearance and dissolution; a landscape of grains that refuse to be fixed.

Some of these readings are touched upon by all the artists in Desert. For example, faminh Collins' large scale desert photographs reveal the complex dynamic between the image and the real desert view. This is as

C C 32

C C 3 3

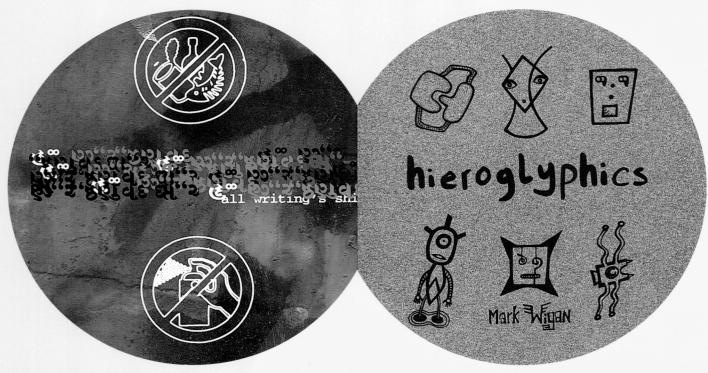

illustrator Mark Wigan

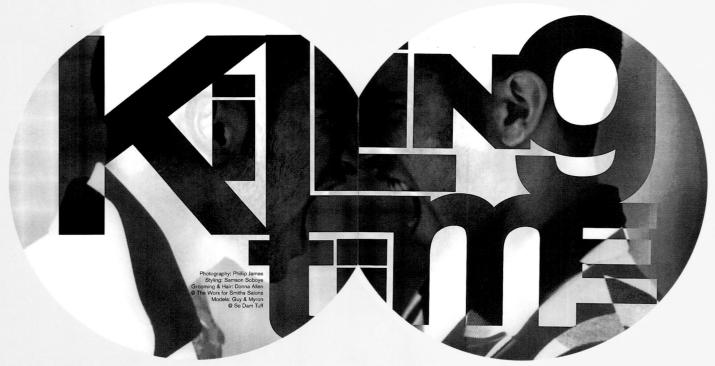

photographer Phillip James stylist Samson Soboye

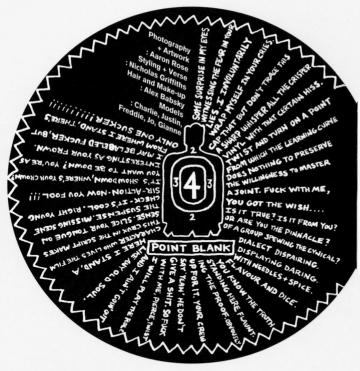

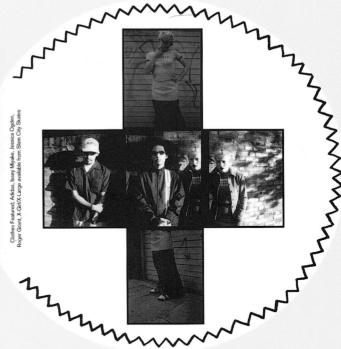

photographer Aaron Rose

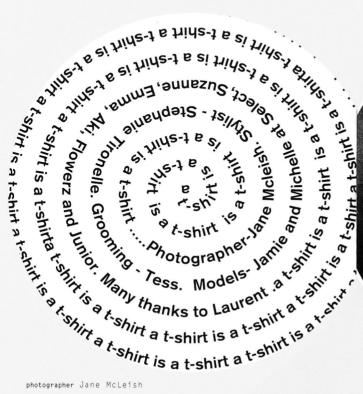

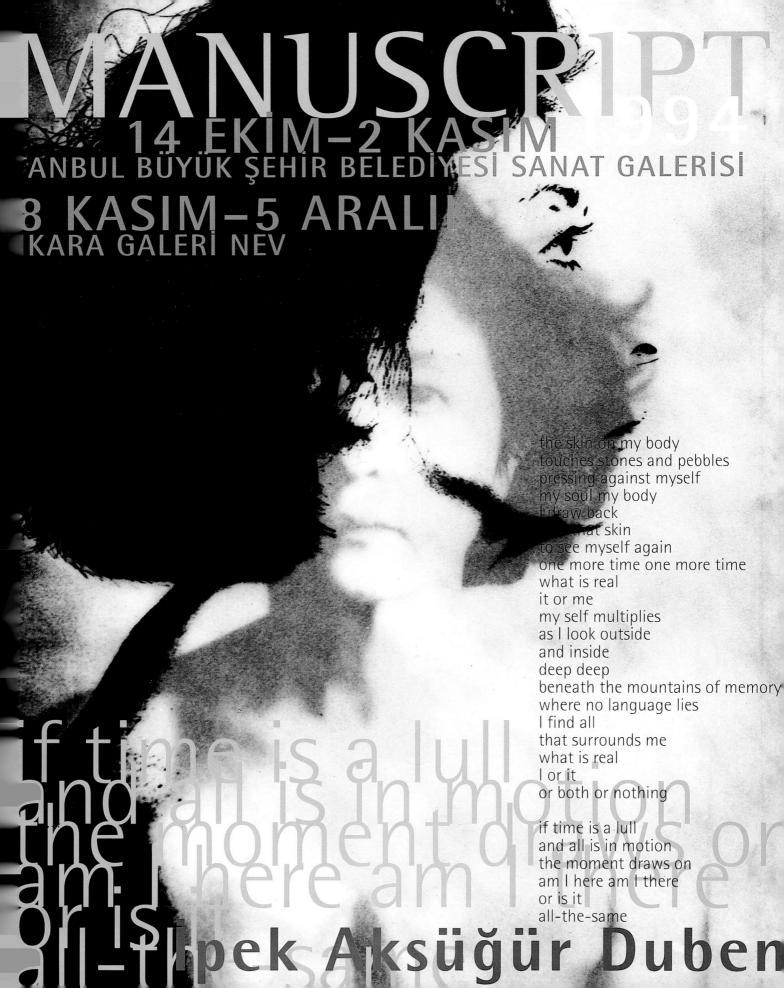

page 74

Manuscript

poster

art director
Gülizar Çepoğlu
designer
Gülizar Çepoğlu
artist
Ipek Aksüğür Duben
photographers
Ani Çelik Arevyan
Douglas Beube
origin
USA/Turkey
dimensions

 $480 \times 620 \text{ mm}$ $18^{7}/_{8} \times 24^{3}/_{8} \text{ in}$

page 75

Manuscript

artist's book 1994

designer Gülizar Çepoğlu artist Ipek Aksüğür Duben photographer Douglas Beube

origin USA/Turkey dimensions 220 x 285 mm 85/s x 111/2 in A CONTROL OF THE WAR SHOULD SEE THE WAY SHOULD SEE

all the same

Facilities in a service of the same of the

VOKSA Constitution

Over more than any service care

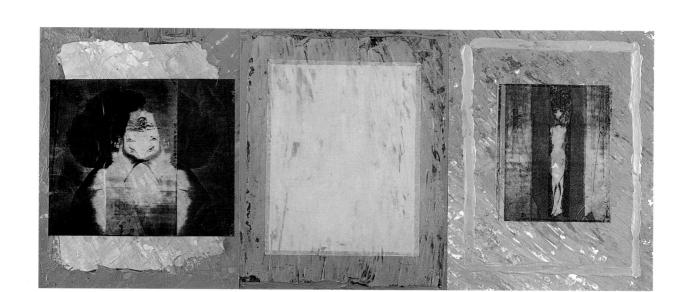

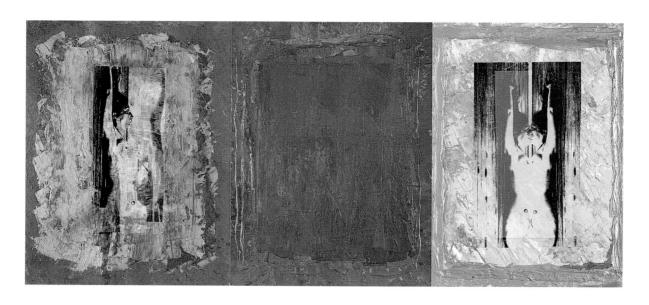

pages 76-7

Re taking London

art director Blue Source
designers Jonathan Cooke
Steve Turner
Mark Tappin
Simon Earith
Rob Wallace
Danny Doyle
Leigh Marling

editor Blue Source publisher Blue Source

origin UK

76

dimensions $480 \times 480 \text{ mm}$

 $18^{7}/8 \times 18^{7}/8 \text{ in}$

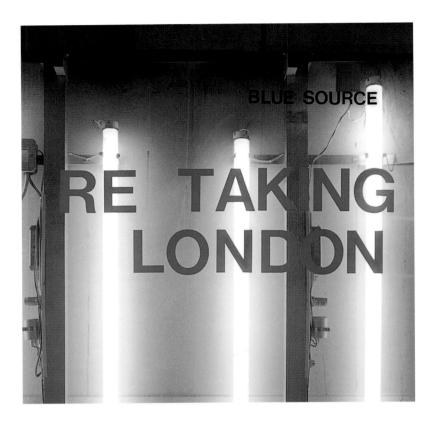

photographer Rankin

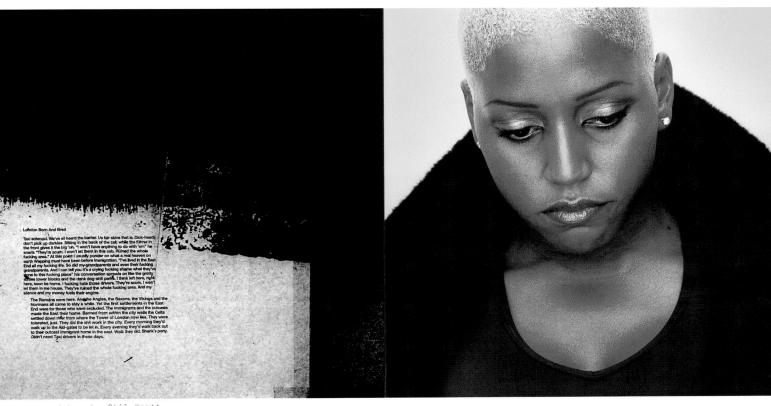

photographer Phil Knott

photographer Donald Milne

Lilly Tomec

designers Anja Lutz Lilly Tomec

editors Anja Lutz Lilly Tomec

publisher Gutentagverlag/Shift!

origin Germany dimensions $148 \times 105 \text{ mm}$

 $5^{7}/_{8} \times 4^{1}/_{8} in$

page 79

Typographic Fascism

art director Chris Turner designer Chris Turner photographer/ Chris Turner

illustrator

publisher unpublished

origin UK

dimensions 297 x 420 mm

 $11^3/_4 \times 16^1/_2 in$

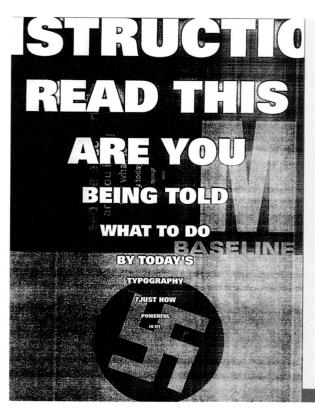

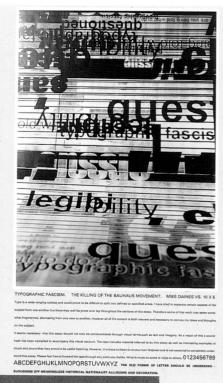

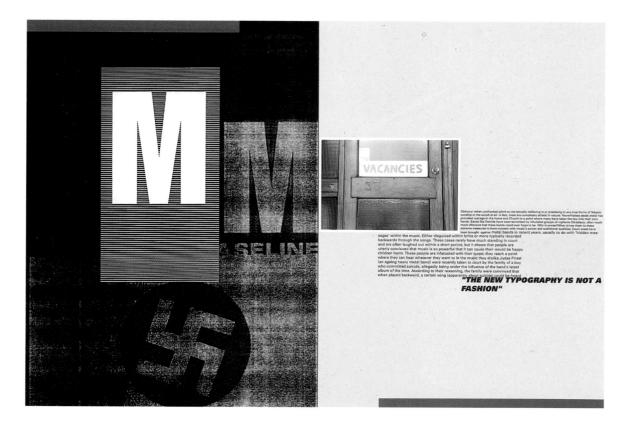

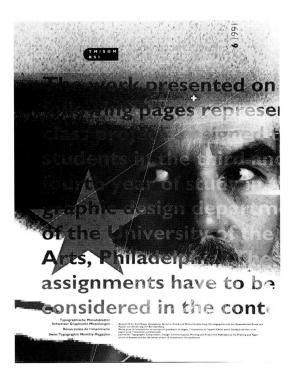

left

Typographische Monatsblätter

art director Jan C. Almquist
designer Jan C. Almquist
photographer Jan C. Almquist
editor Hans-U Allemann
publisher Printing and Paper Union
of Switzerland
origin Switzerland

dimensions 230 x 295 mm $9 \times 11^{5/8}$ in

below

Detail

designer Delphine Cormier
college Ecole Nationale Supérieure
Des Arts Décoratifs, Paris
tutor Philippe Apeloig
origin France
dimensions 448 x 149 mm
179/s x 5/% in

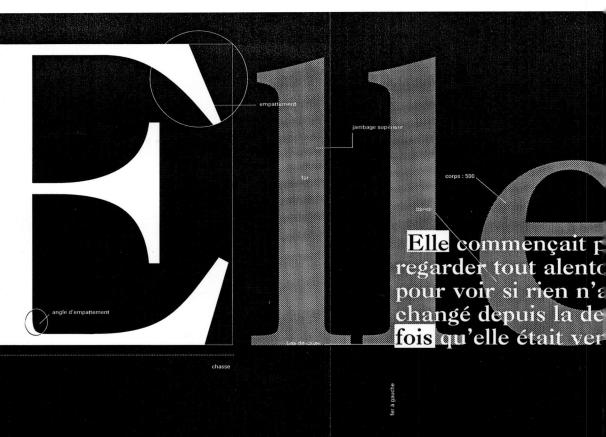

left

Bruitage

designer Suzanne Markowski
college Ecole Nationale Supérieure
Des Arts Décoratifs, Paris
tutor Philippe Apeloig
origin France
dimensions 259 x 347 mm
101/4 x 133/6 in

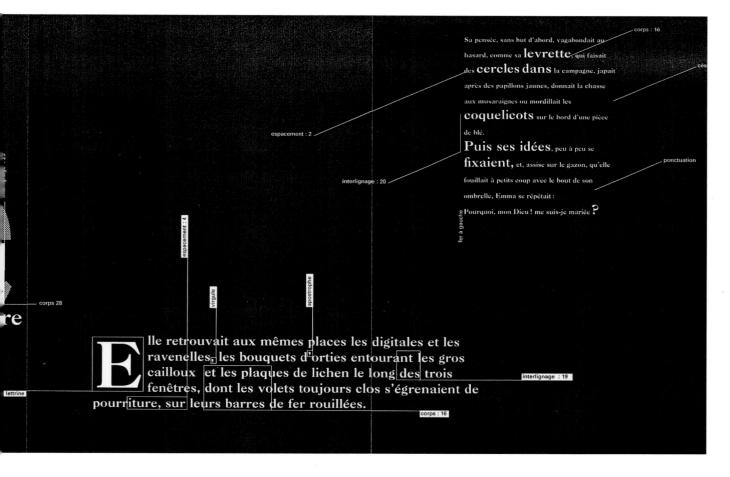

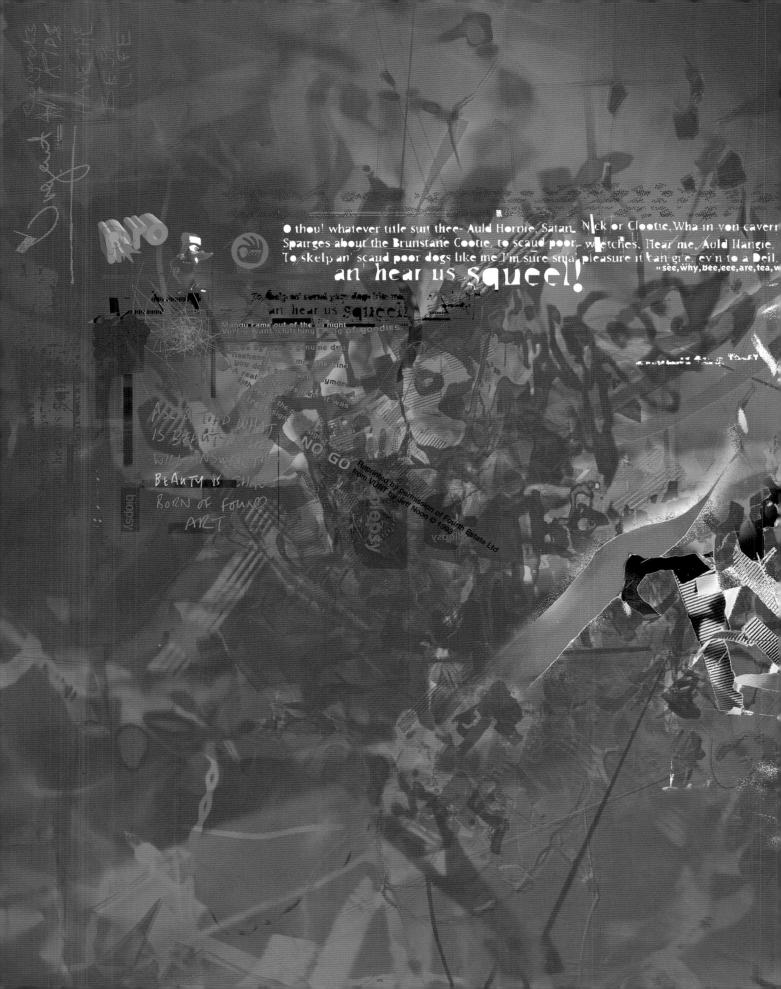

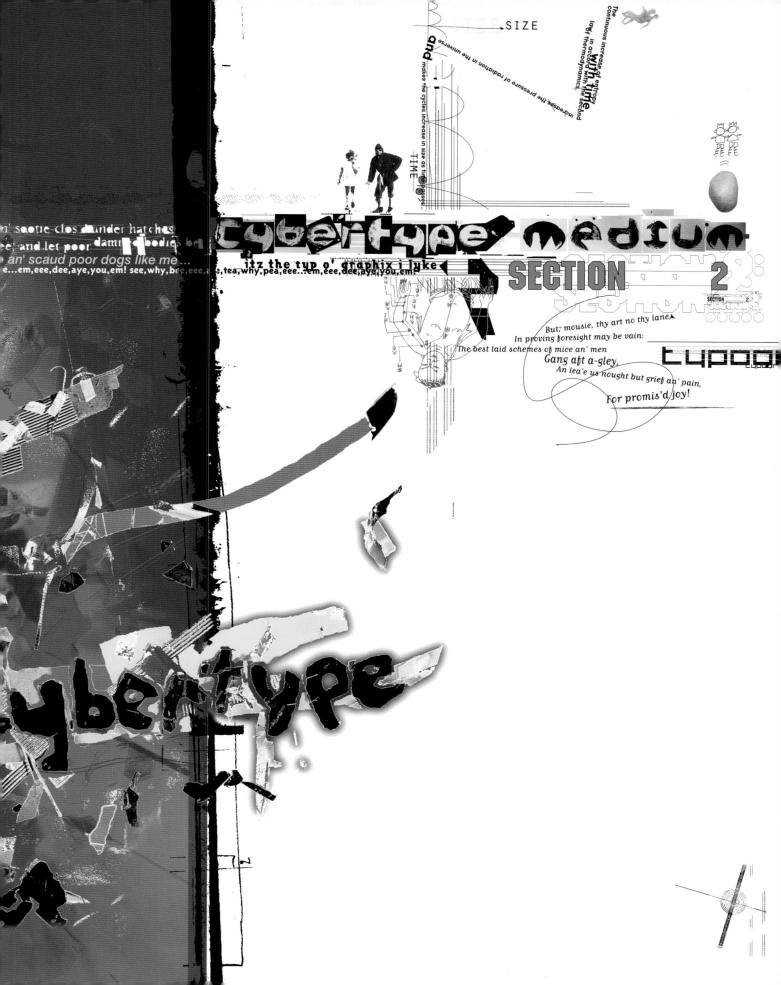

FOR A PROCHUSE FOR THE ACADEMY OF FINE ARTS AN DESIGN IN BRATISLAVA, SLOVAKIA, IT IS A SINGLE USE TYPEFACE: I MAYE MOT USED IT SINGE THEM, AND PROBABLY I MILL NEVER USE IT AGAIN. AS THE NAME OF THE FONT NAY SAY, COLLAPSE IS HIGHLY AFFECTED BY A NEW MAY OF MAY SAY, COLLAPSE IS HIGHLY AFFECTED BY A NEW MAY OF DESIGNING-COMPUTER GRAPHIC. AND BY THE COMPUTER GRAPHIC. AND BY THE COMPUTER OF THE TO BE A SATISFACTORY REASON FOR ME TO DESIGN A NEW FON T. BECAUSE OF A CHARACTER OF THE TASK (STUDENTS' EXHBITION THE TYPEFACE WAS TIMED TO BE "A ON TRA DIT I ON A L". ANOTHER REASON FOR THE CREATION OF THIS TYPEFACE WAS THE LACK OF MONEY: ME COULD NOT AFFORD TO BUY A

FONT, AND TO MAKE ONE UP AS A SCHOOL PROJECT DOES NOT COST

IN ORDER TO GIVE THE FACE A RANDOM LOOK, EVERY LETTER HAS THO DIFFERENT VERSIONS. SO THE FONT EXISTS

IN TWO DEFFERENT SETS-UPPER AND LONGER CASE.

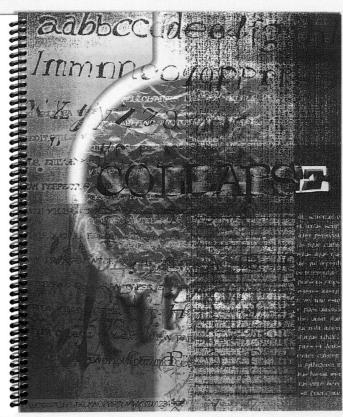

Illegibility

art director Peter Bil'ak designer Peter Bil'ak

publisher Reese Brothers, Inc.

Pittsburgh, PA origin USA/France dimensions 203 x 254 mm

8 x 10 in

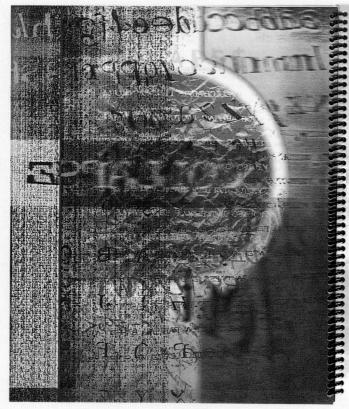

ABCDEFGHIJHLMNB ABCDEFGHIJHLMNB (0123456789)Æ (2128\$¥/5£8‡)

FF ATLANTA EXTRABOLO

ABCDEFGHIJHLMNOPORSTUVWX72

FF ATLANTA BORMA

ABCDEFGHIJHLMNOPORSTUVNXYZ

F ATLANTA EXTRALIBRE

ABCOLLEGALIROW AD FORS TO VEXAS

pages 86-7 ➤

Utopia

art director Gilles Poplin designer Gilles Poplin photographer/ Gilles Poplin illustrator editor Gilles Poplin publisher Gilles Poplin

origin France dimensions 290 x 415 mm $11^{3/8}$ x $16^{3/8}$ in

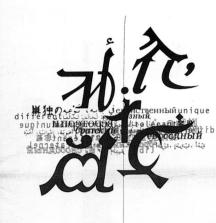

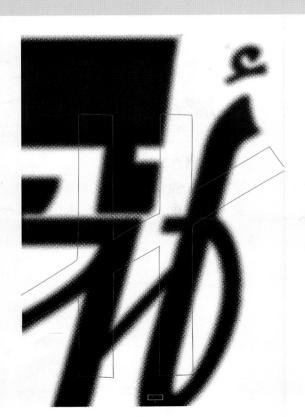

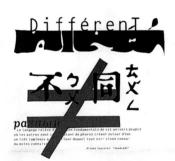

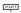

Rulldazer *18f

graphique à paris revue

Bulldozur, phénix graphique, revient vous aiguiser la rétine. Sous la forme moqueuse et l'égre d'un poster recto-veuxo, Bulldozer vous propose d'explorer la jungit touffue du graphisme actuel. Tous les deux mois, Bulldozer braquera son petit cell curieux sur la démarche d'un créateur contemporain chois pour l'exigence de sa réfléxion et la qualifié de ses images. C'est une recherche de proximité que nous désirons aneurs Bulldozer voisimité que nous désirons aneurs polonais à zer débutera ses investigations par une série consacrée à des graphistes français. Tel Michal Batoix, polonis à Paris see qui nous réalisons ce premien numéro. Bulldozer, votre troisème cail, a besoin de vous pour exister, presèérer et prospèrer. Abonnez-vous, faites-vous comaître, réoligier-nous et n'éstine pas à nous envoyer les travaux dont vous étes fiers. La crifque sea terrible et rien ne sear rendu.

En n'oubliez pas: Bulldozer bricole pour vous une autre manière de voir!

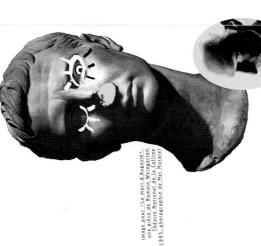

Michal

la méthode constructiviste. Au gré des rues grises de Lodz, les affiches annonçant des événements culturels aviyent les poussent à l'extrême le sens de l'ellipse. Ces rares affiches ne manqueront pas d'exercer leur influence sur le travail de murs et font parler d'elles : dans un état policier où la télévision gouvernementale produit surtout des images fades, édulcorées par une censure omniprésente, où la publicité n'existe pour ainsi dire pas, ces affiches détonnent sur leur l'autorisation d'imprimer de la commission chargée de juger chaque projet, tout en produisant des images fortes qui Batory, qui en retiendra une inclination à la poésie des métaphores, aux jeux d'associations et aux significations latentes. Wajda et Polanski, le jeune Batory découvre les règles de la composition auprès de Balicki, maître rigoureux marqué par environnement. Leurs auteurs rivalisent d'audace et d'habileté subversive pour contourner la censure et obtenir Michal Batory est né en 1959 à Lodz, Pologne. Élève des beaux-arts, non loin de la fameuse école de cinéma où étudièren

113

En 86, sacrifiant ses rèves de cinéma, elle revent au dessa, et réssait le concours d'entrée des Arts Décoraits de Paris. Cest à l'époque de New Order et Reer Swille, des premières poorbettes de AID désignées par Vaugin Olivez, celles de Mark Farrow ou de Josegness Republic

Rulldazer *18f 091095 Bulldozer se plaît à observer la profusion visuelle du graphisme actuel. Explorer différents univers, observer les parcours les plus variés et les plus et de slogans qui forme son regard curieux. Bulldozer, votre troisième œil, étroit, compartimenté en genres respectables ou mineurs. Voilà l'optique 'insolence et l'œil moqueur de Geneviève Gauckler qui orientera votre d'une société de consommation dérisoire. Cette cybercowgirl, avec qui no deux surprenants, préférer les contrastes et repousser l'idée d'un graphisme de ce nouvêau Bulldozer. Après le regard aigu de Michal Batory, c'est nous avons réalisé ce nº deux, vous fera intégrer la mosaïque d'images rétine vers un espace iconoclaste, techno et utopiste, reflet grossissant N'hésitez pas à vous abonner et à le faire savoir! a besoin de vous pour augmenter son acuité... magazine Internatif et Monstere Cyber, a Fedition, en passan par des chemins plus personnels, tils que le concept d'une société de service du lunu, la firme RGB fores, fre., le hazaine hiarant idatu IVC ou les dentries affiches d'Act Up. L'arrivée tardive de son complies el Jideal IVCl, evivitant Loie Prigent, et d'une assierte de fromage, frenci qu'elle accepte erstin de se livres sans retenue. Décision prise, l'interview se tiendra dans un des hauts lieux de la pop culture française le «Flunch» des Halles ! Installée de la capitale, cette jeune Jyonnasse de 28 ans, qui publia son premier dessni équestre) à l'âge de 14 ans dans le trop méconnu Monde du Cheval (?), semble intimidée et fascinée par l'endroit. Depuis quelques années, elle s'est forgée une image hors F Communications et ses pochettes pour le DJ Laurent Garnier ou St Germain, de normes en multipliant les expériences : le sa collaboration avec le label house

Frédéric Bortolotti Philippe Savoir Anne Duranton Pascal Béjean Daniel Pype designers photographer

Frédéric Bortolotti

Pascal Béjean

Bulldozer

pages 88-93

art directors Anne Duranton

Philippe Savoir

déprinée et ut fais ton premier lifuig... Genevève : ... et mon premier meeting du RPR ! Et là, je m'inseris.

.oic : Et là, en octobre 87, t'es ruinée, tu

que sa passion pour le graphisme s'éveillera.

as ce grave accident d'avion, le divorce d'avec Donald Trump. Malgré les 120

editor Bulldozer origin France publisher

dimensions $200 \times 300 \text{ mm}$ (when folded)

7'/8 x 11'/8 in

kédérique gavillet de vos abonnements pour mieux voir l'avenir. Parlez-en Comment supporter, par exemple, de vivre au pays du bien cachée de la planète graphique Tel est le douloureux débat que propose Bulldozer troisième œil, compte plus que jamais sur l'apaisant collyr avec Frédérique Gavillet, graphiste fiduciair à l'impitoyable regard spirographique. Bulldozer, voit chèques et cartes de crédit mais aussi supports sécurisés rels que timbres, passeports, formulaires, cartes d'identité etc. Objets quotidiens de nos existences transactionnelles identité, individuelle et communautaire, quelles image de nous-mêmes renvoyez-vous? Méconnaissables et parfoi formulaire de Sécurité sociale le plus laid au monde la menue revue qui n'en peut plus, dans ce n'trois conç pointant son vif télescope désintéressé sur UNE face le fiduciaire : billets de banque. pièces de monnaie ou administratives, qui se soucie de vous? Miroirs de notn et trébuchante. Bulldozer fait montre d'à-propos en observatoire du graphisme post-moderne, affiche tous serein de Noël, si propice au mercantilisme de masse les deux mois son désir de transversalité. En ce temp et au « marché » d'une communication visuelle sonnant Bulldozer, modeste et cosmiqui pitoyables reflets, pour tout dire selon notre cœur!

oris de norre
celles images
les les partires
les en partires
les en partires
les en partires
les partires
les

aux rennes de ce bon vieux Père Noël...

Une jeune graphiste qui avoue pèle-mèle son goût pour le baroque, les puzzlès, les romans policiers ou la guerre d'Indochine et dont le héros n'est-autre que l'inénarrable général Bigeard... plutôt déroutant, non? Frédérique Gavillet est née en 1964 aux États-Unis.

Elle entre en 1984 à l'école des Arts décoratifs de Paris, où elle se sent immédiatement à l'aise parmi les autres extra-terrestres de l'endroit.

Buildions, part there get a philip use a part of the building and the second of the building and the second of the building and the second of the second of

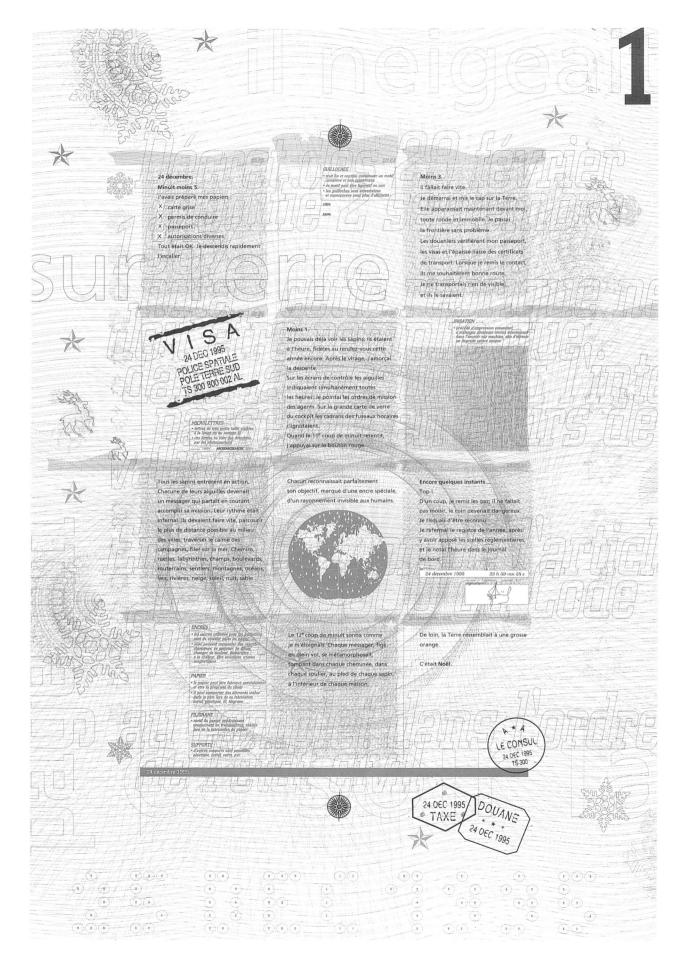

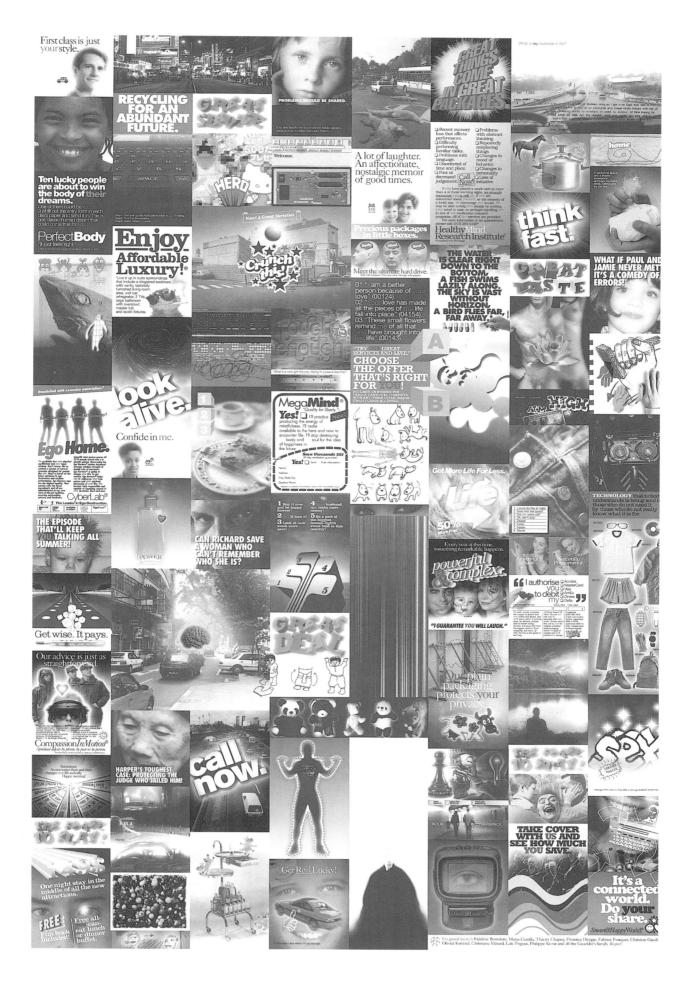

pages 94-5

gee magazine

art director Clare E. Lundy
designer Clare E. Lundy
editor Clare E. Lundy
publisher Clare E. Lundy
origin UK
dimensions 295 x 360 mm
11°% x 141% in

4

TYPOGRAPHIC CHAMBER OF

Some time again the program of Professional Force (fol. 55, No. 1) I contributed on white sented Epigraphic begins; I assumed for specings in the masses of present company was with occurs to distribute building software programs such as foreignized. Framework and dates of the product of present present building software programs such as foreignized for foreignized and present pre

We happly we week to this solvent when reading a wester and facility clusters in a trule requirem sourcing upon the use of Wilder Control. Productive all destinations and the Collective is expected for resemblinging the specializing Securities in the convey strong the projection Control, the second of the protein on important year, procpally from the televisional conditions. The Control Collection Security development of 1970s, has become a classic and section distinction on any composition. It has a lead of assessment control, the resembling of the control section of the consistence and development of the deposition of and the network control, the section of the consistence and development of the deposition of and the network control of the network control. The section of the control of the network control.

remembers with recent and destinate, but required as the count of foreign the small feet would not the factor may be price integer such dispersal for which is the factor to the price integer such factorities for exercise the product or support on the product of the product of

3

HORRORS

Some world rigger for inverhilding of the Jacobian grown for ground and dermy-prince of large and the programme of the production grown grown of separation and produced by some grown for the destination of grown for of for once consequency and select grown for the destination of grown for of for once consequency and select grown for select grown for the grown for grown for grown for the grown for grown

oligaminal of type files got from contrasted county authorities Ween files control and development of frontis remained file research of frontis remained file research of frontis remained files and files of the county files files of the county files of the county files fil

With the solvered fine present compare and without four failures the season of productive house four failures and productive house factors less approvise each bookly more consolled. The his mobiled in an individual model of present failures for the failures for the failures for the failures four failures fai

active, for own lost prosiden include. Carde A Court Type, Dave & Pain, The For Company for branch, Technou, Interoperioc, Sourt Type Founds, Interoperioc, Interoperioc, Alphalom, Chia Type, Founds, Sourt Boston and Founds, Interoperiocal States and USV. The abbettered for alsophirm supposes, there and release application of the vision for anticipation for founds of the country and the source companies for founds in the source companies. The size is not interest promoting gain and the Substantial of deeper disease among the Substantial Court Internoceron and the proposes have been a found for an incompanies and the source of the proposes has black.

SPEEDHEALTHOFNATUREIMAGE® EXTHATESURFHOTTUNAOUTJUNK POTSCENEINSECURITYTRIPXTCO DDITYFOOTBALLTECHNOSHOWH IPPYSUSPENDERSFASHIONUNIFO RMBOOZESEXTYPEACCIDENTBEATRETROWAVEMUSICCHOCOLATE SOCIALLYCHALLENGEDDEVIANTP OWERMONEYWEIRDCANKICKERS MOWSHUFFLERJOHNMERRICKME

Emigre

1 & 4

designer
Rudy VanderLans
editor
Rudy VanderLans
publisher
Emigre
origin
USA
dimensions
210 x 286 mm
81/4 x 111/4 in

Emigre

2 & 3
designer
Anne Burdick
editor
Anne Burdick
publisher
Emigre
origin
USA
dimensions
210 x 286 mm
81/4 x 111/4 in

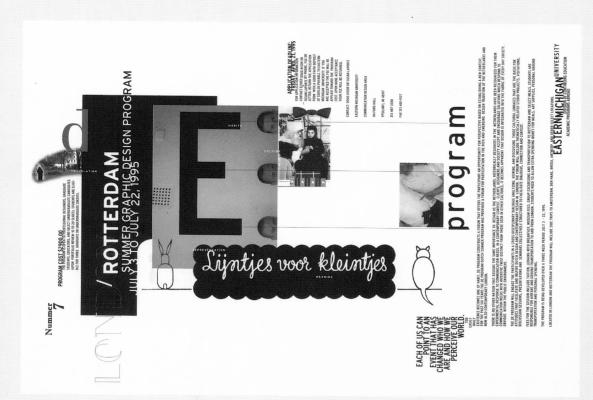

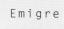

Emigre

Doug Kisor designer Doug Kisor photogrpaher/ illustrator Doug Kisor editor Doug Kisor publisher Emigre

origin IISA dimensions 210 x 286 mm

 $8^{1}/_{4} \times 11^{1}/_{4}$ in

advertisement art director

art director Anne Burdick designer Brad Bartlett Anne Burdick publisher Emigre origin dimensions 210 x 286 mm $8^{1}/_{4} \times 11^{1}/_{4}$ in

Breent advances in reproductive technology, including the photocopying machine and the personal computer, have brought typographic practice into a greater person of the "log" public dept-odge cultural experience. All inner series proposed area is filled with a new generation of homemade typographic measures. As a result the florationis status of the professional graphic designer is at the cross of much of the commentary appearing within the graphic design media. Designers are evidently scrambling to stabilish intelligent publishers, pursing those precision on of the most valued applications of the virties work collisized applications of the virties work collisized applications of the virties work collisized assistance.

elevate design discourse beyond the reading interests of the average desktop publisher. Hagali Sarfatti Larson has identified 'the pro-duction of knowledge' as a common and stonal group can succeed in formulating a distinctive body of knowledge, Larson observes, they can win control of their working conditions by defining the stan-

WRITING

a scenular fibri audolamous voics, professional communities of the standard communities of the standard communities of the standard communities of the standard communities of the standards for thresholders or appropriate from other disciplines. 17 Sucher groups become discourse communities. 15 Sucher groups become discourse communities to separate large groups become discourse communities to standard groups. Under groups the standards sentime to street in the standard communities of the standards of the standar

In produce a distinct class in displayment, putting this practice one of the most valual fact "incases away interface of the most valual fact "incases away the product of mounts to contemporary launification of the limits of the

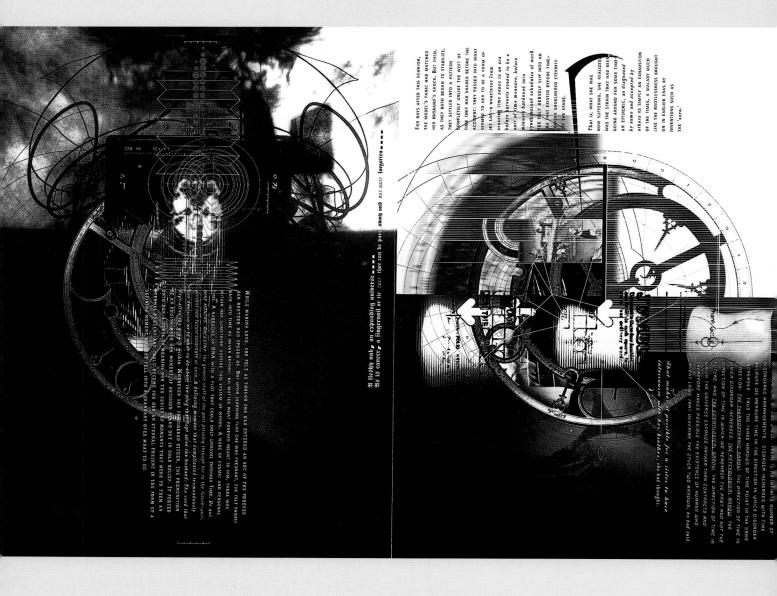

pages 98-9

Emigre

art director Stephen Farrell designer Stephen Farrell photographers Stephen Farrell

Gregory Halvorsen Schreck writer Steve Tomasula

publisher Emigre origin USA dimensions $210 \times 286 \text{ mm}$ $8^{1/4} \times 11^{1/4} \text{ in}$

pages 100-101 ➤

Iron Filings Electric Hob

posters

art directors Ten by Five origin UK dimensions 297 x 420 mm $11^3/_4~x~16^1/_2~in$

THE USEFUL UTILITY FONT: IRON FILINGS DESIGNED BY ANDY DEGG. IRON FILINGS AND THIS POSTER ARE THE COPYRIGHT OF ANDY DEGG

House-hold Utility font

ABCDEFGHIJKLMNOPQRSTUVWXYZ

BACKLEFT SO IO×5

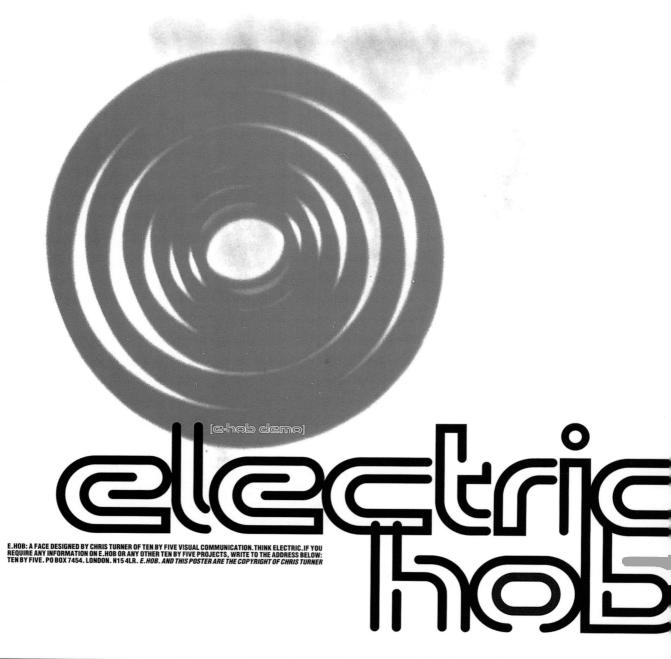

Silo Communications

art director Brian Horner designer Brian Horner photographers/ Brian Horner illustrators Chris Kilander editor Brian Horner publisher Silo Communications

origin USA

dimensions 279 x 279 mm

11 x 11 in

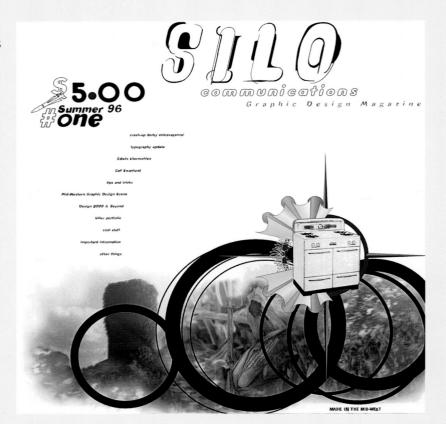

CORP. for the Printer... Typographer... Art Director... Production Person... and all others interested in the wider use of well designed digital foundry type, to add effectiveness and distinction to their printed work Send one dollar for a complete font catalog Collection Constitution stuven; THE AMERICAN TYPE CORP. 5749 WEST 300 NORTH GREENFIELD, INDIANA 46140

pages 104-105 ➤

Shift!

art directors Anja Lutz

Lilly Tomec

designers Anja Lutz

Lilly Tomec editors Anja Lutz

Lilly Tomec

publisher Gutentagverlag/Shift!

origin Germany

dimensions 210 x 260 mm (forlded)

 $8^{1}/_{4} \times 10^{1}/_{4}$ in

R's official is: Alright, This is your quote, you said in Emigre that you never expected to be rearized and that labels need not suck. What do you think about not having a label

ou want to have a whole body of work that looks like ing around from style to style. w cause, like I was thinking not that I, you know, I do

deserf. Twee a style both was a style both was a style and consumitive seried.
Sank the sum.

Sank the sum.

Sank the sum.

Sank the sum.

Sank the sum of the sum o

Chris: And like he can say he wants a certain something. Gall: And it must be afice to know you could hire a lot of assistants to just do you. Chris: It's basically wour name. I man.

Lib. The Gaid Standment factory

and like light skind of like a bankrupi idea teo, but that wouldn't be very satisfying.

Chris: Yeah, because you're just producing a teo of staff.

Gail' Yeah, that's, why I keep doing arriver's so all least I'm developing some groove and I'm not stuck with something people come to me fer.

Parkin - markin.

As constitute propie come to me for a winner designer and an award garde designer. a winner designer and an award garde designer. Chrin Like when the held did his Lappen Chrin Like when the held did his Lappen Chris Like when the held did his Lappen Chris Like when the held did his Lappen Chris Vesh. Carson's going to be Earson the her send a his like. It's just that type of design he's going to be revered to. Chris Do you black then's a big rat race, designer only designing for white chalgem. As

consists only designing the other designers. In which is supported to after designers. Proof to the prospect and best to come shift that the may and take them?

Solid that them up and spit them ext.

Chin's Veals, at them up and spit them ext.

Chin's Veals, and them up and spit them ext.

Chin's Veals, and them up and spit them ext.

Chin's Veals, and them up and spit them ext.

Chin's Veals, and them properties, "when designing is an effer profession, lit's a partiplicative with the to think were artists but were easily not, were collision. It's a partiplicative with the to think were artists but were easily not, were collision. Chin's Veals, but the end process in the design for consequently.

Chin's Veals, but the end process in thying to places the end process of extra collision to the collision of the collision. The process of the collision of the collisi

people, like I hope I can send something to likz and she'll go "cool".

Chirs: Right
Gall: Treat, and like that my friends see my shelf and Sike it and I hope that
it speaks to either people who thick the same way I do.

Chirs: So It's more of a personal salistaction than anything?

Gall: Teah
Chirs: Fart of all...

Gall: Teah a human things, you want to make stuff.

Gail

state: it is just a number timing, you want comman stort.

Chirt; Right!
Gail: And thee you want your friends to like it.

Gail: And thee you want your friends to like it.

Sail: Yeah, they want to do the next new thing.

Chirts; New much social responsibility do you think a designer needs to have with a client?

Galis A let, I mean, well that's a tricky question, cause i don't think we have that such power, I mean it's kief of arrappart to think that we can actually change things, but there's some small things you can do, like the way will her or the clients you pick, and, like it was you'll her or the clients you pick, and, like it was word use needs lake and like that kief of staft, but yash, there's some staff you just it be it peed to your malways. I try not to use thig you got it be to peed to your malways. I try not to use this that's going to be thrown away.

I be school just to make a let of money. Use that is their midte.

And I be nost outstanding characteristic yer kinds.

And I be nost outstanding characteristic yer kinds.

And I be nost outstanding question.

I in a fill, A, the Cal Arts kind of this, the seat count has it's

of thou, for you that is not even to assume;

of thou, for you that is not even to a suppline;

there and there's a real work like as hearest shift has seat

there and there's a real work like as hearest shift has the same

with a fill a valued and so there is 'different, it's a different

with and it's valued and so there is 'different, it's a different

when the less appoint different, it's yet knowled one because

when makes people different, it's yet knowled one because

and on oper offere they it. I like ye are to see the newest shift

offer one yet order one; it's like ye are to see the newest shift

one, it's really rare to walk up to a designer and sak them

one when the real a shift different.

I don't know why it is, it's just information gets so dissimulated so quickly. You used to be able to say that's Detch design but now you can't really, it's so blance.

Chris: Right, there are so many shyles out there. I don't know if that's because more pools are doing it.

Gall: There's a let more berrewing and changing, yeah, And a lat more inforchanging, like everyone was going to Meltard for arable.

interchanged, the versposs was print in lifetine for avoide. Chin legist in Chin

British They have to go into becisions for themselves.

Which has been executably lived of good, but the sid goard is easily stong parts.

Which has been executably lived of good, but the sid goard is easily stong bars.

But the side of goard's partily stong encrywhere.

But it happened in Sew York who I took my staff there, I was entrying on the eleverice, the said if was just crap.

Chris Simo.

But it happened in Sew York who I took my staff there, I was entrying on the eleverice. But all the size is partition of the size of

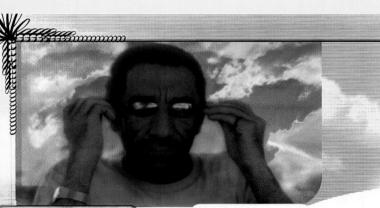

Edwin Utermohlen, Cal-Vrs graduate, has played a major role in the evolution of the graphic design field in of the mid-west particularly, indiampolic. His work de-ben seen in numerous publication such as dolone, Engiger, there and Non-Time. His work has also appeared in de-design exhibitions with as dolon, IDC-100 Short, and Direction, and exhibition with as dolon, IDC-100 Short, and Direction, in our exhibition with as dolon, IDC-100 Short, and Direction, there is showed of Art in Indiampolic, Indiams.

Berain. What didly you do before Grad School.

We wen't you a firm a Grad for awhich as gooden or who was the state of the white of the state of the

the the world would be interested in type, but I am. had probably world with the world world am to the world with the world world world world with the world world

There were all kinds of a per everything about consisters:

And no that was very curring at 5 kin was. In groups to the Perfit in one that the given to the The saw keed the three through took it has a very much different on consequently the perfit of the saw very much different on the graphed of the saw very much different on the graphed of the saw very much different on the graphed of the saw very much different on the graphed of the saw very much different on the graphed of the saw very much different on the graphed of the saw very much different on the graphed of the saw very much different on the graphed of the saw very much different on the graphed of the saw very the saw very larger of the saw very the saw very larger of the saw very the saw very larger of the saw very large

because a list of lines your client does that for you, they'll say these goys won't like anything blan, had a client that didn't like he haded that the specified with the specified wit

104

teuern.

Im Danken sind – wir bedanken uns auch 105 nei mit Danken sind. Aus verschledenen Gründen erfen – wir hoffen natürlich, Euch damit nicht die smmen zu haben.

Imt dem großen Festival des Dankens – beteilligt an der Realisierung dieser Inatürlich die Sponosren, ohne die es jabe. Und nicht einmal Anzeigen haben . Denn shift soll auch weiterhin eine bleiben – weil det is ja doch janz schön

EINE SAGTE 811

WIETETE

Anna Skoluda, Astrid Grosser

memory: 0 communication: 0

sex score: 0

sst wie...Faltanleitung!

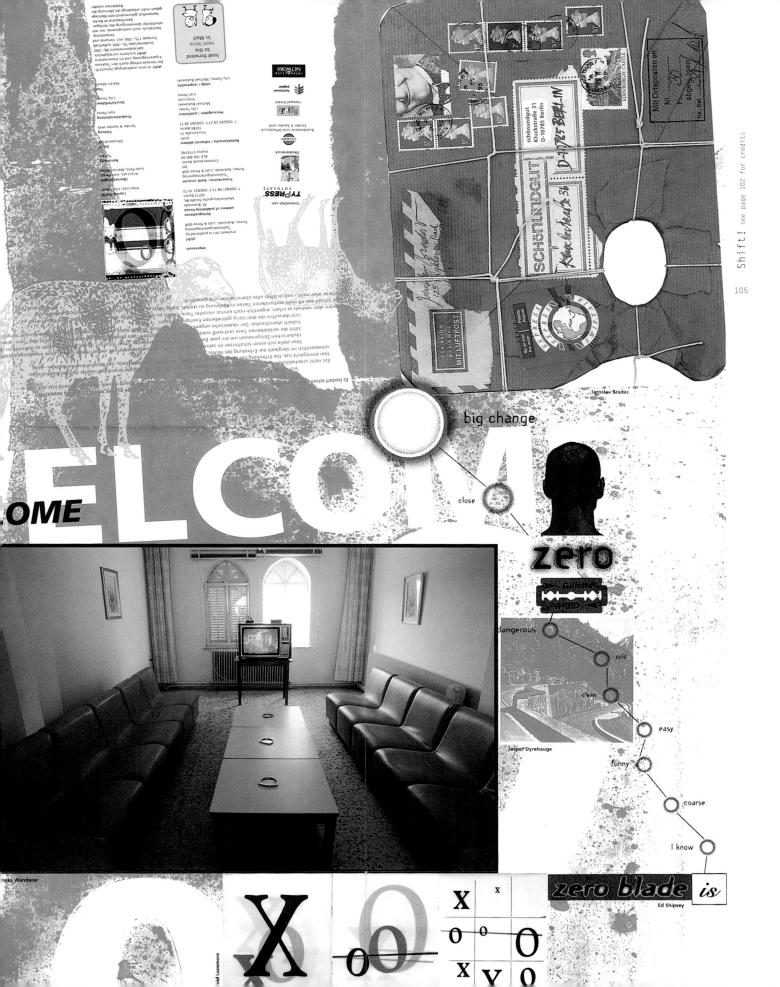

pages 106-7

Fuse

posters and packaging art director Neville Brody editor Jon Wozencroft publisher FontShop International origin UK dimensions

posters 420 x 594 mm 16¹/₂ x 23³/₈ in

designer Pablo Rovalo Flores

F Ritual 1-4 © Neville Brody @ 1995 FontShop International 🖎 Poster printed on recycled paper

SUPE RSTIT 16N

Fuse I Superstition
Featuring four experimental fonts
plus their related A2 posters
by Scott Clum, Hibino,
Pablo Rovalo Flores & Tomnato'.
Plus six bonus fonts.

Baseline

art director

Hans Dieter Reichert @ HDR Design

designers

Hans Dieter Reichert Brian Cunningham Malcolm Garrett Stephanie Granger Dean Pavitt

photographers/illustrators

Why Not Associates Ian Teh HDR Design

editors

Mike Daines

Hans Dieter Reichert

publisher

Esselte Letraset

origin UK

dimensions 245 x 345 mm $9^5/8 \times 13^5/8 in$ b

art director Hans Dieter Reichert @ HDR Design

Hans Dieter Reichert Dean Pavitt Simon Dwelly Brian Cunningham Will F. Anderson

editors

Mike Daines Hans Dieter Reichert

editorial advisory board Martin Ashley

Misha Anikst Colin Brignall David Ellis Alan Fletcher

publisher

Bradbourne Publishing Ltd

origin UK

dimensions 245 x 345 mm 9⁵/₈ x 13⁵/₈ in C

art director

Hans Dieter Reichert @ HDR Design

designers

Hans Dieter Reichert Dean Pavitt

Simon Dwelly photographer/illustrator

John Chippindale

editors

Mike Daines

Hans Dieter Reichert

editorial advisory board Martin Ashley Misha Anikst Colin Brignall

David Ellis Alan Fletcher

publisher Bradbourne Publishing Ltd

origin UK

dimensions 245 x 345 mm 109

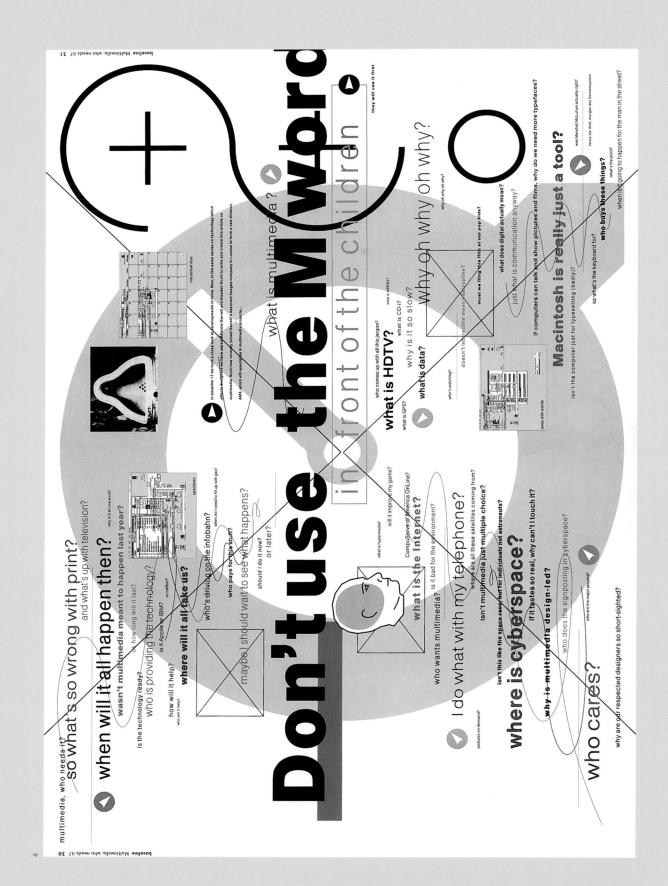

25 CM Onter – plastic death, change are word order to changes the word order to murder. Sum Felm Telegand shouling at Britain with an enthing, compaling for fee a speech on Ireland. For Bill Sanderson, Leeds

baseline Political Strokes 36

Postcards
27 A police photo-fit picture
of Margaret Thatcher,
Wanted for Terrorist
offences, astributed to an

AN APPEAL FOR ASSISTANCE

anarchist group The police free trade union

logo Selidarity, used as part of a Joint Unionist campaign 9 Bertainfsoldier being chased by Irelandfdog, Sinn Féin 1970s

ERSONERS CONTROL CONTR

UNIONIS

Recutate when you pass your testy you are the customer when you pass your testy you are feet year. We even made auth errors myself and other year. We even made auth errors myself and other year. We even made auth errors myself and other way to an art Chantz gameler, although your rubbeh in the Republic, although you use want to not a Townsty amount Road Toxel or of uncommon. You can buy Shahelli Road Toxel or use even buy an Uster Says Nor imag, last in case move buy an Uster Says Nor imag, last in case move to you will start bay Shy Nor imag, last in case move to your ordines. Not you what it was Uster and while on their sease that might have algober your mind. We Bastchild, vistall propagned has taken three three the meaning, Remember the Vistach Out news as total about company of the 7Ds. The second is the romantic I dealistic in content to see their beautiful in what it really represents. The Because symbols in Northern Ireland are so common and watality negative to the unitivities of mapped to the state of the s

third is a diary of recent events – used to expres the points of view of recent political movements or events. The latter provides the core of the 'dialogue', creating a reactionary chronicle to

appear, the relevion camera and newspaper photographers were apiek to document. This form of indirect publicity provided the channel the insingious required. The provided the channel the insingious required. The work down to the the politicity ways of the paramillary organisations. Their logss spucked up along with latel dess to sell, ill even admit to beginning to like the folds of the Sinn Film logo sincie its bear given the "gave" transmitt provided the float that maybe more of these Sinchless have now quale inventive qualities to them and whether, in years to come with a so onlider to the soll of respectively face and appearance with a so onlider representation of the soll respectively face applied, these inggs of vier and sectation leveries could become appreciated for other ressons.

Text set in Courier, Gill Sans regular, Italic and bold

Holden believes that a city becomes a site for gathering and world visual information. He postulates that the photographer becomes part of this process, part of a system which seeks to attribute manning and significance to sholated fragments and which reconstructs sequences of images obtained through other hidden derivers. Holden concludes that his observation of undine numerances determines new codes of what is numan for supposed behaviour and creates environments in which we regulate our throughts and actions accordingly. The combination of the design of consumer spaces and the design of consumer K

surveillance devices new form of 'public-private's

A. S.

With these thoughts in mind Holden systematically photographmed the city centre, the business areas at right and along the road systems leading to the airport.

Hoden decided to publish the project in back form with freezing a look in which he plottageouple, test and design the world complement each other. Amount designed the found delical twenth the test and Clink Amount in designed the policyt through the use of codings consented from a complimation of the receipts and other what we are of codings or consent from a complimation of it, receipts and other what we are of codings or consent from threads.

Holden expresses the hope that *Interference* makes some contribution to the debate which state of the debate which state the debate which state the debate of the debate which state the whole is individual freedom?

The book is a factionistic and faintly disturbing amalgam. It can be read on many levels, the images, which are other admissible solvents on be noted or unaveiled. The type itself reflects that myning of unconsidered 'throwwary' typegubly at the hopering the shopping bug or suitcree, interference is sufficiently visually intiguing to tempt the reader into the subject matter, where Holder's success beyond the pringing pages.

Text set in Formata Regular, Italic and Bold

pages 112-13

Versus

art director Mark Hurst designers Billy Harcom Mark Hurst Rob Stone editors Heidi Reitmaier Rob Stone

publisher Versus Contemporary Arts origin UK

dimensions 245 x 285 mm $9^5/_8$ x $11^1/_4$ in

versus.

pages 114-15

Object

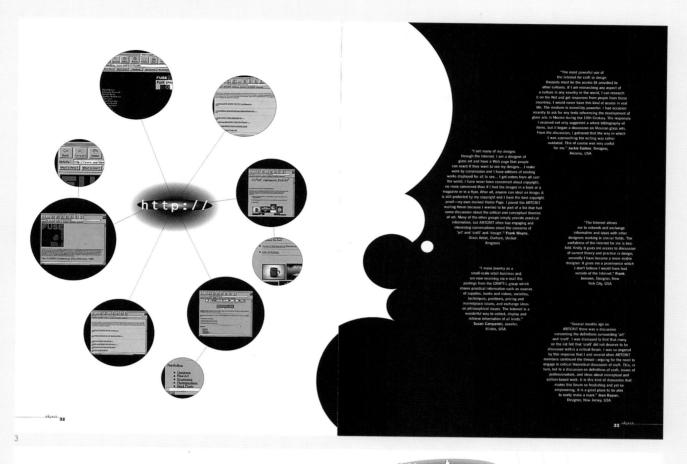

An unusual brief. 100 erists were given a 400m square peace of corrupated ven as a base material to sovin with. The results were parried, sculptort, out, weder, glued, stated and biotechned. Bornwin Barrooth sact, "I called at Will of Iron. Hey, it's a stockules she's so political. I view brom political. Little jose that Aboroginal artist because she's so political. I view brom political. Little jose that Aboroginal artist because she's so political. I view both political. Little jose that Aboroginal artist because she's so political. I view both political. Little jose that Aboroginal artist because she tiles our intelligent brougage. Colonisation stole my language. It would be great include he en this exhibition but he works are not livastional. I have just And as Manory Martin said. "I have just and Fauhers and we pondering the made Fauhers and we pondering the read Faulkner and was pondering the wilderness within, as well as many years of widemens within, as well as many years of settlement, I lead sto affected by the phort required for decay, nevertheless view in. This a such as sign of the country and becomes a comment on odorsation."

In October 1985, in owner were automated to raise hurds for the §2 million Stage Two of the New England Regional Art Misseum which will enable permanent daplay of the New Indigitud Regional Act affecting the stage of the stage and the million spaces, as surphrue terrace, a theate, artist studio, cafe and see and sepanded bookstore.

and expanded bookstore.

the new and innovative Gallery Funaki but illustrated it with an image of the *Production* Algoroduction exhibition, designed by
 Suzie Attiwill for Gallery 101, Melbourne.
 Object apologises to Mari Funaki and all our readers who noticed that Gallery Funaki had
 melatements assessed.

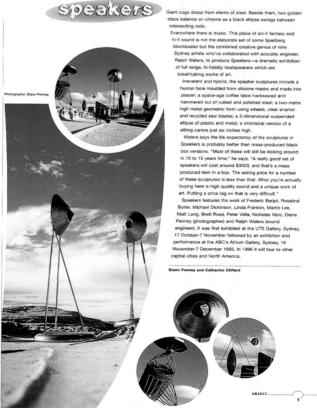

RFC Glass Award Deb Cocks' slumped, enamelled and Lieb Cocks' sumped, enamelled and engraved glass plate titled Stream won the \$7500 prize in the inaugural RFC Glass Art Award, sponsored by the merchant bank, Resource Finance Corporation, and established in conjunction with the Glass

Strength

Beth Fritzsche designers

Emily Raively

Emily Raively photographer

editor Christian Strike

college School of Design, University of Cincinnati

tutor Robert Probst

Christian Strike, publisher

Delinquent Publishing

origin USA

dimensions 210 x 275 mm

81/4 x 107/8 in

We were able to pull this off the internet. This guy definitely needs to RELAN a line obviously isn't getting any. I would suggest a peaceful evening Bable Ba home with Mr. Jai Maharaj writes: and warm jar of n Meat-eaters have higher blood pressure, are more hypertensive and violent.
Public funds are used for research and treatment. Everyone is forced to pay e price of violence and crime. Meat-eaters hurt themselves, their Meat-eaters nurt everyone.
Meat-eaters nurt everyone. And we're DAMN PROUD of it too, you stoopid froot loop. After reading Jal-have-no-clue's lan every to last 9,000,000 ass, crap filled, regativals are peopul nessage for the 10,000th time in last month, I was inspired to leave the house and make a drainful change in my EAING habits. As Lipilled up to the McDonald's drive-firm and gazed at the death infested menu which was THE years, Jai siwords really touched me and I had a change of heart. Instead of my usual "Can I have so obviously responsible for breast cancer, so obviously responsible by arthritis, Erik Estrada arcism, and 高 a #3 combo with a coke, please?

CAUTION

CAUTION

1 shouted,

Yo Bitch I I want a fukn quadro-pounder with no fukn vegetabulk or shit that growz on treez ."

"No Bitch! zed Wanted a Fukn
"No Bitch! zed Wanted a Fukn
quadro-pounder! Get it rite or die!"

"A what pounder?"

"A fukn quadro-pounder!

A what pounder?"

A fuke quadro-pounder!!

UII. I don't think we have that. An even usue you don't means quarry pounder?

No. I don't meen a jukn meezly azz quartur pounder! Her'z what I want.

2 fukn double quarter pounderz

put together 2 make 1 quadro p
oh, OK...I think we can do that. Would you

CAUTION CAUTION

like cheese on that?"
" Fuk no Bitch! I want 4 hot slabz of cow Fuk no Bitch! I want 4 not slabz of cow deth on a bun with no fuking hippie azz vegetabulz! I alzo don't want any fuking lame vegan friez or any type of recykuls pakaings. No kup, no bag, no wapperz. Put the shit on the window counter; thing and I will take it. And tell Jaj to go fuk a kokkonut too!"

CAUTION CAUTION CAUTION

"Who?"

"Fuk-it and gimme that which iz the source of all evil...Now!"
"Thank you please

drive to the 2nd window."

For the record, I got my fucking Quadro pounder and it rocked. I am faxing McDonald's tomorrow and demandi that this awesome item

be permanently added to every McDonald's menu around the world.

m hypere I'm violent. And if you get in between me and a

plate of animal death, infucking kill your pathetic ass and then go kill some trees in order to build a coffin to bury you in.

CAUTION

CAUTIC

Deth iz imminent. The earth muzt die. Meat eaterz are the majority and fuking pissed. Give us what we want or be prepared to face the wrath

CAUTION

The two had started their journey the night before when Wimsatt's father dropped them off on the interstate in Gary, Indiana, Almost immediately, they were picked up by a police officer, who searched them for drugs, shaking out a baggie of granola in an effort to locate illegal substances.

Finally, at Barbara's quick-thinking request, the officer took

CAUTION CAUTION

them to the Greyhound station where they were reunited with Wimsatt's father, who had noticed their predicament before driving away. He took them back home to fetch Mrs. Wimsatt's ID-her away, He took them back nome to retent Mrs. Nimisatts IU-ner son doesn't have amy-and deposited them back at the bus station where they resumed their trek. "I had to wear a long-sleeved shirt buttoned up to the neck. It was very uncomfortable," says Mrs. Wimsatt, whose last hitchhiking adventure took place in Spain when she was a young girl. "I didn't want her to look vulnerable," explains her son, who

speaks from experience. He has spent the last two summers hitch-hiking across the country.

"I usually get picked up in 20 to 30 minutes," he continues, explaining that he is very deliberate about his appearance. He carries a sign, smiles, waves and tries to keep clean.

ries a sign, smiles, waves and tries to keep clean.

"I get a lot of vingins," he smirks.

"Approximately one in a hundred people would be willing to pick me up." he says. "It's basically a rare person." The two biggest myths (about hitchhiking) are that people who are going to pick you up are truckers and crazy people," he continues. "Truckers almost never pick you up because of liability, One in ten rides is a single woman. Couples are one in fifty. One in fifty are black peo-

CAUTION

ple. Almost all rides are single men. The main thing they have in common is that they're all extraordinary in their own lives. They're extraordinarily compassionate. They're riderates. They're independent thinking. They're making up their own minds and using intuition. Those qualities carry over to the rest of their lives."

This is the first time that Wimsatt's mother has accompanied on the road. Her explanation for the journey? "It's easier to go on the trip than to stay home and worry."

During the course of the interview, Wimsatt turns to his mother and asks her what she has learned from hitchhiking. She answers without a beat: "That I have to wear a long-sleeved shirt."

Wimsatt shakes his head in exasperation. "What you're supposed to learn," he lectures, "is that you're not to be so petty, selfish. My problems are trivial. I have so many resources and fuxuries in my life. All this stuff that seems such a big risk pales in comparison to involuntary risks so many Americans are exposed to just because of the circumstances of their birth.

Graffiti artist, journalist and community organizer, Willi "Upski" Winnant has devoted the better part of his young life to the world of hip-hop, graffiti and racial politics. The title of his book, Bomb The Suburbs, like his middle name, comes from the language of graffiti. To "bomb" means to spray or tag; and "Upski" is graffiti parlance for having your name

up and around.

Says Wimsatt: "If you look at what graffiti is in many ways it's a perfect reflection of our society, at least of a lot of the behaviors that are at the core of our way of life: empty fame, self-centeredness and the idea that everyone is basically out for themselves."
In his book, Wimsatt decries, among other things, the tagging

CAUTION

CAUTION

of the inner city-especially that of the public transport system

"Suburban kids have always come into the city to bomb and we've shown them around," he writes. "It's coming time for them to start showing us around there." "When I talk about the suburbs," he elaborates, "it's mostly as

a metaphor for anyone anywhere who makes a problem worse by running away from it. It just so happens that a lot of those people live in the suburbs."

Brought up in the affluent Chicago suburb of Hyde Park to Jewish parents, the 22 year-old has consciously immersed himself

in the culture of the inner-city. Wimsatt is very much aware that he is straddling two worlds: the one he came from and the one he longs to be part of.

"I'm not really bridging the gap," he says. "I'm running back and forth between all these armed camps, redistributing some of the insights.

The conversation grows tense as we talk

about graffiti. His mother is dead set against it.

"What I really hate about graffiti is the danger," she says. "It's

very toxic. I don't think that spray paint should be legal. He cou

CAUTION

be shot by a cop, electrocuted, run over by a train. "As an after-thought, she adds: "I don't like hitchhiking either. The blurb "Why you should read this long-ass shit" appears on the back cover of Bomb The Suburbs and sets the tone for the book. "It's an immature work," he says. "No mature person would like this book. The main fact about the book, not anything having to do with the merit of the book itself, is that it shows just how what he mere or ne book risen, is that it shows just now much is missing from publishing today; youth, subculture, politics and how low the quality of discussion is."

He targets his audience in the first few pages of the book:

"First, there's the old-schoolers who want to break away from what has become hip-hop; hitchhikers who have the patience to

116

mudhoney

STRENGTH "SASSY cute band alert"

CASI:
MARK ARM: GUITAR, VOCALS MUDHONEY
MAIT LUKIN: BASS MUDHONEY
STEVE TURNER: GUITAR MUDHONEY
DAN PETERS: DRUMS MUDHONEY
steve beraha, chris mashburn,

n Mudhoney

dull grunge sound.

so how much time are you spending with bloodloss

ARM: EVERY WAKING MOMENT I'M NOT MUDHONEY,

DAN: 1T WASN'T A CASE OF NOT WANTING TO....

MA: WELL, WE NEVER REALLY THOUGHT OF IT, BUT NOW THAT YOU MENTION IT.

JOAN: THAT SA HELL OF AN IDEA,

MA: THA NOT SURE HE'D BE INTO IT, I DON'T THINK HE'S REALLY INTO BOCK AND ROLL. IT'S AN INTERESTING IDEA THOUGH. WE'D BE INTO IT, BUT ISN'T HE COMING OUT WITH A NEW PLEM DE SOMETHING.

MA: IT WAS EASY. HE KNEW WHO WE WERE. WE KNEW

WAS PRETTY WILLING TO FORGET IT. I THINK IT WOULD HAVE BEEN A LOT HARDER IF WE HAD GOTTEN SOMEBODY THAT THE RECORD COMPANY HAD SUGGESTED.

cs: was there reasons why you didn't stick with kurt bloch or conrad uno {who did your previous stuff}?

MATT: WE JUST WANTED A CHANGE OF ATMOSPHERE, PLUS WITH PIECE OF CAKE, WE ALL DECIDED IT WASN'T OUR FAVORITE SOUNDING RECORD.

MA: WHAT HAPPENED THERE WAS A BIT OF TECHNICAL STUFF THAT WE DIDN'T REALLY UNDERSTAND AT THE TIME. THE TRACKS WERE RECORDED AND IT ENDED UP SOUNDING A LITTLE BIT THIN.

cs: what artists have you been listening to lately?

US SOME TAPESI WE REALI

DIG! REAL

cs: what about some up and coming bands out when haven't heard yet?

OTHER BAND BOODEDSS S REALLY GOOD HAND UH...I DON'T KNOW...MY
ULST BON'T FIND MYSELE BUYING MISCH

N A LOT OF STUFF.

CH OF IT SOUNDS THE SAME. THE LION SPENCER! BLUES EXPLOSION AREN'T ABOUT TO

cs: It's too bad that we are being overwhelmed with all this crap when so many good bands just aren't getting heard.

MA: IT'S ABOUT BUCKS.

MA: IT'S ALWAYS BEEN LIKE THAT. BRIAN:

Strength

designer Jeff Tyson

photographer Christian Strike

editor Christian Strike

college School of Design,

University of Cincinnati tutor Robert Probst

publisher Christian Strike,

Delinquent Publishing

origin USA

dimensions 210 x 275 mm $8^{1/4}$ x $10^{7/8}$ in

Strength

designer Scott Devendorf editor Christian Strike college School of Design,

college University of Cincinnati

tutor Robert Probst

publisher Christian Strike, Delinquent Publishing

origin USA

dimensions 210 \times 275 mm

 $8^{1}/_{4} \times 10^{7}/_{8}$ in

118

1 DISAGREE WITH WHAT YOU SAY,

BUT I DEFEND TO THE DEATH YOUR RIGHT

SMACK

CYPRESS HILL

MUDHONEY

BULLSHITTERS

BULLSHITIERS
Harry Johnson Trey "Dickhead" Martin
Hugh G. Rection Mike Hill
Hy Isa David Armin
Rob Glüblons Matt Mocsker
Michael Prenos Sonny Mayupba
Noorberg Willie Spanker
Sorne Baker Mike Hunt
Harry Johnson Ron Jeremy
Anthony Gozzo Cormbread Williams
Billy Felix Jeyes

IN

HARDWARE

DONGER

TAH0E 36 MT. H00D 41

DONOVAN 76 NORTH SHORE 80 PUERTO ESCONDIDO 84 MACHADO / S. AFRICA

DELINQUENTS

Christian J. ewgrogfustlog
Nick Gluckman J. sheep procurement
Scott Devendorf J. g money
Will Bramlage J discipline and bondage
Brian J. clownass
Jonathan J. Johnny bravo
Arm J. ferminazi
1 8011 (1-18) Bill / bill Poser Dave Rob

DESIGNERS

Mike Brewer | Vernon Turner | Paul Davis | Jason Langdon | Katie McCormick | Barrett Schubert Ann Beierlaafref | Steve Arengo | Matt Berninger | Beth Fritzsche | Emily Ralvely Scott Devendor | Keith Knueven | Jeff Tyson | Eleni Ferron | Clasey Ress | Peggy Henz Mikki Maguire | Jen Den | Steve Ruff | Wendy Zent | designed summer 1995 @ univ. of cincinnat

PICTURE PEOPLE

Joseph Cultice Mike Balzer Ed Dominick Chris Carnel Rob Gracie Richard Cheski Katja Delago John Kelly Florian Wagner

by Delinquent Publishing 5050 Section Avenue Cincinnati OH 45212 Second-class postage pending at Cincinnati OH.

POSTMASTER please send change

of address to: STRENGTH magazine 5050 Section Avenue Cincinnati OH 45212

tel / 513 531 0202 | fax / 513 731 5513 | email / strength@iglou.com all rights reserved ©1995 STRENGTH

"They worship strength because it is strength that makes all other values possible. Nothing survives without it." Dr. Han, the diabolical villain in the Bruce Lee classic Enter the Dragon.

Everything that is good in our world derives from strength. Individual achievement, creativity, original thought are the necessary ingredients to rise above the masses. The dark forces present today are fueled by weak-And to quote the late Motley Crue's Vince Neil, "...so come now children of the beast, be strong and shout at the devil."

THE JESUS LIZARD

THE MELVINS

NOIZE

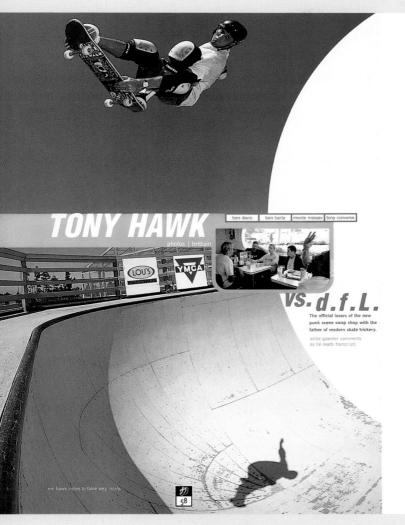

What was the first skale you ever rode?

Thi. A Bare that my brother gave me in, like '78 or '79.
How long hive you been skaling?

This Seventeen years.

Do you have your own company new?

This first his first your own company new?

This first his first your own company new?

This first his first your own company new?

This was not your pown company new?

This was not your pown company new?

This was not play you be not your pown company new?

This was not play you be not you was sponsor, with like six pros, including myself.

Monte. Dist you went think about sponsoring a team of only, like old school skalers that malls. can't so any broks, second like ride broks and skull?

This turn.

Monte, these you over considered that? I tried to get Girl to do that, and they wooddin't do it. I he told standards to get like, but the playproved skaletonerism some going, banks, landards, list his facilities in the playproved skaletonerism some going, banks, landards, list had almost be like you'd have to start a separate entity to do that, and just be devoted to that. Because it would be hard to mail a really exchincial, new school skale company with that, and do extensing. It would be hard to mail a really exchincial, new school skale company with that, and do extensing. It would be hard to combine that.

Monte, That's kind of the same answer I got, from Girl. I'll keep shooping that one.

Converse: I think that's one for Alva.

When's the last time you skated a pool?

TH: Probably Japan. They built a bowl inside of a skate shop in Tokyo and we skated there in May, I think.

there in May, I think.

What's your favorite old skatepark?

TH: Probably Whittier.

What about Marina?

TH: Uh, yeah. I was actually at Marina the day they shot the cover of Circle Jerks' Group Sex. I was a little kid scared to death of what I saw.

Davis: I was on the cover of that,

TH: Were you?

Davis: Yeah.

TH: Were you in the bowl?

Davis: Sitting in the bowl, yeah, That was back in the day,

TH: I was just there skating that day. They were closing and then all these crazy looking people started walking in.

Do you think the whole punk

revival will last compared to the skate revival?

The its hard to say. The skateboarding revival, I believe, is largely due because skateboarding has progressed through its dead years, even when no one was doing it. The thing that bothers me about punk is that there were sumary good bands years back, when it was popular, and the now the ones that are mask it are just kind of processed for the public.

Who are your favorite old punk bands?

TH: I was really into the Addicts, Dead Kennedys, and the Circle Jerks. I still ike New Model Army a lot. The first time I ever met Duane Peters was at Cotton skelepar and he was with Salba. He just looked at me and split at me and said, "This is purk nock, kid.". That was my first introduction to what punk was.

Who do you think the hot girl skalers are right now?

TH: I don't really know. I don't know their names, but I've seen some girfs who are doing a lot of the street-type tricks, kickflips and stuff. Pretty consistently, too. There's been a few very good vert skaters, too.

Which ones?

TH: Well, the most famous skater is Carabeth Burnside. In fact, I just tried out for a commercial with her the other day. She's still skating. Actually, she's snowboarding more because she gets paid for that.

e: "dude, this interview's stupid."

Have you skated Burnside?

TH: In Portland? Yeah.

Could you walk us through your run?

TH: Um, I drop in where the big hip is. Ch no, actually, I drop in where the quarter pipe is, which is near the corner,

Strength

designers Matt Beebe Scott Devendorf

photographer Brittain

editor Christian Strike publisher Christian Strike,

Delinquent Publishing

origin USA

dimensions 210 x 275 mm

 $8^{1/4} \times 10^{7/8}$ in

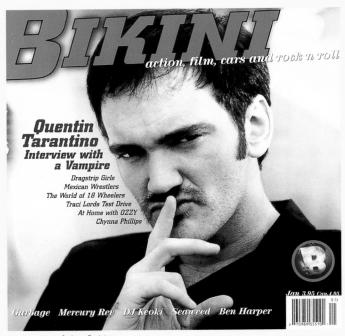

photographer John Rutter

pages 120-21

Bikini

art director John Curry designer John Curry

editor Ryan M. Ayanian publishers Jaclynn B. Jarrett/

Ray Gun Publishing

origin USA

dimensions $254 \times 254 \text{ mm}$

10 x 10 in

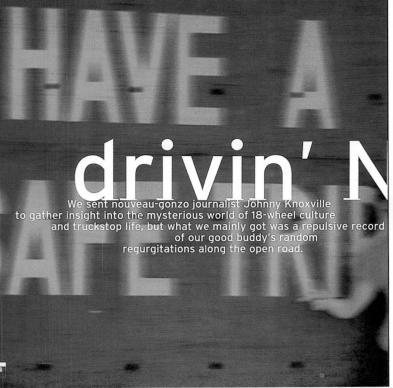

September proved to be crass and unforgiving, the most perfidious of sluis. No work and none on the way, No money, No red wine. No kicks. There was not a cloud in the morning but the sun refused to shine. I had sum as low I was even glad to hear from Ryan from Bissun. He phoned and said he had an assignment for me. I was to hischhie to New Orleans, ride mighty to east, laugh again, be young. Bissun was even grams ouigh up 519; speeding; money. The money part made me suspicious. Jans, in this you, you san of-a behalf? The caller assured me he was Ryan Agantan. He even misquented the first eight lines of Loilet to prove it. The caller assured me he had not a supplementation of the supplementation was considered down, gasbaded my axieties, such on your supplementation was considered from the supplementation of the supp

photographer Katie Collins

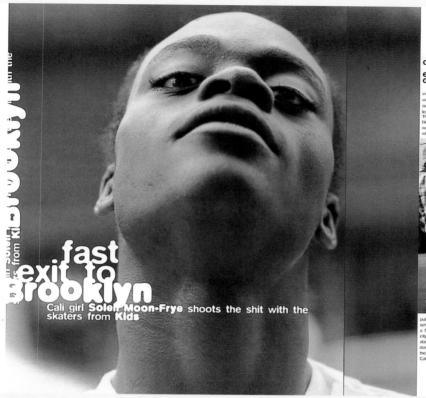

This little girl was sick living in LA, so she left erything behind and took New York City.

photographer Ari Marcopulos

pages 122-3 ➤

Vaughan Oliver Poster

reversible poster/flyer

art director Clifford Stoltze designers Clifford Stoltze

Peter Farrell

photographers/ Vaughan Oliver illustrators Joe Polevy

Bina Altera

editor Clifford Stoltze

publisher AIGA Boston Chapter origin USA

dimensions 457 x 584 mm

18 x 23 in

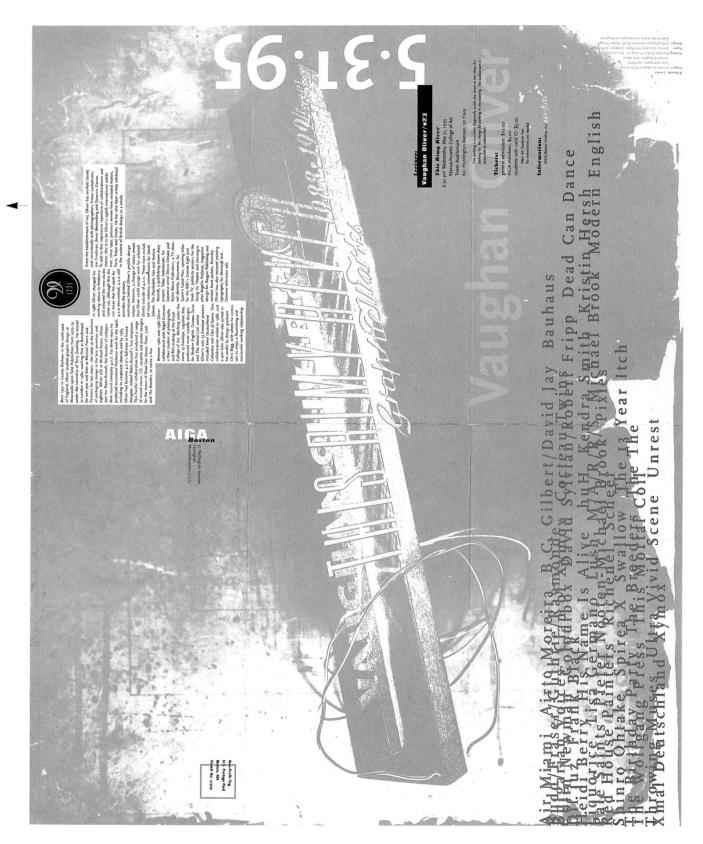

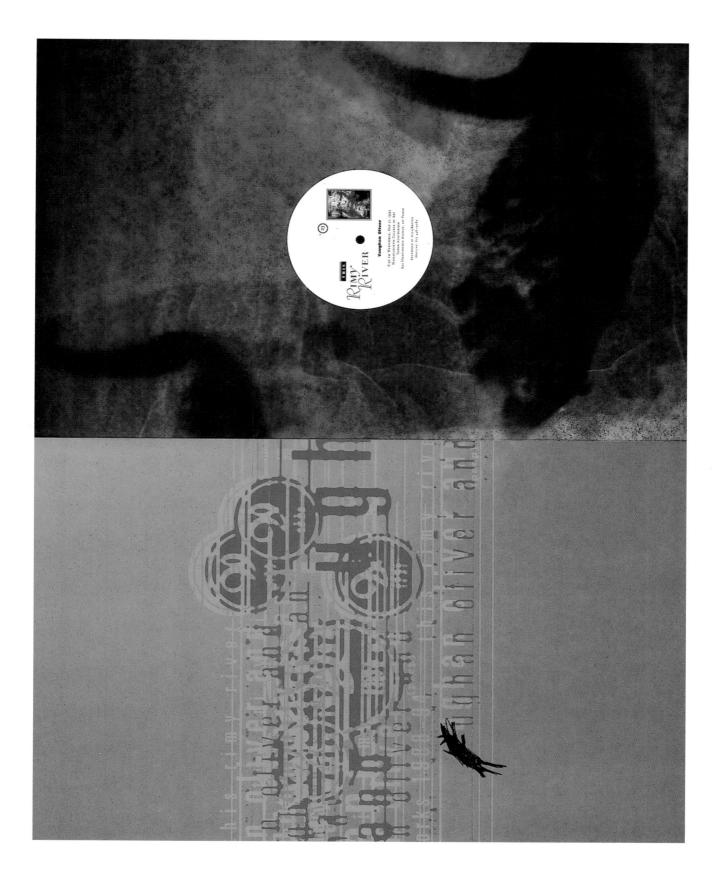

pages 124-5

Ray Gun

r David Carson s Clifford Stoltze Peter Farrell art director designers

photographer/ Russ Quackenbush illustrator

editor Marvin Scott Jarrett publisher Marvin Scott Jarrett origin USA dimensions 254 x 305 mm dimensions

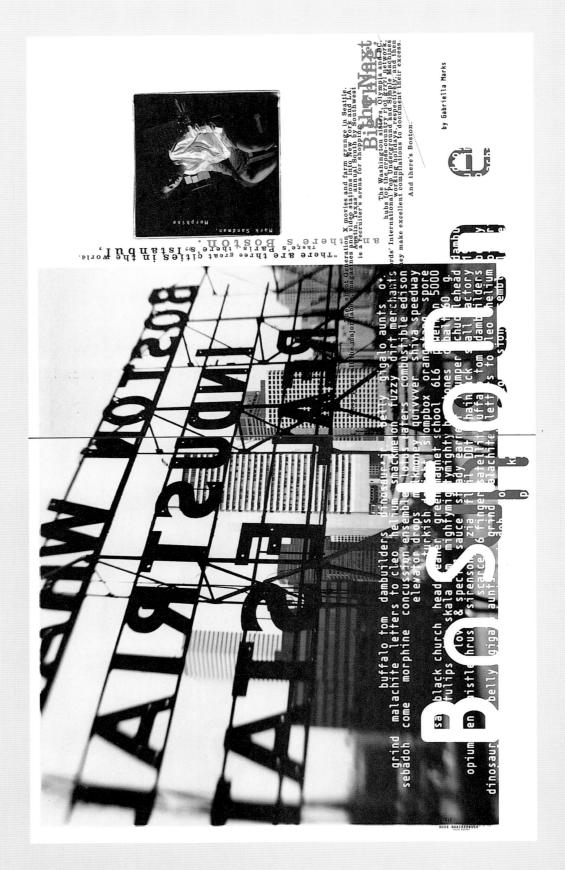

"There are schools for this for the form of the for

AND THE PROPERTY OF THE PROPER

For Jides Che WE BEEN CAN

S C P V P L MAS N. "

The transfer of the part of the

34

 \mathbf{m}

of distance and time, in the immediate electronic digital zone, The temporal conference may because assure in the numerical and the sounty at any incidente. My sope of the 180 model in its anged missures carrier pleasures on commercial acts of alternor the country of the plant electronic parts of the sounty and the company of the context and the country and the conference of the country and the consequency of the conference of the country and the consequency of the conference of the

The third includes that a particulated by a conductoring and of the properties, and to next the transition and a serious and a s

Therein seems, "I is absolutely backened by Strike and Hittering that a set of the seems of the

to

Que

and the state of t

the bar, there is a serious lounge as a well-styld surface millioning to U. Eightes doston band Christon spo be conseinle their latest incar- be condustible Edison. Catering to the he might operatible Edison. Catering to the he

An almaybure assenable to experiments in audio attracted Revers districts that its bottons after usuring above and will be to be successful to the theory of the property as a successful to a sense to the theory of the part of the part of the theory of the part of the pa

pages 126-7

MassArt 95/97

catalog

art director Clifford Stoltze designers Clifford Stoltze Tracey Schroeder Heather Kramer Peter Farrell Resa Blatman photographers/ Cecilia Hirsch illustrators Jon Baring-Gould editor Kay Ransdell publisher Massachusetts College of Art origin USA dimensions 222 x 210 mm 83/8 x 81/4 in

f m 1

A strong foundation program supplies an essential ingredient in an effective and comprehensive four-year art college experience. The six required courses taken in the Studio Foundation Department are prerequisities to the suphomore year when students enter their major concentration. The first-year courses build an important transition between the pre-art college experience and advanced studio work.

Active artists, dedicated teachers, and community-minded people, the Studio Foundation faculty share a strong interdisciplinary philosophy. Their familiarity with the wealth of educational opportunities at the college provides students with direction and encouragement on all levels. They inspire and inform, nurture each student's drive to put ideas into form, and prepare students for successful upper-level study and a lifetime of learning.

First-year students explore drawing, design, color, y-dimensional arts, and a choice of one of the following media arts: film, photography, computer arts, video, or interrelated media. They are introduced to a wide range of materials and techniques as wehicles with which to develop forms for their ideas. The program provides students with a basic 'tool chest' of vital resources their advanced studio training and liberal-arts studies, and a variety of information, experiences, and knowledge of art forms from all over the world, past and present. The Studio Foundation program is carefully designed to help students develop a critical eye and formulate a personal vision. Visting artists and lecturers at the weekly Artists Seminar present valuable information about professional skills required to perpetuate visual ideas in the practical world.

The Studio Foundation program uses a pass/no credit grading system, which removes unnecessary pressure from first year students and provides an atmosphere conductive to experimentation and exploration. The faculty believe that students should be encouraged to discover the things that evoke their curiosity, and find their own unique paths to greater intellectual and artistic sophistication. In-class critiques, frequent student exhibitions, and special department-wide projects prepare students for the scrutiny of their more mature productions, and instill a vision of the potential of their work.

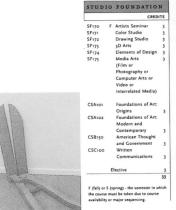

pages 128-9

Art Papers art director designers

Pattie Belle Hastings Bjorn Akselsen Bjorn Akselsen

editor Glenn Harper publisher Atlanta Art Papers Inc. origin USA dimensions $254 \times 343 \, \text{mm}$ $10 \times 13^{3/2} \, \text{in}$ dimensions

ing African art and cultur

student in Philadelphia. In while still a high school incorporated a Southern vernacular that includes as sources for his own onal and collective history from both his recent years, he has

of a series of loose sketches

found objects. It often

scattered over a surface

sometimes directly on

nuseum walls) with a

parallel of written and visua ative South Carolina and

the narratives of his work. A present. His work is seriou but interjected with humor both important aspects for Music and storytelling are narratives of the past and drawing or sculpture, his clothing, black-eyed peas, Whether in the form of sugarcane stalks, and black Philadelphia. work could incorpo

tate fellowship awardee, and studio Program, is a Florida University of Miami gradutte, he has participated in the Whitney Museum's

received two public art Dade Art-in-Public-Places ions with Metro-

9

Onajide Shabaka: What were your plans for the May 95 exhibition at Gutherrez Fine Arts [Miami Beach]?

Gary Moore began explor-

GLT, MAROUE 1 1902 as approached to do a sub-easility the committenests, there want found that the committenests, there want from the committenests, there want in suitable from the committenests, there want in suitable from the committenests of the committenest

Shabaka: Black people al-ways talk about how great the work is and how much they like it, but one very rarely sees them out at the gelleries and museums. They seem to get their seeing through the print media.

More Smithing instantive Securities of securities to a Securities of the instantive relationship and a validate to public the design of the public the design of the public the securities of the public the public to a government in securities of the public securities of the public securities of the public space to the public space of the public space and the public space and space and space and the public space and the space and space and the public space and the public space and the space and the space and space and the space and

A few drys, ago, at the Performin (Ford-feer, the Micropal),
and (Ford-feer) and Micropal
her my mind. They programmed a sisson of what in
open hall well be in 10 or 20
yours. What they proposed was
yours. What they proposed was
with the Treated estimation
either the Treated estimation
either the Treated estimation
from the Operation of the
Berman to do pertraits of this
Cortical Opportants of this
cortical Opportants of this
proposed was a serious of the
proposed was a serious proposed to the contrained of the contrained of

there's a maze of escalators, which have the same function. That's taking historical ideas, reconstruiting them to a specific site and expanding that, with vision. That's where I think the use out these in an open space, as called public space, has a future.

Sheahar, "Hart, sone of the ling," that seem is to be profes for Mamin in the Last sentance, I and a discussion about those who will be a first sentance of the country Manin and the potential to be one ways so many of the forther. There is a ways so many feet and that proper the country of the forther Mamin and the proper the throughout the country that was a feet and the sentance in the people throughout the country that is a feat more is going on here found the throughout the country of the throughout the country that the country of the throughout the country of the c community gaing; the we with an ed for must of damer chances and ort chance. Goard, were any brager. It thin that people once-again know that the artists have to really confront this media, and the media's impact on people. And the gallery is until strenger in people. And the gallery is until strenger in people. And the gallery is until strenger ing one we that public at that more again impact than the community center. Those place function only on a limited or lean place function only on a limited or lean Shabaka: I know that public art certainly impacts a lot more people. That's especially true with the public transit system here in Miami, the Metro-Rail. Shalaka: Yeal I hear a lot of people talking Martin the occlusive murine of the arts in Month Tyon areast Latin—even futther. If Shan areast Latin—even futther, I when the Charles of the whole the whole The national out of the whole the whole The national out of the whole who when the whole shout how Martin is not believed place, and it is, That has both believed place, and it is, That has both when as well in design with different seed mas well in design with different seedments of the community.

Moore: This city has the potential to be all that if it can build on its history in an inclusive way. But everybody has to be included.

Moore: Uthink one of the things that's going future is given to be caused, that Mism's future is given to be consease that Mism's and more open, it to have a dislapen among artists, with understanding and exposure. But this true for any city. You need to bright work from our of this community to bright work from our of the community to reties in that community. Heavily, and the given to give back to the people where they will be used to the soft of the community of the But if the artists aren't able to be in touch with a general disagne and and in-Moore: My first two public art commissions have been perely attanted in approach. There has been perely attanted in approach. There has been perely attanted in the last frey sparse and the perely attanted the and to brown in the perely attanted the and to brown in the art of the perely in the decement the old communities (by critical to decement the old communities (by critical to the perel complete of the the perely attanted to the perely att

Shabaka: You don't think that is happen ing locally?

More: I think it's happening in Minni-cretainly it's happening bit is could be happening in little pockets where you have been also that the properties of the properties of the international properties of the properties of the waiting to be involved in large disappear, waiting to be involved in the properties of the monty links, ratios of Latin strike, it's leaders to make these things work. Artists

Art Papers • January/February 1996

Ħ

- 129

OCTOBER 1995 \$4.95 JUST WHE FE GO. WE

telephone. Telefactory

COMMISSION TELEGRAPHING

Telefactory

Letter musting telegraph

Telemarketing

Telecommunications

Telemarketing

Telecommunications

Telestope

Telesto

telecommuting

Architecture Architecture A73.5 Design CS ACHITECTURE A73.5 Design ACHITECTURE A73.5 Design

	DUE DATE		
look in	OCT 2 2 1995	UAN 3 1996	
	NOV 5 1995 NOV 1 8 1995	JAN 2 5 1996	
	NOV 2 7 1995	JEB 4 1996	read.
	NOV 2 8 1995	FEB 1 3 1996 FEB 2 2 1996	
	DEC 1 199	MAR 1 1996	
	DEC 5 1995 DEC 1 8 1995	MAR 7 1996	
	DEC 2 3 1995		
	form #069	THREE WEEK LOAN	

library renewal

mixed media

corporate heavyweights such as Hewlett-Packard and McGraw-Hill around the creation of SIBL, A feast of information and uses of public libraries. aging, new, and developing is expanding the contents technologies—a mixture of techniques and technics-

"the nation's largest public in-formation center devoted exclu-

sively to science and business." This \$100 million library is the

rate faith that easy-acci eurship and grow wealth.

> BY ANDREA MOED in the crowded, contested spaces of New York City, privilege is defined by where one sits: a seal and abstracom at a selective school, a courtiside seet at a Knick game, a roble at a fashionable restaurant. So it goes as well in the Age, I think, as I tour the soon-to-be-home of the New York Public Library's ocience, Industry and Business Library (SIBL for short). In the future Research Reading Room, I'm ooking at a row of library carrels that should soon se some of the most sought-after tables in town.

make it seem as if the books and bytes them-selves are to sustain us through this time of eco-nomic privation. Perhaps this is why many of us with power, access to technology for the al population becomes more and more cru-proclaimed New York Public Library presiriding a lot of local publicity for the library, as well ss the occasion for many words on information as a matter of survival. In fact, it seems that more and subject in ecological terms. As manufacturing de-clines in the so-called First World, our new indus-tries are said to be "information-fueled." As media forms proliferate and media companies diversify on a par with food, but equations like LeClerc's dent Paul LeClerc on the recent installation ing of SIBL this coming May (see "Goodbye 227, Hello SIBL " - "" ation may not yet be nteractors, but "information . Hello SIBL," p. 49), the nev eral population becomes

The Magic Keyword

Council, and even the governor to bring the digi-tal cornucopia of Internet, database, and electron-ic catalogue access to branch library users all over the city, For the mostly privately funded research libraries, the NYPL has taken a different tack, uniting find informational abundance so satisfying, why we flock to on-line services, megabookstores, and ren libraries, like tourists to a Las Vegas buffet The NYPL has adeptly seized the cultural moment, attracting support and \$9 million in funding from the mayor, the borough presidents, the City 595 LEO LEGHORERC, Anna H ESE harem life. Barker, 195 3). 228p. *. 21cm.

BLE ON APPLICATION

BUN TREBOOK BUN

desktop computers provided by the or via laptops they bring with them erence books and directories will erence books and directories will for s what makes SIBL appealing. Even the books and computers have not library's on-line catalogues, CD. databases, or access the Interves around the carrels. If they what to order, patrons will be ce desk. CNN news and stock rived, it's easy to imagine contenter users sitting here in their trendy chairs, devouring all forms of data. will flow freely from a video array corner. This confluence of tra ibrary's 800,000-volume nonci t collection. Without leavir es, users will be able to sampl nd high-tech media and persona gourmets of the wider popula-tion, Its design was driven from the outset by surveys, focus NYPL's largest project in a cen-tury, built on the new public and ted in the offices and labs of on with lots of networked puters and amenities genesulting program serves up the erally associated with private esearch facilities, such as com-SIBL aspires to attract current and potential scientists and businessees information training programs and free story to commercial informa

interesting. Because part of their rhi is preservation, library collection naturally full of seams; SIBL will do microform cards from the 1960s as Jw ilker, the director of the NYPL's re raries, claims that the library's nless access," but it is the "; een formats that will make the what intimidating place for mar echnical people, with its volu quantitative and arcane inforn on, I suspect that SIBL will be rtheless, it can provide sor uch broader value: the char eling, vaulted ceilings, and cupo-laed entry halls. Under mellow, indirect lighting, ample wooden tables can hold several courses of data at once. At an elegantly services and consultation by librarians skilled in data preparation and presentation. Given the spirit of the enterprise, it is not surprising that SIBL's interior The reading rooms are spare but formal, with light wood panrs, market-fresh facts are not ough; the library's house speresembles that of an upservices. For SIBL's projected

an open book on a computer monitor. In advertising for CD-ROMs and on-line ▶ 44 pect of reading and libraries in the future In an AT&T ad, a woman reads an image o

1996 march METROPOLIS 43

42 метяолом тогей 1998

The control of the co

Metropolis

pages 130-33

art directors Carl Lehmann-Haupt William van Roden

origin USA dimensions 280 x 380 mm $$11\ x\ 15$ in

publisher Bellerophon Publications Inc.

artwork Ali Campbell

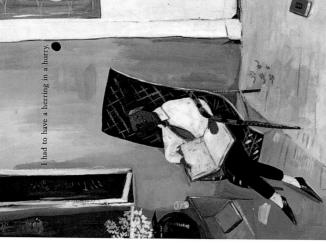

SNACK BAR

order now

That goes on inside the mind of children's book creator Maira Kalman?

the YAXIO BUSCH Somehow in my heart of hearts 1 decreev I wastry going to meet bask and familie in co-6-1 free bas And Ediori, instead, she suggested that an were meet at Woolmenth's on East 42nd Steed, and chow we're striked at the banch comer apparing the form of the strike and at the banch comer apparing the most Case Steel at the banch comer apparing the most offers. She is stilling me an anecdose from her authority of the supermarket with her mother and as her monther and she helmost. This is how ris swith also a very beautiful and very complicated missions. She has a very beautiful and very complicated missions. But with wetter and author of numerous in the allower banch and supplicated behaviored. I have a been strong them, what is influenced and and the supermarket and author of numerous in Million, all published by Viking Penguin. She has an Million, all published by Viking Penguin. She has an

then add coffee and stir.

designed mannequins for Pucci International Ltd., a formulae abouton m New York City, these seener and whimical personae bring some of her storybook characters into three dimensions and earn some thing like a Stepford family that has discovered Zen, bioleesback, and expensive harcust. And alse is married to Thors fallow, who apathic design film MidCo. In and—up until last fall—the editor in cheft of Colox, the magazine published by the Minetal Colox of the Memagazine published by the Minetal Colox of the Married of Thors who like the back in New York and Kaliman is ability one why Worthy. It is worth cluden has been dishinant is deling one why Worthy, it is well of the New York and Kaliman is alling one why Worthy. It is well one with the difficulty of getting anything done is the color of the Mines in definition is alling one with the difficulty of getting anything done

1996 january/february METROPOLIS 63

illustrator Maria Kalman

Mix one or two of life's big mysteries with all the trifles for sale in Woolworth's,

(),-)==

MERINGUE PIE

The pieces of tender baked classical with a creamy suggestance and flutty white rice and flutty white rice is the control of t

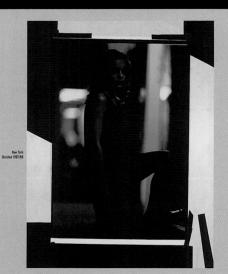

Monument () 64

bill henson fragments

faces

Los Angeles Unsided 1983/84

This year, the fragmented photographs shown over the page occupied the Australian pavilion at the Venice Biennale. They drew comments ranging from 'magical and deeply disturbing' to 'I wanted to call the police' (this last, not surprisingly, from England, the land of Tory scandal).

Henson's camera has been active in many parts of the world. As a curtain raiser to showing some of his current pictures, MONUMENT offers readers a selection of photographs taken in New York, Los Angeles and Suburbia.

Photographs on this and preceding page courtesy of the artist

a personal reflection by Harry Seidler

As he is the oldest practising architect in the world today with his reserved herebyl invalined in 1969, Philip behaviors's treatable, enignating and chamoleon-like cared warrants, examination, Both the influence he has had on others, and through them on the course of architecture in the second half of the hereinth century, should be seen in the onested to his early work of the 1940's and 1930's and his buildings in more recent decades:

has building in more recent decades.

In building in more recent decades, of the control at family of wealth, which made him independent. He possessed great intelligence and was elected at the best schools. He graduated with a degree in Arts from Harvard in 1930. This made him emission justified by the position of Decedar of Architecture and Design at the Missouri of Modern Art in Harvard and Design at the Missouri of Modern Art in Harvard and Harvard Harvard Harvard and Harvard and Harvard Harvard Harvard and Harvard Anderson Harvard and Harvard Harvard Harvard Anderson Harvard Harvard Harvard Anderson Harvard Harvard Harvard Anderson Harvard Harvard Harvard Anderson Harvard H

As one could expect, given his art-historical education, the subject was dealt with as a new fixed style rather than as an emerging philosophy and methodology of building, which by definition changes with time, and holds the promise of revolutionising all conventional approaches to architecture.

Through his long travels, Johnson became intimately familiar with not only the built results, but also the individuals, the pioneers that produced the early modern architecture of Europe: men like Mies van der Rohe, Gropius, Oud and Le Corbusier.

During World Wale II. he decided to study srchitecture at Harroad (1943), which was then under the leadership of Moleter Coppos, it is and that there was open histion between holeson and Gropius, probably in no small measure due to blooson's under reported fination with Nast Germany (companied to that of England's deposed her to the thore, Chaud Vills, from Wester Gopus had emigrated. When conflored with his Nasi part, Solvinon shall write the companied of the companied of shall be solved to the companied of world for the public of solved to the conflored with the Nasi part, Solvinon solved to the public of solved to the conflored with the Nasi solved to the solved to solved solved

Harvard became a horbed of new architectural orientation in the USA. In the years during and after the wax Johnson student contemporaries such as Pei, Barnes, and Rudolfs went on to revolutionies American architectura. Gropulus unique teaching, however, did not penetrate architectural schools deserbiere. Only superficial images became popular without the depth of the underlying principles. methodologies and especially the aesthetic components.

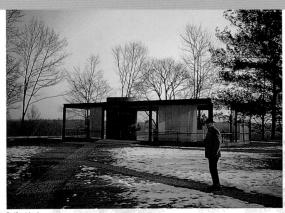

which were integral to teaching at Harvard. This is, in part, the reason why later developments, lacking in the essential foundation, soon deteriorated into historicist reaction.

Johnson started Jis career as an architect on a high note. Mes Yan der Robe had moved to Chicago, where he exerted art firereaing filleduce on the American scene As each his thesis 1st Hayrard. Johnson actually built a courtyard hisses as his fillar prefect. a design which was influenced heavily by Mesean precedents of the 1930's.

solvens were no so cent investible influence of with New York power structure through his sciedul, Fort years of the because he was a shreed publicit. For yearthy shreetings, as the built haves of eging and inchess and yet they were inhold with restaured minimakin, which made them virtual income through articlectural principages and apublishing of the time. The finences with pitich he assembled the finence of matching and the sup her piceword exchibitions and the manufacture of a statistical principal and the sup her piceword exchibitions.

unungamend in standards of excellence.

Throughout \$8.1995 you at 1990s is no exchenicular designs were roughful per land standy on the wink of the house of the standy of

Johnson's lasting importance, however, rests heavily on his collaboration with Mies on the Seagram Building, completed in 1958 - the quintessential prototype of endices, but lesset, glass curtain wall buildings to follow

After that triumph, Johnson felt he could no Jonger contribute to such developments. His dissatisfaction with the language of modern architecture became exident in his

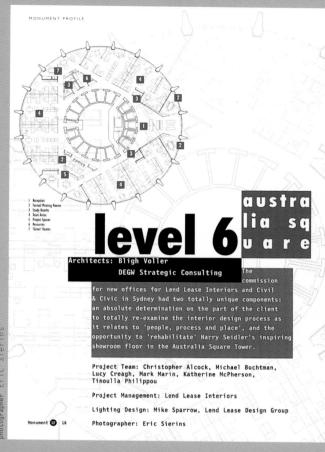

playing dumb

the photography of john gollings

John Gollings' individual, theatrical style of photography has made him a sought after recorder of the work of such distinctive practices as those of Edmond and Corrigan, Daryl Jackson and Associates, Ashton Raggatt McDougall and Denton Corker Marshall. Gollings is now also working extensively in Asia and has established himself as one of the world's leading architectural photographers. He has also pursued a successful career in the areas of commercial and advertisting photography. Here he talks with Marcus O'Donnell about that 'Gollings look'.

Monument 🕕

Monument

art director Ingo Voss designer Ingo Voss editor Graham Foreman publisher Monument Publishing origin Australia dimensions $240 \times 325 \text{ mm}$ $9^{1/z} \times 12^{3/4} \text{ in}$

pages 136-7

Silk Cut Magazine

art director Jeremy Leslie
designer Jeremy Leslie
editor Tim Willis
publisher Forward Publishing
origin UK
dimensions 290 x 290 mm $11^{3/8} \times 11^{3/8}$ in

136

SMELLS:

they weave in and out of our nontitils, guiding us through life. They warn us of danger, stimulate our appetites, stiract us to other people — or replet us. They intotacite us or autosate us. They work to the standard or the translated into notation or just replayed; and the standard or the translated into notation or just replayed; and the standard or the translated into notation or just replayed; and the standard or the translated into notation or just replayed; and the standard or the translated into notation or just replayed; and the standard or time, awakening past exercised in time, awakening past exercised in time, awakening and time, and the standard chinese the standard or the standard chinese that the standard chinese that the standard chinese the standard

art director Nick Bell

designer Mark Hough @ Nick Bell Design, London interpreted by Verónica Sosa @ Egoiste editor Emilio Saliquet

publisher Egoiste Publicacions S.L., Madrid

origin UK/Spain

dimensions 228 x 300 mm $9 \times 11^{3/4}$ in

Marc Almond sigue seduciendo. Una estrella viviente que no pierde luz.

Un poeta que toca la luna y no tiene miedo a llorar. Lo último, su biografía.

photographer Wolfgang Mustain

talento

talento

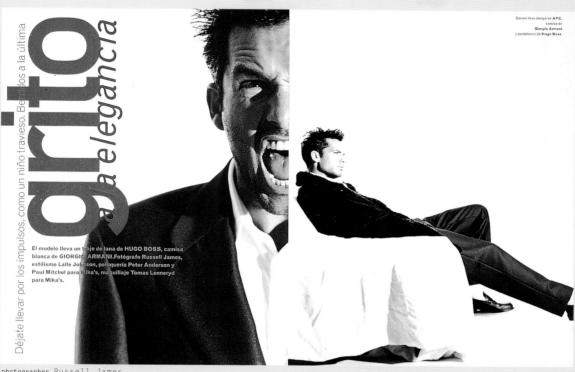

photographer Russell James

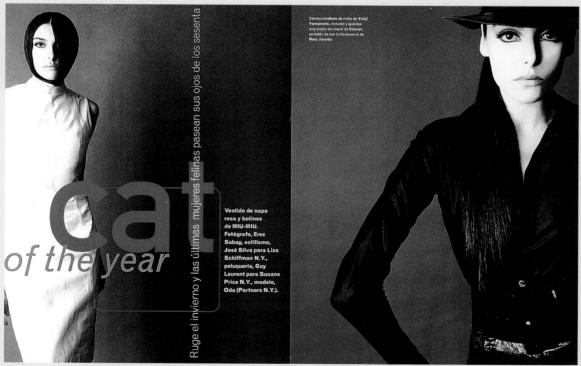

photographer Erez Sabag

True

art director Matt Roach @ Astrodynamics designer Matt Roach @ Astrodynamics

editors Claude Grunitzky Sunita Olympio

publishers Claude Grunitzky/Sunita Olympio

origin UK/USA

dimensions $230 \times 287 \text{ mm}$ $9 \times 11^{1/4} \text{ in}$

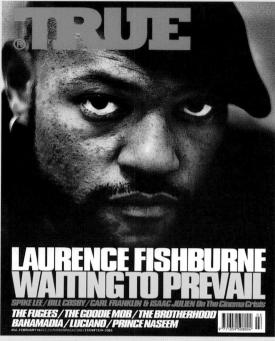

photographer Nicolas Hidiroglou

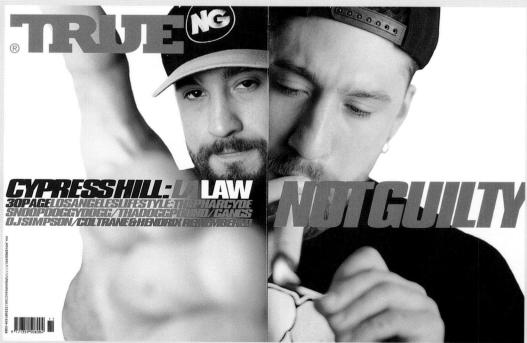

photographer Shawn Mortensen

140

photographer/illustrator Electro Astrosuzuki

photographers Phil Knott/Electro Astrosuzuki

photographer/illustrator Electro Astrosuzuki

photographers Thierry Legoues/Electro Astrosuzuki

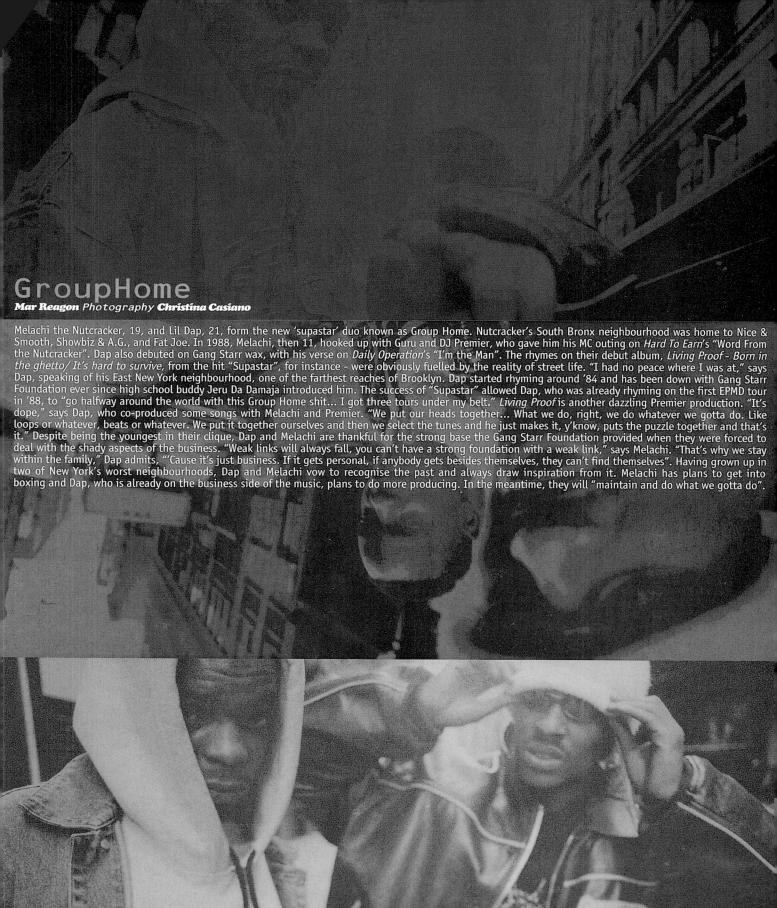

MartineGirault

Darren Crosdale Photography Wandy

Martine Girault's laugh is a low-down, dirty rumble which starts in her chest, grinds upwards and emerges from her thrown-back head. Wonderful. The phenomenal underground success of 1991's "Revival" gained Martine a loyal fan-base. The recognition of "Revival" as that rare, divine tune secured Martine and the song's producer, Ray Hayden, a six-album deal with London records. But, after realising which single the record company chose as a follow-up to "Revival", Martine and Ray asked to be set free from the contract. "I didn't mean to step on anyone's toes. I just wanted to feel good about myself," says Martine, hand on heart for emphasis. Instead, after realising that a great chance might have slipped through her fingers, Martine "felt very depressed" by the lost opportunity. Unlike Mary J. Blige, who went through a highly-publicised self-development programme, Martine's approach to conquering depression was rather inexpensive. "I was in this second-hand bookshop and I didn't have a lot of money. I found this book, The Magic of Thinking Big. It was torn and in bad condition but it taught me the importance of self-confidence." Brooklyn-born Martine grew up in Queens with her Haitian parents, three sisters and a brother. One day, Martine "just decided" she would sing. "My mother cried when she first saw me. She said, 'Who taught you to sing?'" Actually, Martine, whose background is in theatre, grew up listening to very little black music. "It was only what crossed over into the mainstream - like Motown." Martine once played Dorothy in the touring version of Stephanie Mills' show The Wiz. "I used to walk by Stephanie's theatre every day going to dance class. I used to say to myself, 'Why couldn't anyone write a play about me?" Martine's new single, "Been Thinking About You", precedes her forthcoming debut album. It captures the moods Martine wanted to express and, though she didn't write any of the material, she wonders at "how well Ray knows me!" More than just a producer, Martine admits that "He's my mentor". He

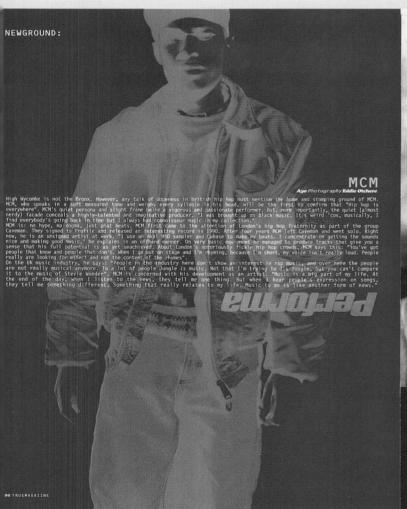

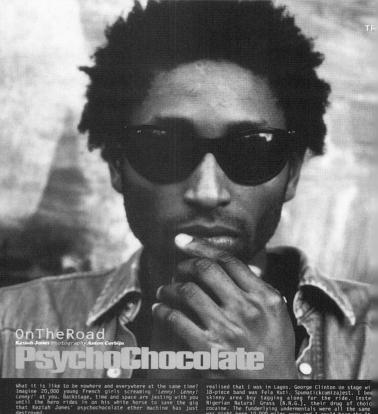

photographers Eddie Otchere/Electro Astrosuzuki

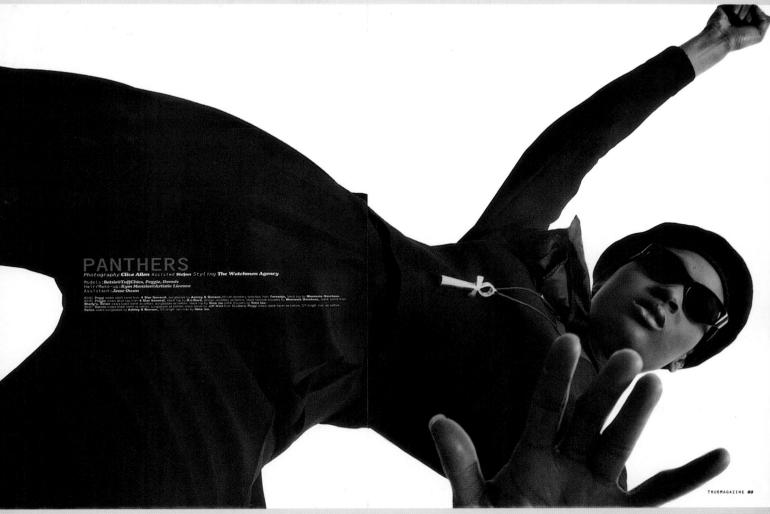

photographers Clive Allen/Electro Astrosuzuki

pages 146-7

Creator

1 & 2 Bernhard Bulang 3 Karin Winkelmolen & Edwin Smet Adam Shepherd art director designers

photographer 3 Vincent van den Hoogen

The Netherlands/UK 240 x 297 mm 9½ x 11¾ in Patrick Collerton Nick Crowe editors Nick Crowe origin dimensions publisher

has 0 4 UP enterta inmen! demanded as KPW grubb PU G 20 00 PQI o o S P

200

0

DUP

7

PIJ

0

0

9

PA

death

PITPO

I have declared pure art dead.

I think that every designer or photographer is, in principle, also a pure artist.

The myth of pure art.

	The myth of pure art.
Paul van Dijk, director	Art education in the free arts is regressing drastically, it is very evident and there is no stopping it. Sure, you could put on a brave face and say, "I'm glad that only 20% of the students are painters and sculptors," but in reality, of course, it impoverishes culture.
Visual Arts,	I have declared pure art dead, But I also think, and this is an opinion that I have held for some years now, that pure art as such has never really existed, because people have always been depen-
Maastricht, discusses	dent on patrons and customers. Particularly in the visual arts, the big commissions are always in the hands of these people. Offer the pure autonomous mage is found precisely in applied art, in the plant of the proper of the property of the particular and the property of the property of the property of the particular and the particu
art education.	ones, and a source of the distriction as a set of the distriction and a set of the distriction and a set of the distriction in everly day utilities. In fact it is pure and if you are the one who thought it up and shaped it in your own way and now see it there, as a thing in itself, and believe that's the best thing that you've ever made.
	However, the departments of the free arts, in the sense that pure art is undestitood in art education, are important in an academy. They allow things to occur that are not directly related to the usual educational models. These can be every integrated, these can be leony for don't lift the definitions. Penings we can't say whether they really have taken, to that their approach is such that they do things in the visual arts that are unpredictable or penhaps even unimagnable. You can see this in every department, So-called free at a topical that such people are often found in the so-called free at at departments so-called free at it doesn't have to be that way, because someone from the free art might start accepting commissions to normow, but would still have to meet the standards as a pure artist, to win paying commissions.
	I think that every designer or pholographer is in principle, also a pure artist. And vice versa. The pure artist is strongly affected by the market, and the artist's own approach, own aesthetic, and own integrily, determine whether it goes any further than what the market expects. And that is when you come to the concept of quality, that is the heart of the matter, or should be it is so difficult to define, for the departments of the appeal ants, it is timy dear what should be expected of the students at the end of their fraining. But for the departments of free arts?

Academy of Visual Arts Maastricht 🖪 Herdenkingsplein 12 🔳 6211 PW Maastricht (Netherlands) 🖿 tel.++31 43-466670 🖪 fax ++31 43-466679

pages 148-9 ▼

Creator

art director Jonathan Cooke designer Jonathan Cooke concept Leigh Marling @ Blue Source Damian McKeown @ Blue Source

editors Nick Crowe
Patrick Collerton
publisher Nick Crowe
origin UK
dimensions 240 x 297 mm
9/2 x 11²/4 in

- 147

IS THE FUTURE WHAT IT USED TO BE
MOST OF US ARE EMBEDDED IN OUR CURRENT LANGUAGE OF REALITY. SO,
INEVITABLY, WE ENVISION A FUTURE THAT COMES FROM THE DRIFT OF WORDS
WHOLLY BASED IN THE PAST, WE SEE THE FUTURE AND SAY WHY? WHEN WE COULD
DREAM THINGS THAT NEVER WERE AND SAY WHY NOT?

SAYING THE SAME THING AGAIN AND AGAIN BUT EXPECTING DIFFERENT RESULTS!

CHAPTER 3

LANGUAGE, FREDLOGY AND SUBJECTIVITY

"Say Cockney five shooter. We bus'gun

Cockney say tea leaf. We just say sticks man

You know dem have a wedge while we have corn

Say Cockney say 'Be first my son' we just Gwaan!

Cockney say grass. We say outformer man

Cockney say Old Bill we say dutty babylon ...

Cockney say scarper we scatter

Cockney say rabbit we chatter

Leas by bleach Cockney knackered

Cockney say triffic we say wackaard

Cockney say blokes we say guys

Cockney say alright we say ites!

So say pants Cockney say strides

So et as a nut ... just level vibes, seen."

Smiley Culture 'Cockney Transla

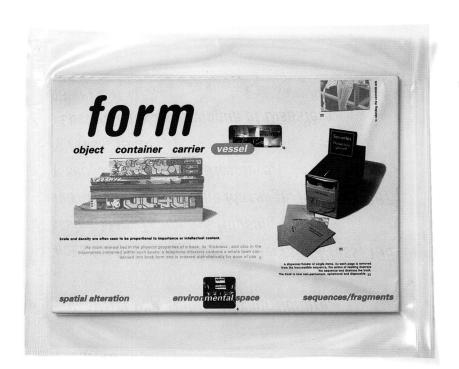

pages 150-51

form

designers Martin Carty @ Automatic Ben Tibbs @ Automatic photographers/ Martin Carty @ Automatic illustrators Ben Tibbs @ Automatic

editors Martin Carty @ Automatic

Ben Tibbs @ Automatic

School of Communication Design Royal College of Art, 1994

publisher self-published

origin UK

dimensions 210 x 148 mm (when folded)

 $8^{1}/_{2} \times 5^{7}/_{8}$ in

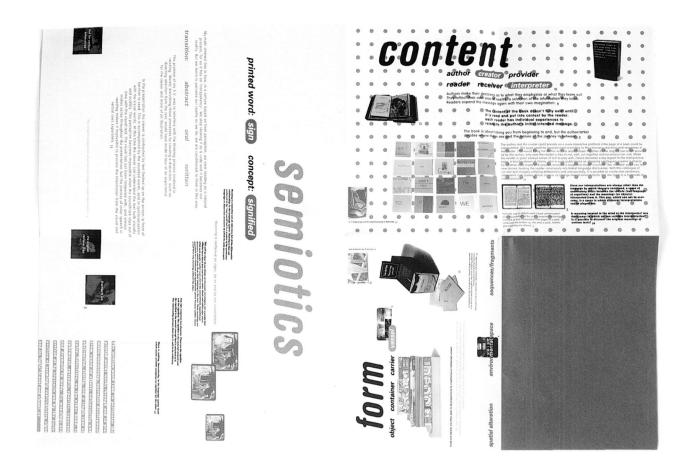

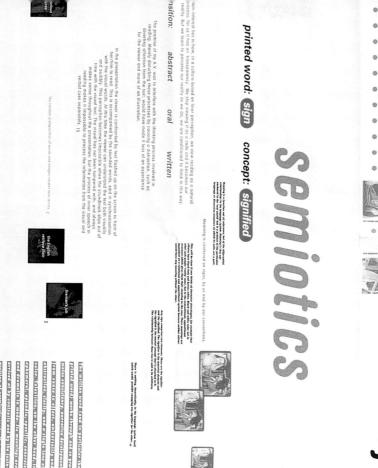

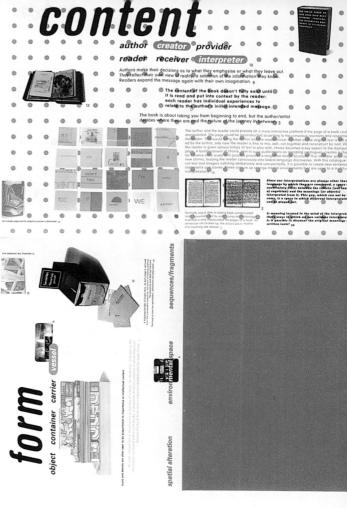

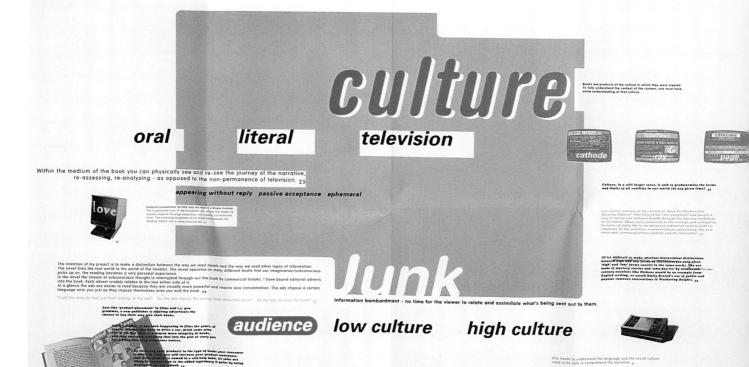

target market

autho

SIE GONI 3

Mail aniw sylen read year lend

BOLD

BOLD

.....

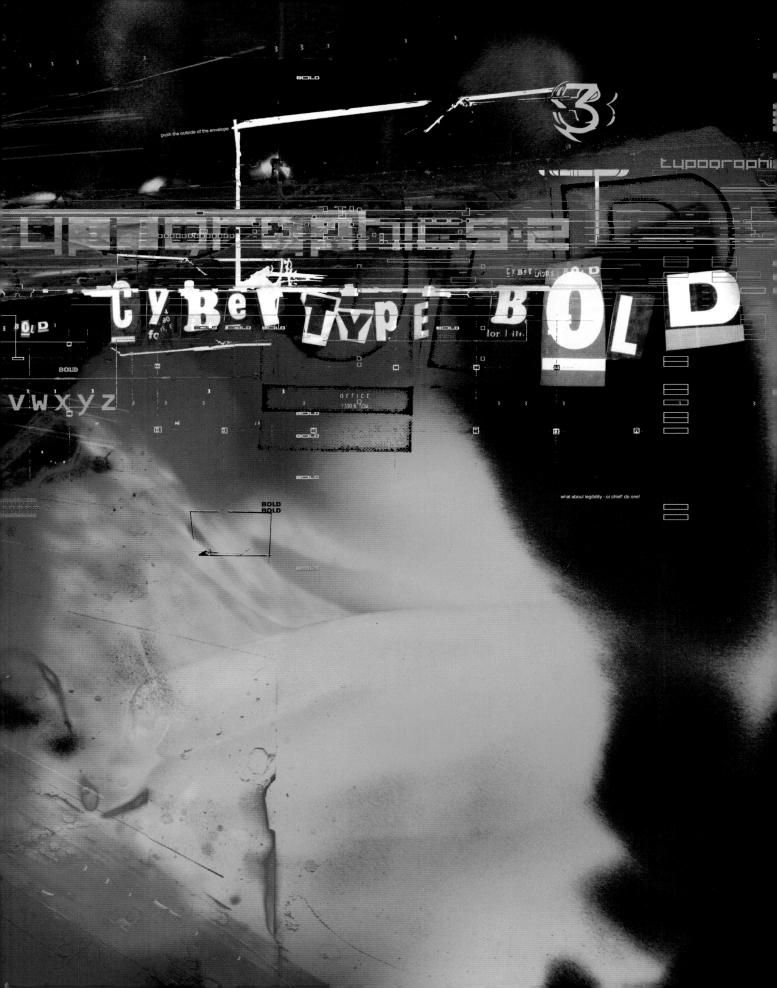

huH

illustrator Dominic Davies
editor Mark Blackwell
publishers Marvin Scott Jarrett/
Ray Gun Publishing
origin USA
dimensions 254 x 254 mm creative director Vaughan Oliver @ V23 art director Jerôme Curchod photographer Alison Dyer

huH

creative director Vaughan Oliver @ V23

deisgner Timothy O'Donnell
photographer William Hanes
illustrator Timothy O'Donnell
editor Mark Blackwell
publishers Marvin Scott Jarrett/
Ray Gun Publishing
origin USA x 254 mm
10 x 10 in

JULIAN COPE BOY GEORGE PRETENDERS THERAPY?

huH

creative director Vaughan Oliver @ V23
designer Jerôme Curchod
photographer Michael Muller
illustrator Chris Bigg @ V23
editor Mark Blackwell
publishers Marvin Scott Jarrett/
Ray Gun Publishing
origin USA
dimensions 254 x 254 mm

huH

creative director Vaughan Oliver @ V23
designers Chris Bigg @ V23
Rees Hubers
Rees Hubers
photographers Mart Gunther
Dominic Davies
editor Mark Blackwell
publishers Marvin Scott Jarrett/
Ray Gun Publishing

USA 254 x 254 mm 10 x 10 in

dimensions

origin

ohotographer Matt Gunther

pages 156-9

huH

art director Jerôme Curchod designer Scott Denton-Cardew editor Mark Blackwell publishers Marvin Scott Jarrett/ Ray Gun Publishing

origin USA dimensions 254 x 254 mm $$10 \times 10 \ \mathrm{in}$

AC/DC continues on p.60

bereitund undergad groupie saps her dad sants to enne fan's tu.

son de genera. The distrance has far, again entall, kerne son de decenty "long pai diest de dang delest, pou hour There son de decenty" son get all este de dang delest, pou hour There were son de decenty. Then get all este de dang delest, pou hour There were far get all este delest all them and ask, (%, we can't print hat.—

er they part of looked a flow and sale, (%, we can't print hat.—

"Their hume" — who was a love of their "Hour John". Thurst, what he called formed? I have popular pelicit.

7

U

are playing

world as High Voltage.

Which is my favorite AC/DCLP, with the funniest back cover in rock history, featuring letters to the band members where, for example, one

Argus and Bran don't have for seen to card, much about current Ausse, piblish gungs hearthrobs Streechal, (And Teogra to ask then about harmen some called Angles, only 18 timp for all the firm on many. The Misself the Paul Basterfeld Best and any out Theory (In Mayor New Coppon was on E. Corposodi, Sathimo, or Cho Chlomy, Bay Janes.)

Thus, he refeat, "What a vect, I ber that women's vect, i'd sid by that vects."

The second is that per least in LiCC comp, the "This of "Me that he has promy planteers that inted boogse blast on the Coderny districts command and society explanation and the command of States, the Alega demos, a "They were garg more the let commerce commerce and we shall not plant and society and all command of States, the Alega demos, a "They were garg more the let commerce commerce and the production of the production of the commerce and the production of t

When I govern the companies and the companies an

the more much, since ACCP is a found in a few more much, since ACCP is primary assessment and the since ACCP is primary assessment a

The same of the sa Anger reflexe, but a forther war restriction to mand, They had different better a forther and the forther and

was still cotted tigether We were a band that could go out and \$4 in \$2.0 km in most and \$4 in \$

The Section in region of cost after the former principle foots to death in his car after inching to much alcohol in 1960. Here a forecast in the section of the section of

The Golden List), Vance the Impugate they say, a very smith to the Golden List and College and the College and Col

count, Victor 2011 rest and part as it may, fast it that are when you've in you zot. I wan not a cited worder as inlight, but were first and the control and fast in the factors and if least this flow county is the control and your I want to the control and your I were the solid when the said to the county of the control and your I want to the county of the control and you were the said the glober of the county of the county of the county of this district control and were the county of th

He stall found to both He als a couple potenting ploater to a locate beloy memority. The Black and souple potential ploater and the Life of the stall below the stall a couple ploater and the stall below the stall a large below and to a locate the stall below the stall and the stall below the stall belies the stall below the stall below the stall below the stall be

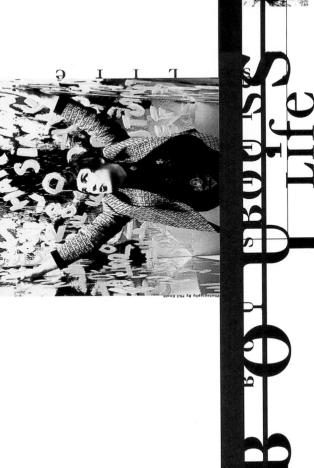

 \mathbf{O}

 \mathbf{B}

are of under aggregate of the state of the three of thr

Decreate hear received featured a bandle does for presental days and materiated despendent changed to emercity our explicit like for presental days and presental days and presental days and the following the second part asserted to work or treating the present and the following the present and the corner and part of the effect, a counted gas asserted earlier corner and the second part asserted on the corner and the second part asserted on the corner and the second of the following the second material second on the following the second counter and the second of the following the part of the following the second on the following the property counter following the second or part of the following the following the following the second or part following the following the second or part of the following the second part of the following the following

lon't know whether they like me becaus Haying, because I don't really cite abo

The control of the co

12

159

Мах

art directors Robert Kirk-Wilkinson @ Research Studios

Alyson Waller @ Research Studios Tom Hingston @ Research Studios Simon Staines @ Research Studios

designers Robert Kirk-Wilkinson @ Research Studios

Alyson Waller @ Research Studios Tom Hingston @ Research Studios Simon Staines @ Research Studios

photographers Robert Kirk-Wilkinson

Alyson Waller Tom Hingston

publisher Max Magazine, Germany

 $\begin{array}{ll} \text{origin} & \text{UK/Germany} \\ \text{dimensions} & 235 \text{ x} & 335 \text{ mm} \\ & 9^{1}/_{4} \text{ x} & 13^{1}/_{8} \text{ in} \end{array}$

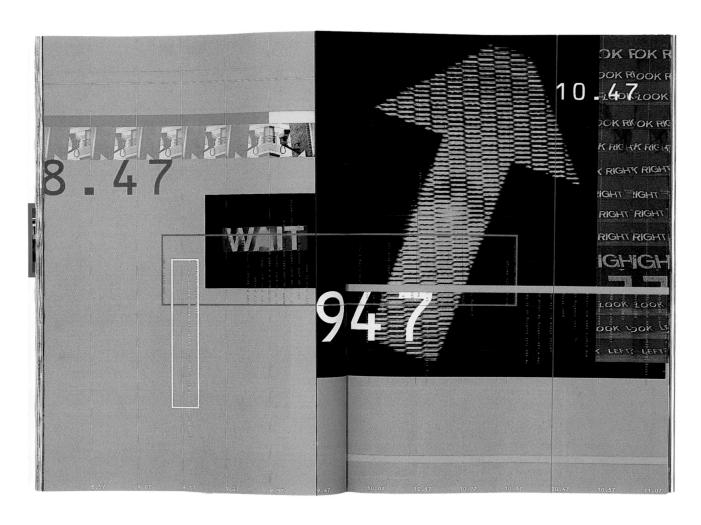

160

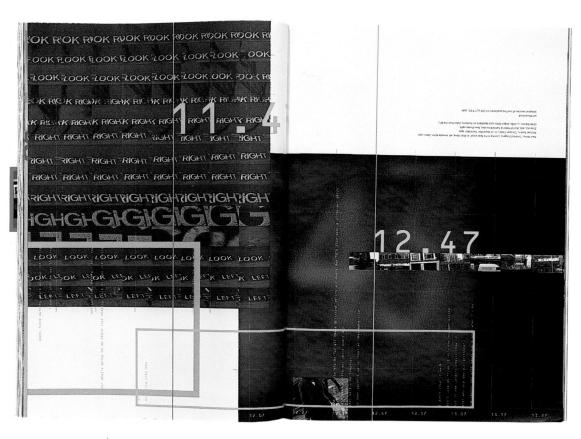

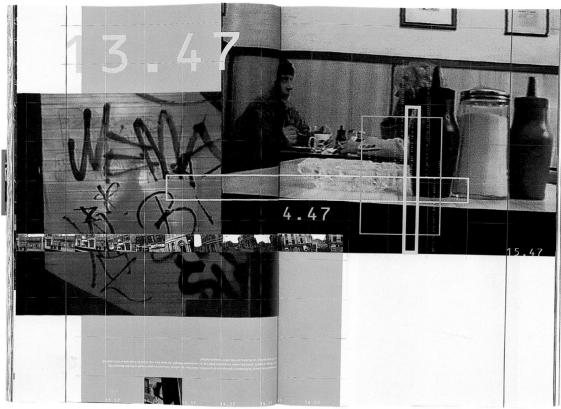

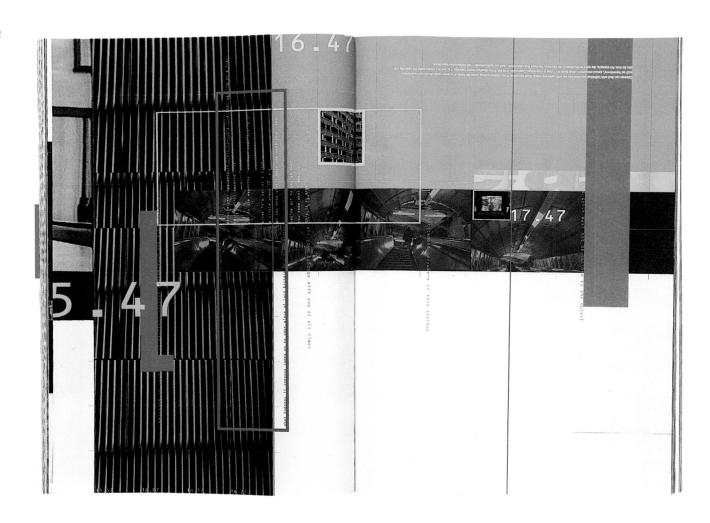

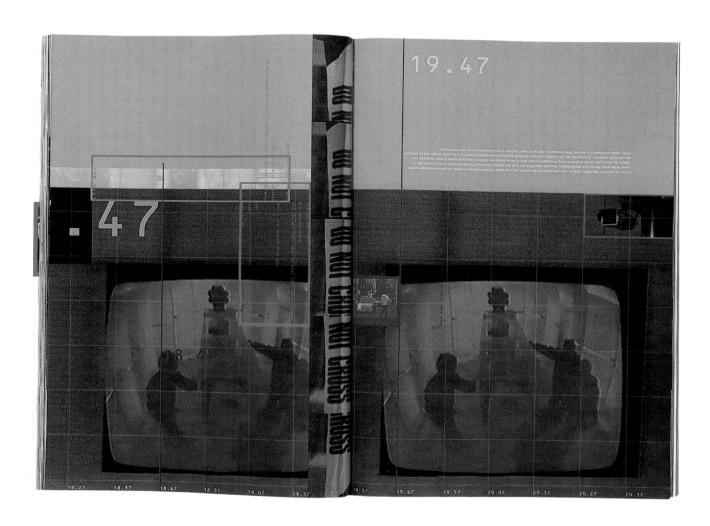

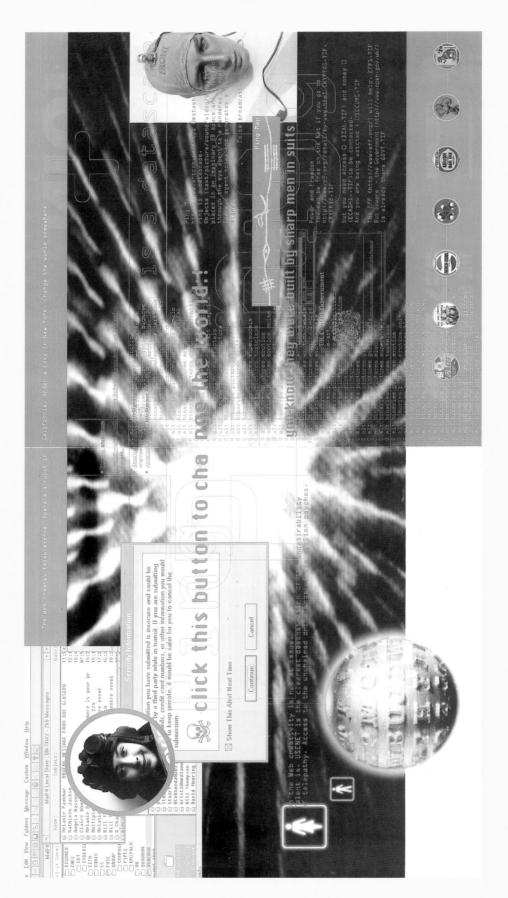

page 165

Blah Blah Blah 1995

a short-run magazine

	Seán O'Mara	Seán O'Mara	Seán O'Mara	Seán O'Mara	Seán O'Mara	self-published with the aid of	Central Saint Martin's College	of Art and Design		295 x 420 mm	11 ⁵ / ₈ x 16 ¹ / ₂ in
pu pu	art director Se	designer Se	photographer Se	illustrator Se		publisher se	Cel	of	origin UK	dimensions 29	11

page 164

Creative Review

Centaur Communications/Creative Review

publisher origin dimensions

 $267 \times 275 \text{ mm}$ $10^{1/2} \times 10^{7/8} \text{ in}$

Roland de Villiers Louis Blackwell

Seán O'Mara

illustrators editor

Seán O'Mara Seán O'Mara

designer photographer

art director Seán O'Mara

0

supplement of DJ Magazine

Michèle Allardyce Michèle Allardyce art director

designer

Claire Morgan-Jones editors Christopher Mellor

publisher Nexus Media Ltd 230 x 300 mm 9 x 11⁷/₈ in origin dimensions

hix and match and see what we come up with. New interactive nights and installations are at lubs like The Big Chill and Ministry and with everyone from Coldcut to 2 Unlimited releasing technology anoraks by day. So anyone who's half switched-on is thinking what the hell, let's ames co prepared for a mini-revolution as technology anoraks finally many of these so-called anoraks are clubbers by night and i es in the USA, with the clubs like The Big Chill

C

Modified

M.C. - 40 C. B.

はは一般になる。

photographer Chris Everard

youwant? youwant? youwant? youwant? youwant? youwant? youwant? youwant?

PREPARE FOR THE FUTURE GET READY

Christopher Mellor and Claire Morgan-Jones

design and art direction Michèle Allardyce

assistant editor and sub-Lindsey McWhinnie

contributor

Andy Crysell, Paul Davies, Chris Everard, Sam King, Ian Peel, Steve Pitman, Ronnie Randall, Helene Stokes, David Thompson, Phil Wolstenholme

2000 free with DJ Magazine issue 142
Spock says "Insufficient facts invite danger" (so read it)

nci as the latern of the answer to all our communication prob

music what does the future

Intro to 'The Prisoner', cult 60s TV series

technolo

past visions views of the near

interaction interactive on-screen entertainment

hexmatt black gets into the fall

drugs glossary

Zfind ut how futured-up you really a

hiona print-out flagest in

machines; the death of cd

Society formal service will not be estimed

GIO Con Words and phrases

6

0

de la

X

pages 170-73

EQ

CD magazine

art director Rob Bevan

designers Robert Corradi Howard Dean

Rick Nath photographer/ Lee Robinson

illustrator

editors Tim Wright

Laurie King

publisher NoHo Digital

origin UK

above

NoHo Digital

letterhead

art director Rob Bevan . designer David Hurren

publisher NoHo Digital

origin UK

dimensions 210 x 148 mm (folded)

 $8^{1/4} \times 5^{7/8} in$

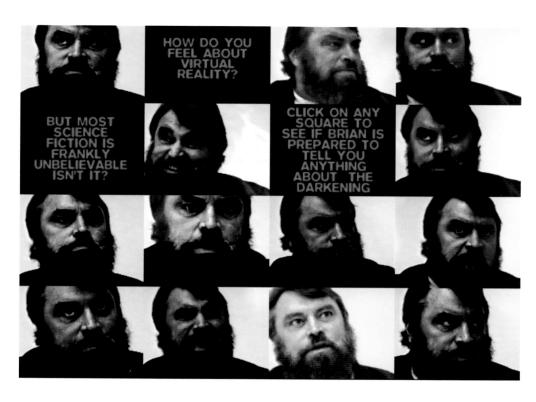

Insidetrack

magazine for Sony Playstation

art directors Neville Brody

Tom Hingston @ Research Studios

designer Tom Hingston @ Research Studios editor Graeme Kidd

publisher Bastion Publishing

origin UK

dimensions 297 x 210 mm

113/4 x 81/4 in

pages 176-7 ➤

Playground

designers Martin Carty @ Automatic

Ben Tibbs @ Automatic

photographer Des Willie editors Jake Barnes

Richard Johnson

publisher Playground Music Network

origin UK

dimensions 210 x 297 mm (folded)

 $8^{1/4} \times 11^{3/4} in$

175

CONTENTS. #01.Digital Defiance - The History of Jungle #02. The Metalheadz Sessions #03. Reinforce Records #04. One in The Jungle - Brian Belle-Fortune #05. What Do U Think? #06. SOUR Competition #07. How A Major Record Company Works #08. A&R #09. Publishing #10. Tech by Tech - A Brief Summary of Technological Change in The Music Industry.

Managing Editor Richard Johnson aka Rick Slick Comissioning Editor Jake Barnes Design Automatic Photography Des Willie Words + Knowledge The Young Wonderfuls: Lynford Anderson, Sandie Duncan, Kathleen Henriques, Grace Mattaka aka Spacechild, Tracey Roseman, Vanessa Richards aka Butterfly, Jaison Mclaren - the Original One, Diana Hughes, Kerys Nathan. The views expressed are not necessary the opinions of Playground. No Liability will be accepted for any errors which may occur. Letters, articles and images are welcomed. These will become the property of Playground. Text may be edited for length and clarity. No responsibility will be accepted for unsolicited material. Information from Playground cannot be reproduced in any form, without the written consent of the publisher. Copyright ⊙ 1996. Published for Playground Music Network 12 The Circle, Queen Elizabeth Street, London SE1 2JE Telephone 0171 403 1991 Facsimile 0171 403 1992 E-Mail 100617.1423@compuserve.com

#01.

#BULLETIN BOARD. The FREE resource for Playground members wanting to contact other Playground Members. You may want to soil records and/or music equipment, find a new band members or form a fan club.

Advertising

Want to Join Playground?

From time zero to this present period of existence, creative geniuses have inspired from the content and inspired human time and the deeper levels of consciousness. The pombaries of content and inspired to the content and the content and

TALSOTICE

*May/June 1996 LAYGROUND

THIS IS J

THE HISTORY OF JUNGLE

Jungle. Probably the most popular music in the country at the moment, certainly the most fashionable. But where has it come from? Why does

it sound like it does?

The dilemmas surrounding the word 'Imagic' affer the first clues. Many involved with the music don't like the term, preferring something class like Rardcore, Drum And Baas, Intelligent or Hardsteep, Some don't like names as hall, preferring simply to call it master. And therein lies the beginnings of an investigation. Jungle is to only one to be defined by a single word. All, preferring simply to call it master, and therein lies the beginnings of an investigation. Jungle is the productor of preserved development, and appertiementation. One of the greatest different ways are there of avaign food, sox, or money? Jungle is the productor of preserved development, and appertiementation. One of the greatest different ways are there of avaign food, sox, or money? Jungle is the productor of productor of preserved development, and appertiementation. One of the greatest and its lungle is larged own new musical arises. The music brings together a disparate set of influences its low productions. The distinct of influences its low of influences its lo

Ecstasy. The role of Ecstasy in the development of rave enture, and later Jungle, is unquantifiable, but many of those incovered would claim that its indistructions are reflected from the control of the music began to reflect the drug. Listen to Baby D's first version of Euphoria or the Aphac York's Analogue Bubble Squt If for clair examples of Euusic.

ACCELERATING INTO THE NINETIES

AWINGS

As the Eightles began, American hip hop emerged from the ghetics of New York and hid down the rules for the decade's musical methodology, introducing two deck mixing, sampling, drum machines and MCling as the techniques at the root of modern shares music.

Fast forward to the mid Eightles where hip hop and house are bastling it out for deminance on the floors of a newly created British club seen. In a fine the state of the

E MHARRERS

THE BEGINNINGS

MBBELTS.

Chief catalyst was the popularity of Acid House, its cause aided and abetted by the proliferation of pirate radio stations up and down the country form of the property of the prope

of Abstracts actions with a small sus gener to cop actions could be a small state of the state o

AN to suphore: Eighties rave seems faced into memory a new style emerged. The Eighties had provided the infrastructure
— illegal and legal radio stations, artists, clubs, shops, fans, the Nineties made use of it.
The first change was in the tempo. Nieties il none was faster and more stylistically spilntered. Genres sprouted from all
the first change was in the tempo. Nieties il none was faster and more stylistically spilntered. Genres sprouted from all
chief name—steps house, hard house jabba, handbag, so many names in fact that names started to become irrelevant.
Chief name—steps house, hard house jabba, handbag, so many names in fact that names started to become irrelevant.
Chief name of the property of the started of the started

THE LOST YEARS

E LOST YEARS

In retrespect the multi-visibilities (tid) is no harm. It caused a sense to become self-reliant and to appreciate itself. As Hardcore mutated into Drum & Base an entire juncted infrastructure; or one up around it, from artists such as Lemis De Ire and IN Crystyl; record labels such as Irelation for the property of the

JOURNEY INTO THE LIGHT

a result of this ner

new and delicens.

In 1994 and 1995 Jungle experienced unprecedented levels of cultural credibility and good press. The Face and The Gaustian ran features on Jungle. So did the NME, the Sunday Times and Vegue. Radio One gave the music its own shew (see One in The Jungle article excreted), as did Kine Frid in London and Manchester and Choice!PM in London and Birmingham. Jungle had brevien out of its Demy the Company of the

i Familys, valuer of unite music magnatine statung, mas his wwn higery as no way sungre organ receiving massive ambunts of la good story, says Phillips. "And it's been a long time in dance music since there's been a good story. Beys with posytalis making so music in their bedroom was never very interesting to the Guardian and The Face. With Jungle they've got something they can social and political angles into. There's the black aspect, the inner pity aspect — it's a whole cultural package."

One of the contentious points within Drum And Bass is whether it can be termed a black music, as Hip Hop, HAR, and Borgue often are. There is a view that is was the injection of a black aesthetic, principally base and complex drum breaks, into House that created Jungle and made it a memory of the property of the prop

THE PRESENT TENSE

TENNE

pages 178-9

Mainartery

posters

art directors

- 1 Peter Hayward & John O'Callaghan
- 2 Peter Hayward & Scott Minshall

designers

- 1 John O'Callaghan
- 2 Scott Minshall

publisher Mainartery Ltd

origin UK

dimensions

420 x 594 mm 16¹/₂ x 23³/₈ in

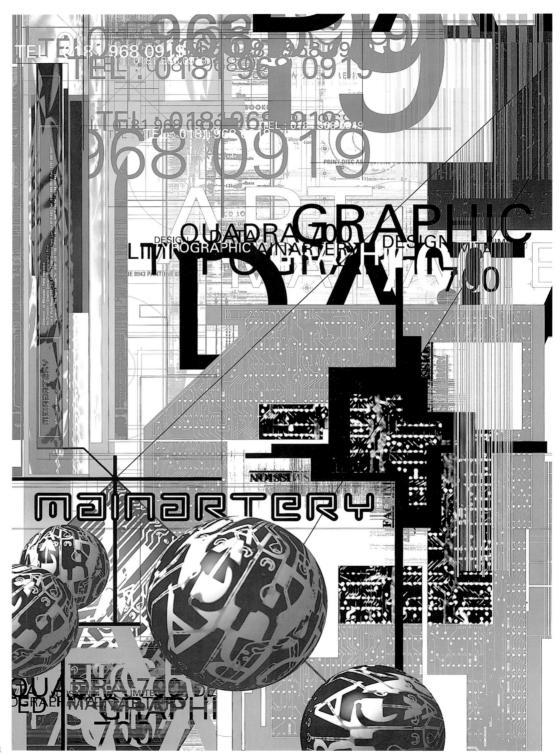

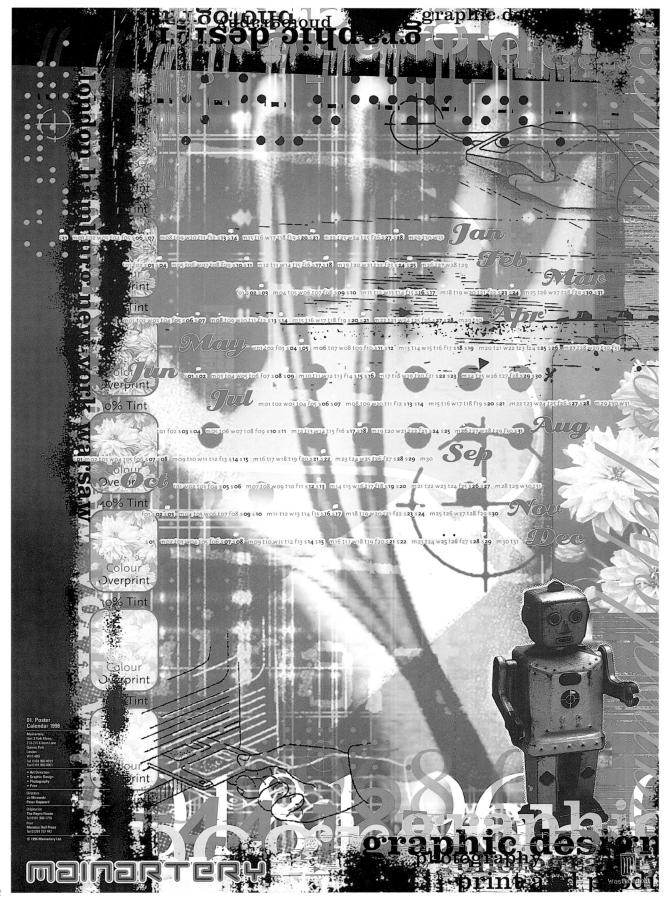

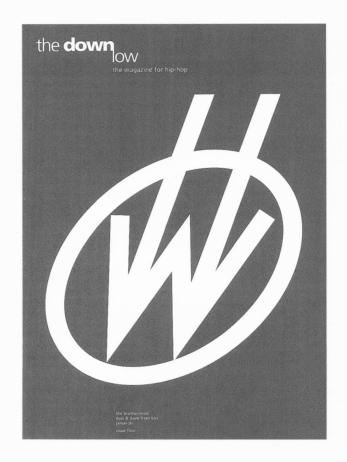

above

the downlow

designers Mark Diaper
Domenic Lippa
editor Matthew Carter
origin UK
dimensions 210 x 297 mm
8¹/₄ x 11³/₄ in

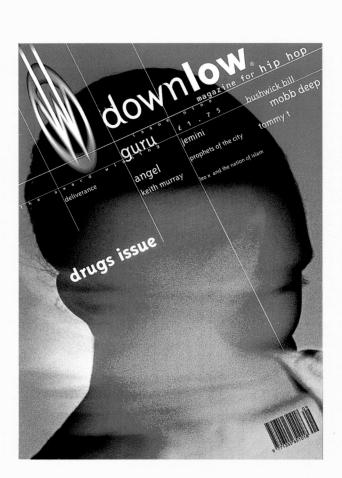

above & opposite

the downlow

designers Mark Diaper
Birgit Eggers
Mike Davies
editor Matthew Carter
origin UK/The Netherlands
dimensions 210 x 297 mm
8³/4 x 11³/4 in

The Noised Kingdow as a positive of the second state of the second

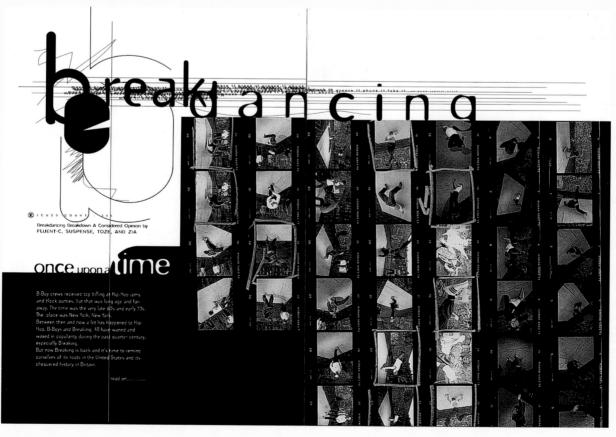

Bob 1 see page 184 for credits

183

Bob 1

pages 182-7

designer Richard Dempster

designer Richard Dempster

designer Simon Dixon

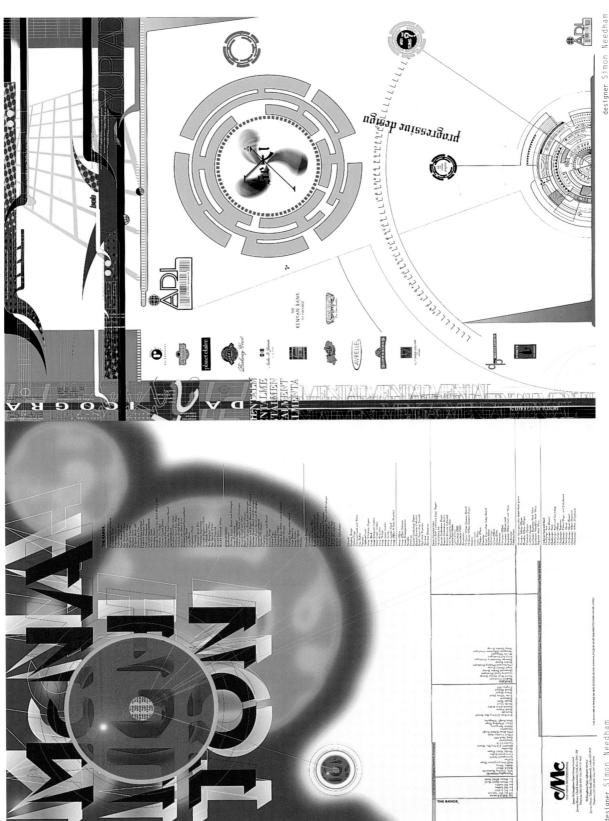

designer Simon Needham

pages 188-93

Code

art director Mandy Mayes @ Dry designers Alison Martin @ Dry Martin Isaac @ Dry

Wayne Jordan @ Dry

editor David Waters publisher Mark Lesbirel

origin UK

dimensions 210 x 275 mm $8^{1/4} \times 10^{7/8} in$

photographers 1 Mark Alesky 2 Oscar Paisley Mark Alesky Trevor Fulford Phil Knott @ ESP Niall McInerney Rankin Jeremy Maher 3 & 4 Phil Knott @ ESP

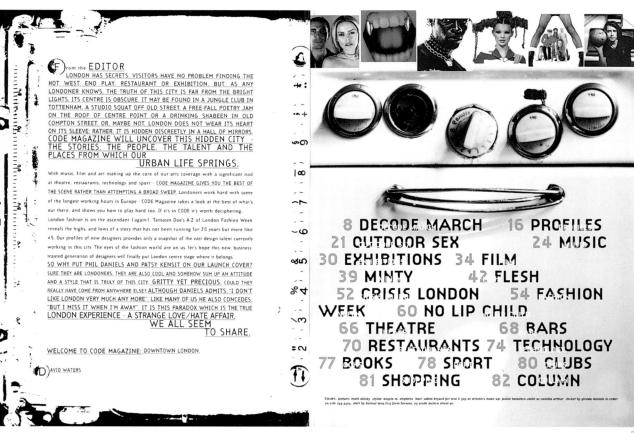

no-mishment

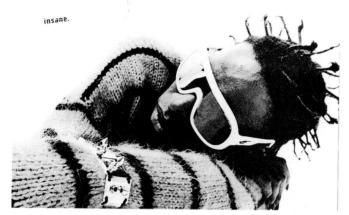

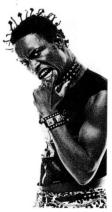

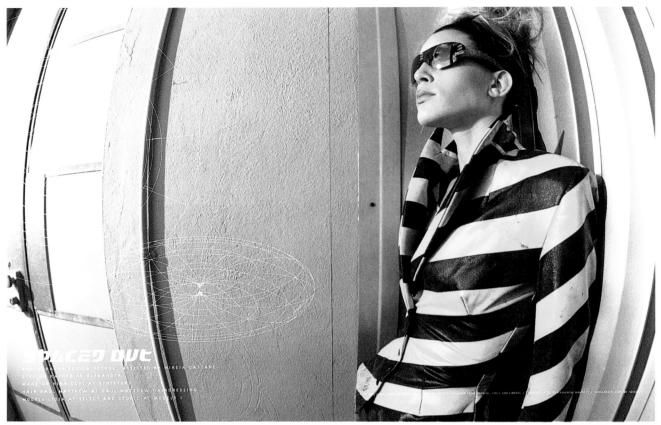

photographer Soulla Petrou

LONDON HAS BEEN INFILTRATED.

AMAZONIAN AMERICAN. NESTLING IN OUR MIDST RESIDES A SIX FOOT. BLONDE.

AMAZONIAN AMERICAN. NESTLING IN OUR MIDST RESIDES A SIX FOOT. BLONDE.

CHANCE TO STRUT MODEL-STYLE ACROSS THE GLOBE. RACHEL WILLIAMS IS

CURRENTLY HOLING-UP IN WEST LONDON IN LAID-BACK MANNER WITH LOVER

ALICE TEMPLE - CHECKING MOVIE SCRIPTS. MUSING ABOUT LIVE TV AND ENJOYING

TONY WARD AS HER TEMPORARY HOUSE BOY. ARRIVING FROM PLANET FASHION

WHERE REBELLION CAN BE SEEN IN YOUR CHOICE OF HILL STEEL

CRACKS AND STREET-WISE PHILOSOPHY. CUTS THROUGH THE

USUAL FASHION-PLATE PLATITUDES.

SHE'S CURRENTLY PLAYING THE POST-MODEL-ABOUT-TO-TURN-ACTRESS/PERSONALITY TRIP HER WAY, WRITES DAYID WATERS

CODE: WHY LONDON?

TROUSERS. THE GREASIER YOUR HAIR. THE DARKER YOUR ROOTS - THE GROOVIER YOU ARE HERE. It suits me just fine. In Paris it's the complete opposite to London, everyone has those perfect little suits on. They're all clones of each other. It's so bourgeois. Boring, boring, boring. I like the people in New York, but somehow I don't have any friends there I have a lot of friends here, but that's through Alice, but they're great. HOW DID YOU GET INTO TV?

I never thought of doing TV in my life. But English TV is better than American TV. I did live TV for the first time the other day on MTV and that was really fun I gives me an adrenalin rush because I know that they can't stop me, they can not control me. When I did the Girly Show. I've got an earpiece coming in here they just don't let you get on with it, they should let us go off and edit out the rubbish. They are so scared. I think that the Girly Show should be live. And we

HAS EVERYTHING BEEN BORTED OUT WITH IMMIGRATION? (ALTHOWGH RACHEL'S MOTHER IS ENGLISH, RACHEL WAS DENIED A WORK

wasn't allowed to present the show, all I was allowed to do was do interviews from abroad and send them in I lives really (rightening, they said you are going out to interview this person and I had never interviewed a fucking rat. They just sent me out with a cameraman and a sound person. But it worked out.

WHAT MAKES A GOOD INTERVIEW?

Don't stick with the questions they give you. They would give me tons and ton ions. As a conversation goes on other questions occur naturally. It was a veren't listening. I wanted to ask about other things. I would not go with those questions when there was a more interesting angle. It would throw the other presenters off because they would be waiting for a set question from

WHO WOULD YOU LOVE TO INTERVIEW?

Rose Force (Spanish/American acress) was close to my lantasy servicesee.

I WOULD LIKE TO INTERVIEW LIAM
GALLAGHER AND TURN HIM OVER MY
KNEE AND SPANK HIS SORRY ASS. I would be

telling him to get a grip. I used to have a crush on him. I don't think all that obnosious, mucho bravado is interesting at all. I think it is a really bad cliche. The guy's a genius so why diminish himself and his brother by being such an idiot? It's really so easy to be like that. If he thinks that's clever—for fuck's sake. give me a break. That's really simple.

ISN'T HE JUST INTO BEING FAMOUS?

I went through that fame thing you become enamoured with fame and you become an arsehole for a little bit. For me it lasted four or five months. But

man, his stuff's going on too long.

WHAT BORT OF THINGS DID YOU DO DURING
THAT TIME?

someone as well. I threw it in her general direction, it didn't actually hit her or anything. The work slowed down for a bit so you come back to earth again. People go through it. it's just how quickly you come through it that counts like

poor fucking Noomi. She's never come out of it! WHAT IS THIS BETWEEN YOU AND NAOM!

I am giving her a hard time now. I figure, well, she already hates me so I've got othing to lose. She hates everyone and she especially hates me. I slagged her off on the Girly Show I did her as "Wanker of the week". People stopped me body had to say it. In my life if I've hurt people it is only out of carelessness or thoughtlessness, and as bad as that may be, it's not as bad as going out and

INTERNITIONALLY HUMING SOME PRESS OF THE TABLOID PRESS OVER HERE?

moment I can do no wrong IM THE BEST THING SINCE

DO YOU SEE YOUR FUTURE IN LONDON?

Yes. I've got all sorts of great projects on the burner here. And in New York and America I'm a sort of has been model but here people are approaching me every other day with a proposal. It's really exciting, TV, movies and I would like to come up with some of my own concepts. I've got movie offers and have even been asked to do vocals for a house track. I don't know if I can sing for jack shit, but I'll give it a shot. I've got a couple of good offers too. Great roles. In fact there's this one role the character is an American model who comes to London. This guy was trying to cast all over New York and everybody kept saying you've got to see this girl Rachel Williams and he finally tracked me down I think he liked what he saw. I haven't read for him yet but I'm going to be doing it at any moment. I think he likes me. Learning lines is the hardest part but I figure any idiot can memorise things. The character is beautiful - she's six

CAN YOU RELATE TO HER?

pages 191-3 photographer Phil Knott @ ESP

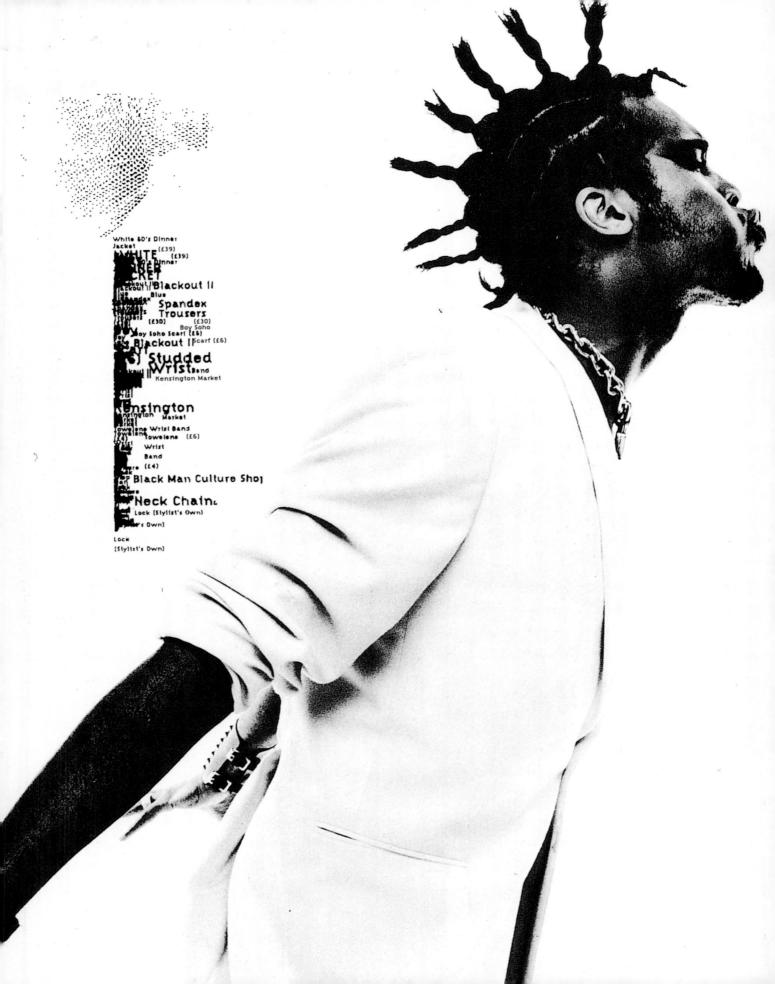

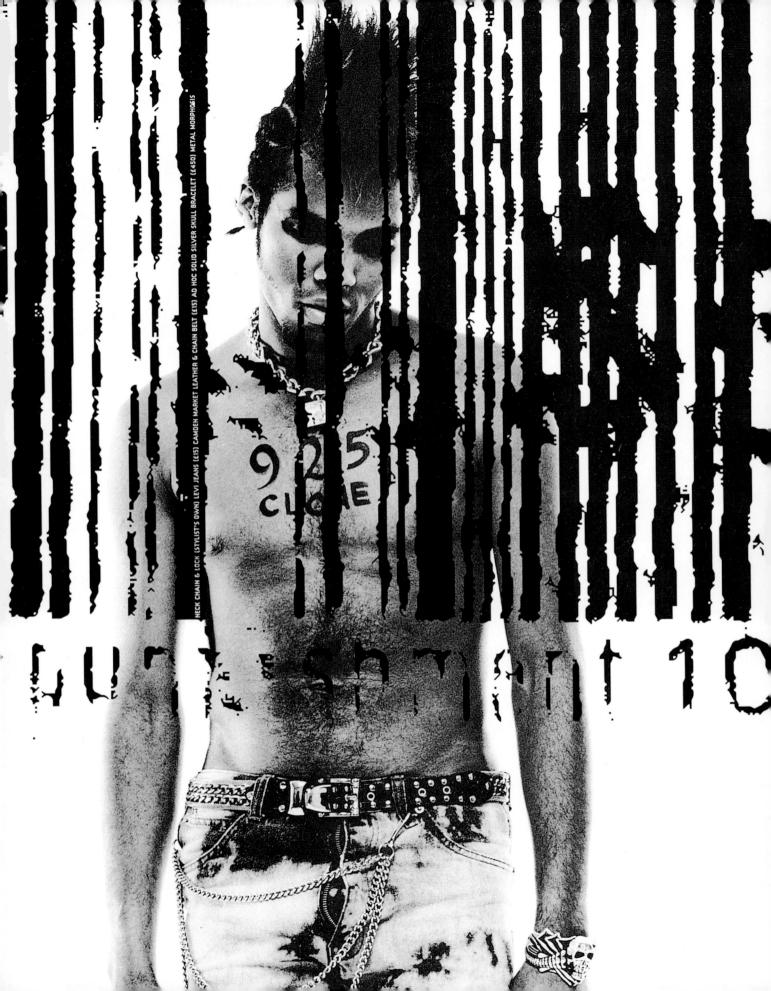

page 194

Blah Blah Blah

stationery

art director Neil Fletcher @ Substance designer Neil Fletcher @ Substance publisher Ray Gun Publishing Limited origin UK dimensions

headed paper 210 x 297 mm $8^{1/4}$ x $11^{3/4}$ in

white envelope $215 \times 110 \text{ mm}$

 $$8^{1}/_{2} \times 4^{3}/_{8} \ in$ business cards $$65 \times 65 \ mm$

 $2^{1}/_{2} \times 2^{1}/_{2}$ in

brown envelope 305 x 305 mm

12 x 12 in

FAD - ROGER WAUTON DUNCAN BAIRS PUBLISHERS CASTLE HOUSE 75-76 WELLS ST WIP 3RE.

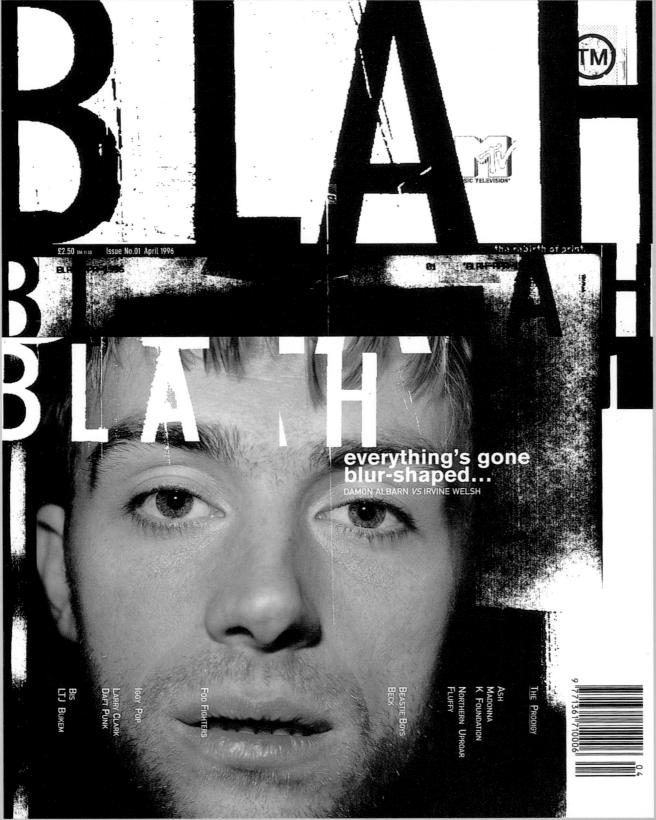

Blah Blah Blah

art directors Chris Ashworth @ Substance

Meil Fletcher @ Substance
designers Chris Ashworth @ Substance
Neil Fletcher @ Substance

editor Shaun Phillips

publisher Ray Gun Publishing Limited

origin UK

dimensions 230 x 300 mm

9 x 11⁷/₈ in

pages 198-9 ➤

photographer Joseph Cultice

photographer Peter Anderson

196

photographer John Holden

Time Out New York, Mar. 6-13 ably Blur's most adventurous recor ng Stone s for the disaffected."

magazine advert for The Grea ONLY DABIS "Timbe for the great article about Dasis ["T Riot", Lanuary). They may be arrogant and so noxidas, but it's a nice change from the con BLUNDERWA On their last weekend "Stateside" BLAH BLAH BLAH trails the jetstream left by Oas

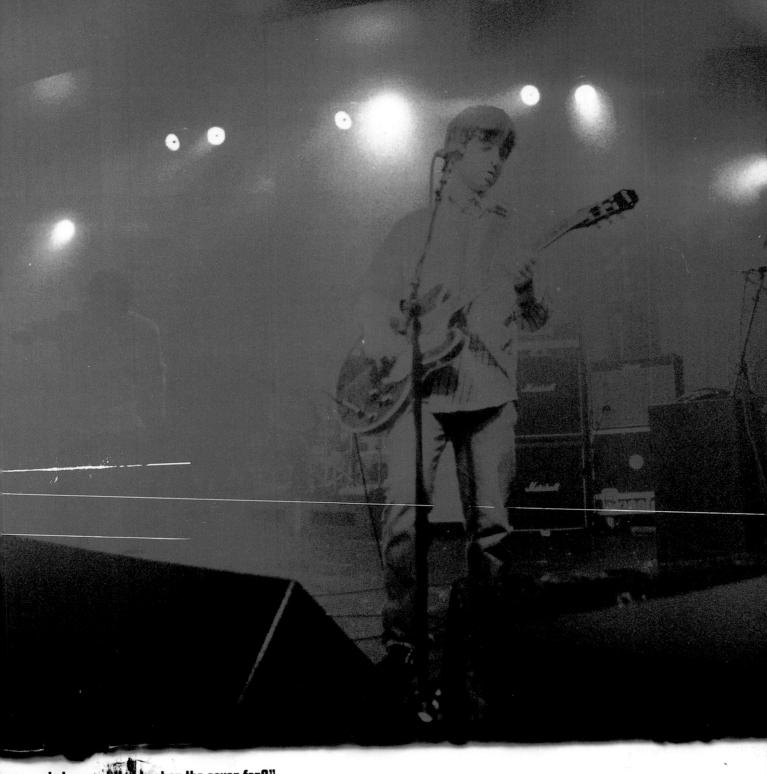

man, what you got that twat on the cover for?" Noel Gallagher of Wah Blah Blah's Damon Albarn cover.

nothing better to do: craig melean likewise: Joseph cultice ictory tour" but gets distracted by a bunch of hardcore punk kids. Some might say, 'Hey, who needs another Oasis interview anyway?'

editor Takeru Esaka

designer Kayoko Suzuki editor Takeru Esaka

designer Madoka Iwabuchi editor Takeru Esaka

designer Fumiko Furukama

editor Shinya Matsuyama

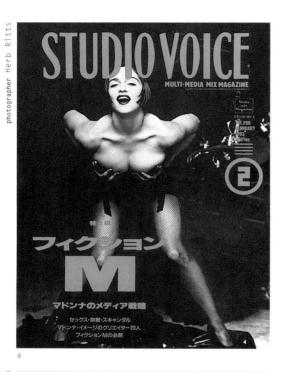

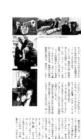

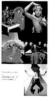

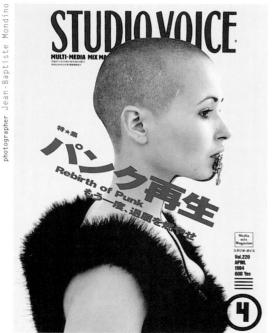

200

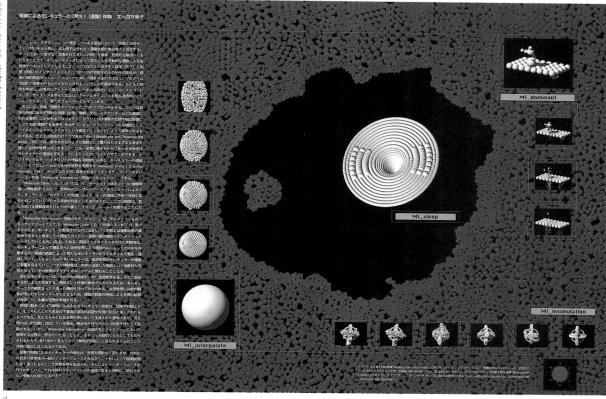

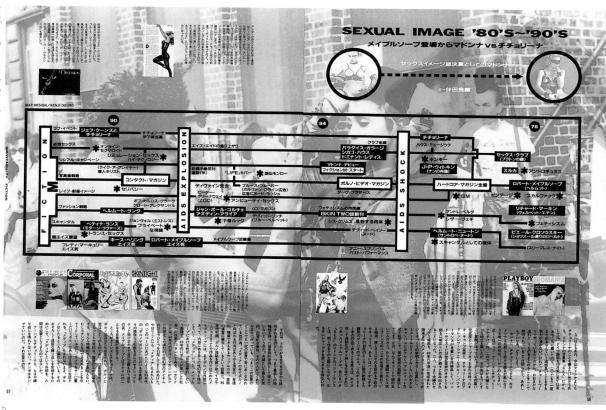

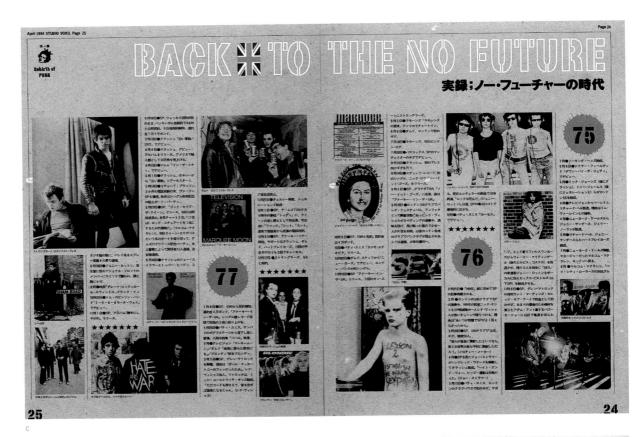

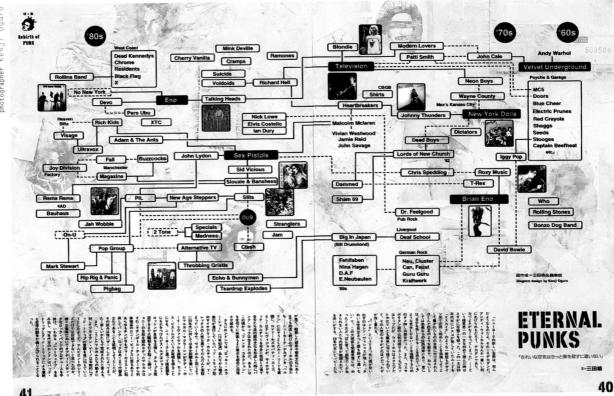

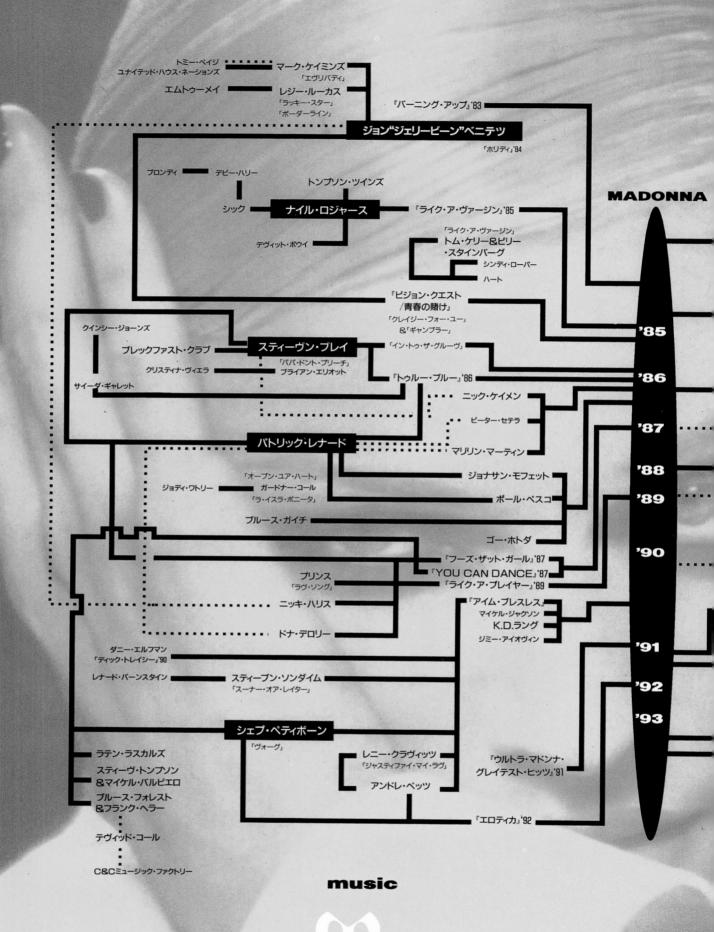

CREATORS of FICTION M

マドンナ・イメージのクリエイター達

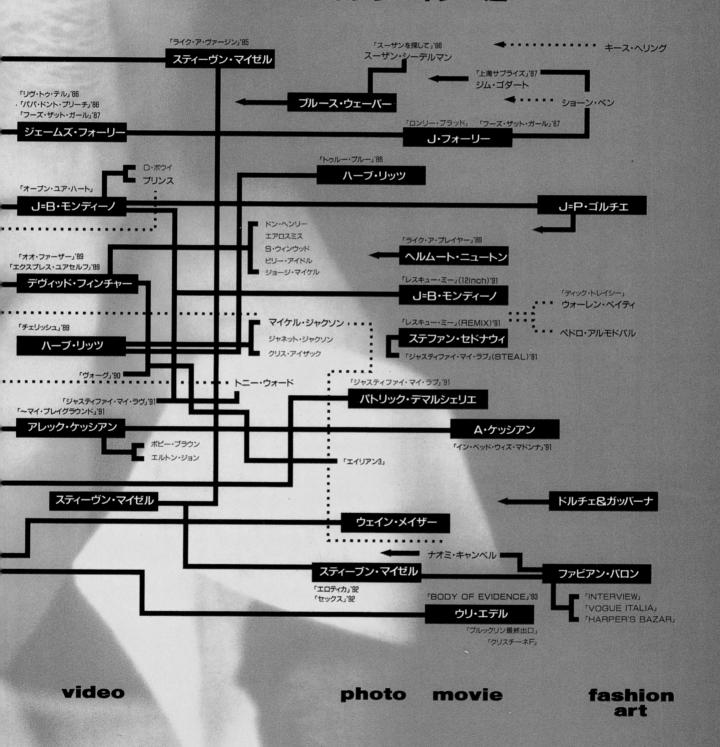

MAP/YUUJI MURAOKA, S.V MAP DESIGN/TSUTOMU MORIYA

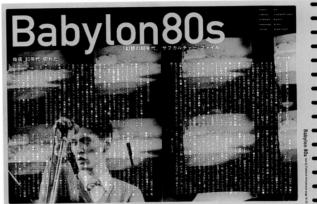

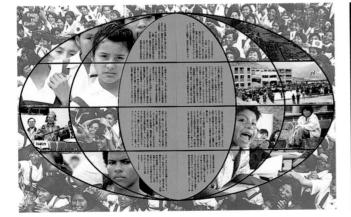

d

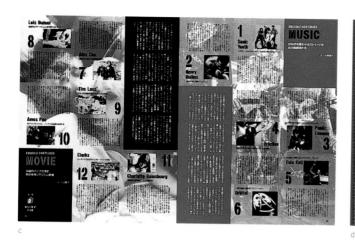

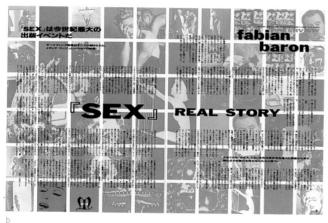

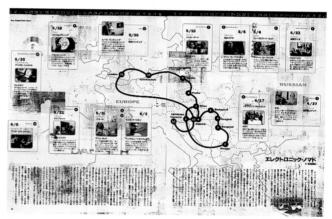

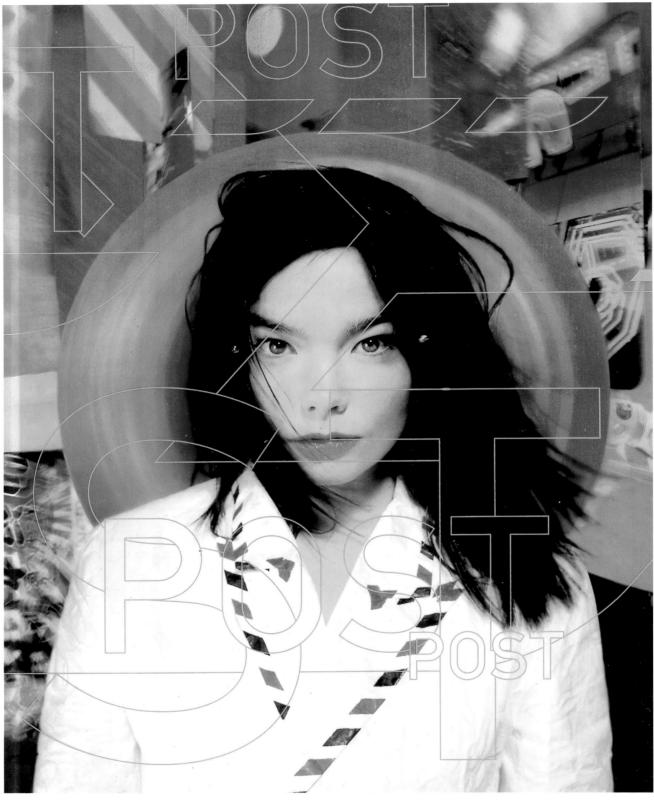

pages 208-13

Post

art director Paul White designers Craig Hewitt/ME Company illustrators ME Company
editor Sjón
publisher Bloomsbury
origin UK
dimensions 267 x 337 mm
10½ x 13¼ in

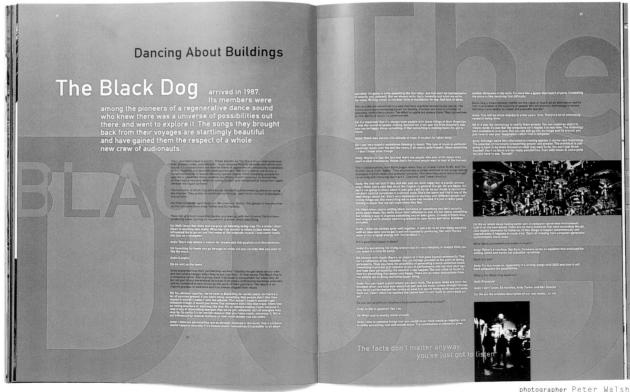

photographer Peter Walsh

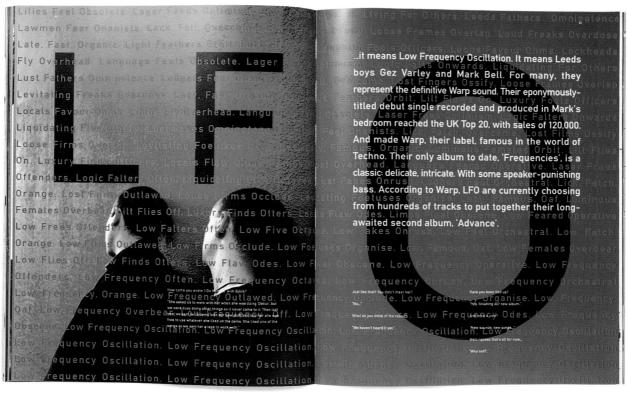

photographer Bernhard Valsson

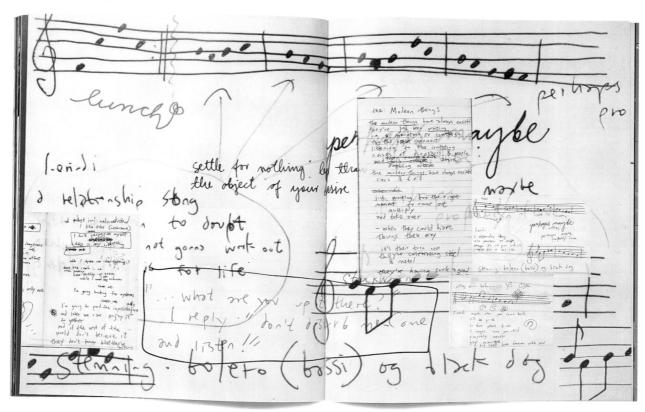

source Björk's Notebooks

The Birth of NovaBjörk

A tale in the old style of Science Fiction. For the children of NuWorld.

But the composer didn't mind living in such poor circumstances. He had no thought for anything except his beloved music. All he asked in life was to be able to create enough compositions to feed the starving MuBots hidden in his cellar

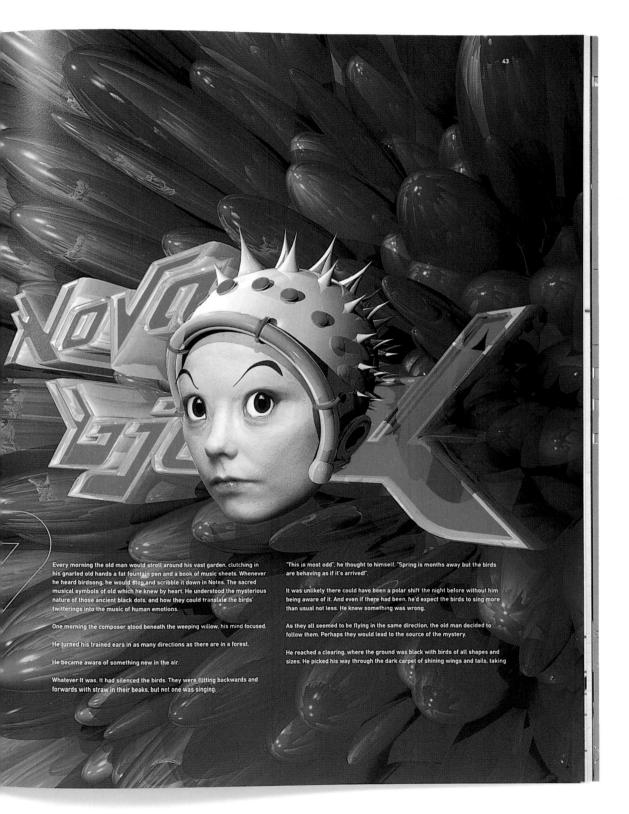

designer The Attik Design Limited

(noise)

designers all designers specified are from The Attik Design Limited publisher The Attik Design Limited

origin UK

dimensions 220 x 330 mm $86^5/_8$ x 12 in

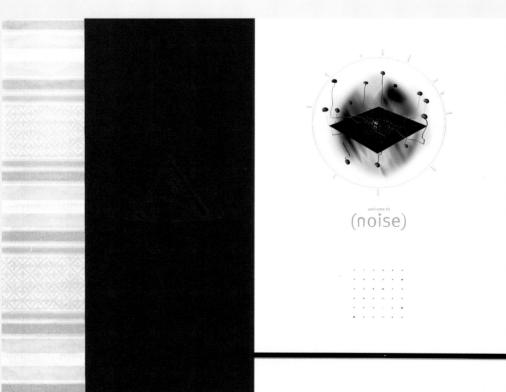

designer Simon Needham

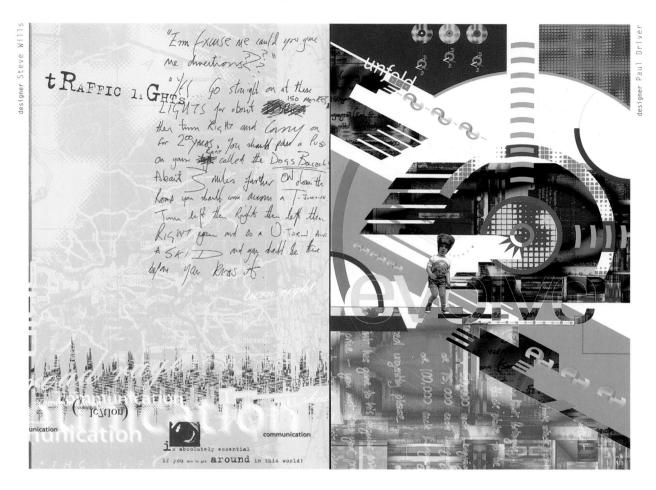

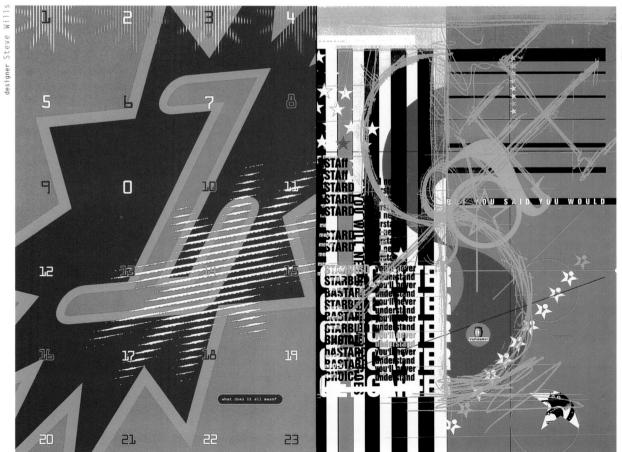

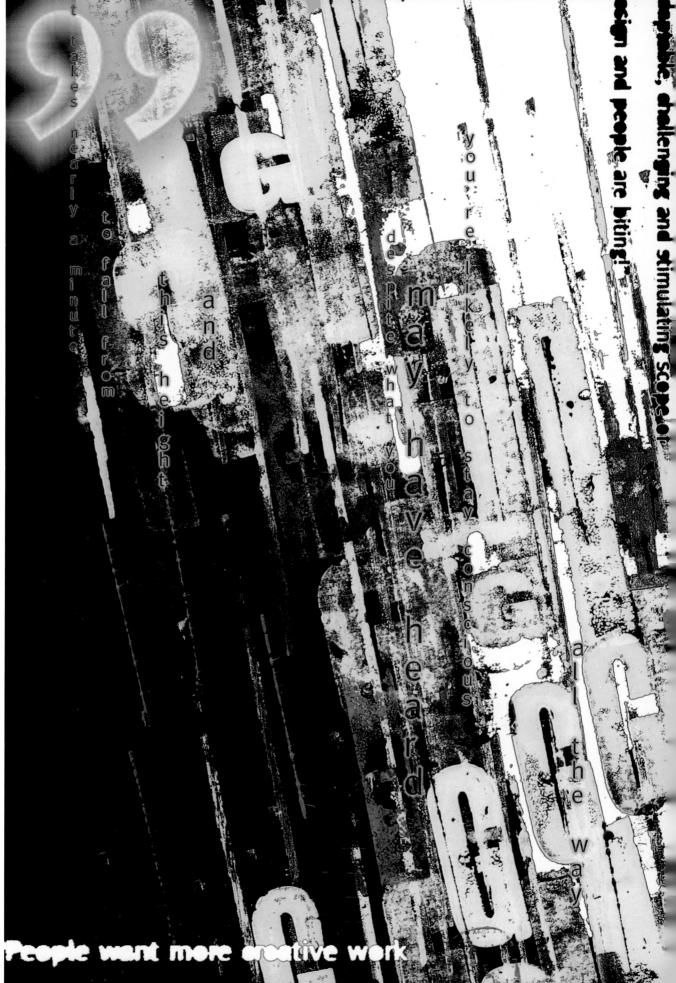

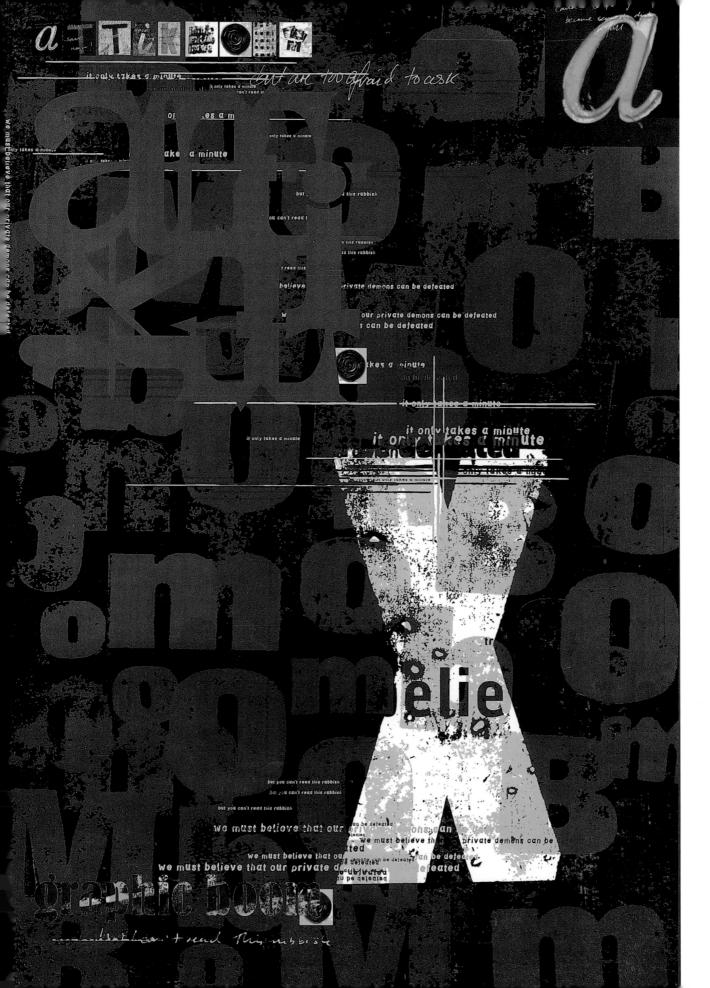

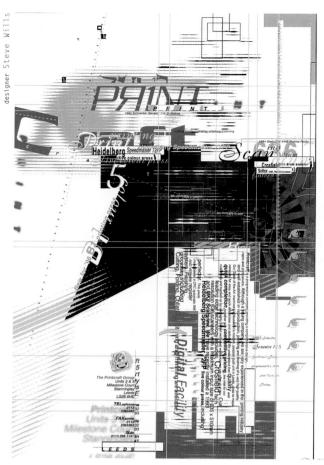

designer Simon Needham

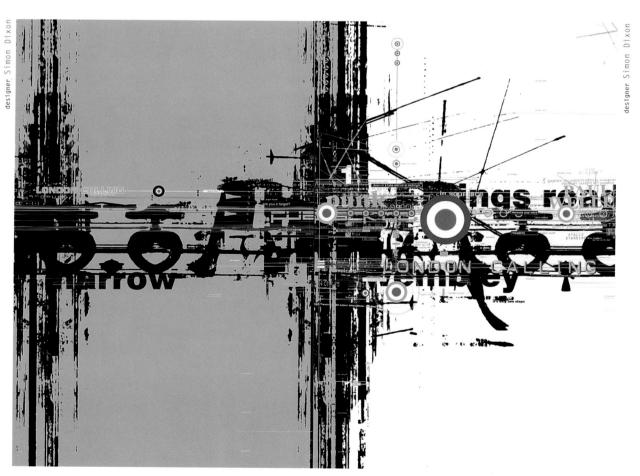

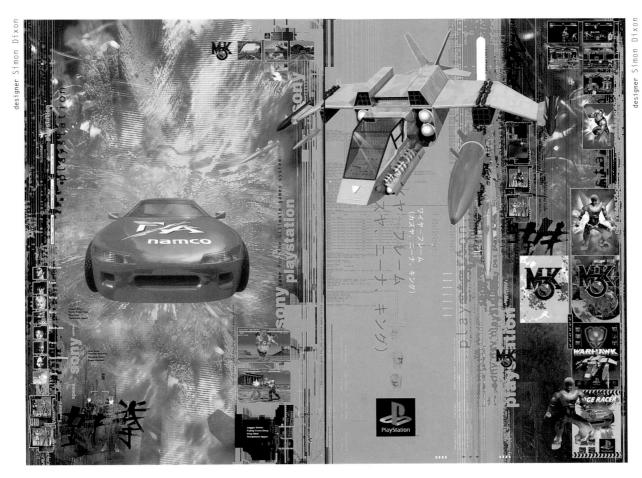

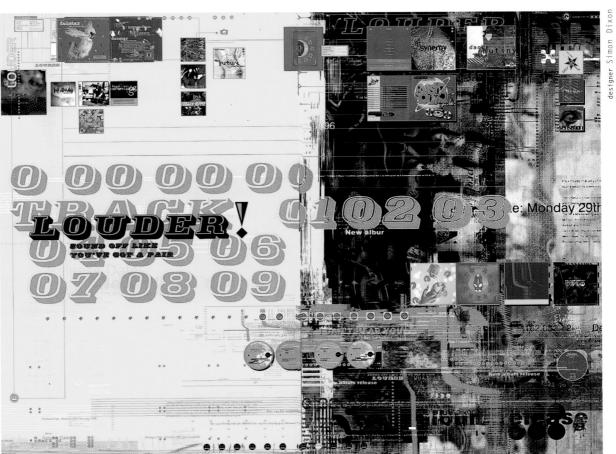

designer Simon Dixon

219

Akselsen, Bjorn 128-9
Allardyce, Michèle 66-7, 166-9
Almquist, Jan C. 80
Anderson, Will F. 108-11
ANTART 114-15
Arena 50-51
Art Papers 128-9
Ashworth, Chris 195-9
Astrodynamics 140-45
Atlas 16-19
Attik Design Limited, The 1-11, 82-3, 152-3, 182-7, 214-9
Automatic 150-51, 176-7

Ballesté, Patricia 26-9 Banham, Stephen 22-5 Barosh, Miyoshi 33 Bartlett, Brad 97 Baseline 108-11 Beebe, Matt 119 Béjean, Pascal 88-93 Bell, Nick 30, 138-9 Benson, Karl 186 Berlage Papers 56 Bevan, Rob 170-73 Bicker, Phil 69-71 Big Magazine 52-5 Bigg, Chris 155 Bikini 120-21 Bil'ak, Peter 84-5 black + white 46-9

Blah Blah Blah 194-9
Blah Blah Blah 1995 (short-run) 165
Blatman, Resa 126-7
Blue Source 76-7, 148-9
Bob I 182-7
Bortolotti, Frédéric 88-93
Bourke, Marissa 50-51
Brody, Neville 106-7, 174-5
Brouwers, Arlette 56
Bruitage 81
Bulang, Bernhard 146
Bulldozer 88-93
Burdick, Anne 96-7

Caffeine Magazine 68 Carson, David 124-5 Carty, Martin 150-51, 176-7 Çepoğlu, Gülizar 74-5 Cherry, Vivienne 40-41 Chick, Sam 50-51 Clarkberg, Larry 38-9 Coates, Stephen 42-5 Code 188-93 Colors 12-15 Contretemps 20-21 Cooke, Giles 215 Cooke, Jonathan 76-7, 148-9 Cormier, Delphine 81 Corradi, Robert 171-3 Cossutta, Renée 33-7 Creative Camera 69-71

Creative Review 164
Creator 146-9
Crumb, Harry 31
Cunningham, Brian 108-11
Curchod, Jerôme 154-9
Curry, John 120-21

Davies, Mike 180, 181 Dean, Howard 171-3 Degg, Andrew 100 Denton-Cardew, Scott 156-9 Dempster, Richard 184 Design 57 Detail 81 Devendorf, Scott 118-19 Diaper, Mark 180-81 Dixon, Simon 185, 186, 218, 219 DJ Magazine 66-7, 166-9 downlow, the 180-81 Doyle, Danny 76-7 Driver, Paul 215 Dry 188-93 Duranton, Anne 88-93 Dwelly, Simon 108, 109, 111

Earith, Simon 76-7 Eggers, Birgit 180, 181 Egoiste 138-9 Electric Hob 101 Emigre 96-9 EQ 171-3 Euro Club Guide (supplement of DJ Magazine) 66-7 Eventual 64-5 Experiment 72-3 Eve 42-5

Farrell, Stephen 98-9, 122-3, 124-5, 126-7
Ferguson, Heather 68
Fletcher, Neil 194-9
Flores, Pablo Rovalo 106
Form 150-51
frieze 31
Fritzsche, Beth 116
Frost Design 32, 52-5
Frost, Vince 32, 52-5
Fujimoto, Yasushi 200-207
Furukama, Fumiko 201, 203, 206, 207
Fuse 106-7

Garrett, Malcolm 108-11 gee magazine 94-5 Granger, Stephanie 108-11 Gutiérrez, Fernando 12-15, 26-9

Hall, Jeremy 30 Harcom, Billy 112-13 Hastings, Pattie Belle 128-9 Hayward, Peter 178-9 HDR Design 108-11 Hewitt, Craig 208-13 Hingston, Tom 160-63, 174-5
Hogan, Terence 62
Holt, Chris 46-9
Horner, Brian 102-3
Hough, Mark 138-9
Howard, Glenn 57
Hubers, Kees 155
huH 154-9
Hurren, David 170
Hurst, Mark 112-13

Illegibility 84-5
Independent Magazine 32
Insidetrack 174-5
Iron Filings 100
Isaac, Martin 188-93
Iwabuchi, Madoka 200, 202, 207

Jordan, Wayne 188-93

Kim, Somi 34 Kirk-Wilkinson, Robert 160-63 Kisor, Doug 97 Kramer, Heather 126-7

Lamba, Sonia 216-17 Lausten, Judith 33-7 Lawrence, Mike 72-3 Lehmann-Haupt, Carl 130-33 Leslie, Jeremy 136-7 Lippa, Domenic 180 Lundy, Clare E. 94-5 Lupi, Italo 20-21 Lutz, Anja 78, 104-5

Mackay, Seònaid 40-41 Magazine of the Book, The 40-41 Mainartery 178-9 Manuscript 74-5 Markowski, Suzanne 80-81 Marling, Leigh 76-7, 148-9 Martin, Alison 188-93 Martín, Pablo 26-9 MassArt 95-6 126-7 Matador 26-9 Max 160-63 Mayer, Nancy 35, 36-7 Mayes, Mandy 188-93 Mazzucca, Paul 38 McKeown, Damian 148-9 ME Company 208-13 Meer, Koos van der 56 Mello, Leslie 12-15 Metropolis 130-33 Middleton, Lyn. P. 34 Minshall, Scott 179 Miranda, Nina Rocha 64-5 Monument 134-5 Myers, Chris 35, 36-7

Nath, Rick 171-3 Needham, Simon 187, 214, 218 Newark, Quentin 57 Nick Bell Design 30, 138-9 NoHo Digital 170-73 (noise) 214-19 Now Time 33-7

Object 114-15
O'Callaghan, John 178
Ockerse, Tom 38
O'Donnell, Timothy 154
Oliver, Vaughan 154-5
O'Mara, Seán 164-5
Opara, Anukam Edward 30
Organised Design 115

Pavitt, Dean 108-11 Playground 176-7 Poplin, Gilles 86-7 Post 208-13

Qwerty 22-3

Raively, Emily 116
Ray Gun 124-5
Reichert, Hans Dieter 108-11
Research Studios 160-63, 174-5
Re taking London 76-7
ReVerb 34
Riederer, Heidi 115
Roach, Matt 140-45
Roden, William van 130-33

Rose, Aaron 72-3 Rubinstein, Rhonda 58-61

Savoir, Philippe 88-93 Schroeder, Tracey 126-7 Shepherd, Adam 146-7 Shift! 78, 104-5 Silk Cut Magazine 136-7 Silo Communications 102-3 Sin 24-5 Smet, Edwin 147 Sosa, Verónica 138-9 Staines, Simon 160-63 Stoltze, Clifford 122-3, 124-5, 126-7 Stone, Rob 112-13 Strength 116-19 Studio Voice 200-207 Substance 194-9 Suzuki, Kayoko 200, 201, 203, 204-5, 206, 207

Tappin, Mark 76-7
Ten by Five 100-101
Tibbs, Ben 150-51, 176-7
Tilson, Jake 16-19
Tironelle, Stephanie 72-3
Tomec, Lilly 78, 104-5
True 140-45
Turner, Chris 79, 101
Turner, Grant 50-51

Turner, Steve 76-7 21C (supplement of DJ Magazine) 63 Typographic Fascism 78 Typographische Monatsblätter 80 Tyson, Jeff 117

U&1c 58-61 Utermohlen, Edwin 35 *Utopia* 86-7

VanderLans, Rudy 96
Vanidad 138-9
Vaughan Oliver Poster 122-3
Versus 112-13
Virgin Classics 30
Visible Language 38-9
Voss, Ingo 134-5
V23 154-5

Wallace, Rob 76-7
Waller, Alyson 160-63
Waller, Christopher 63
White, Paul 208-13
Wills, Steve 215, 218
Winkelmolen, Karin 147
Wishart, Zoe 114-15
World Art 62

Acknowledgments

The Publishers would like to thank: Geoff White; Richard Horsford for design assistance; Lucy Walker for researching and sending magazines from Australia; and John McKay, Head Librarian at Ravensbourne College of Design and Communication.

Disclaimer

The captions, information, and artwork in this book have been supplied by contributors. All material has been included on the condition that it is reproduced with the knowledge and prior consent of the designers, photographers, illustrators, client company, and/or other interested parties. No responsibility is accepted by the Publishers for any infringement of copyright arising out of the publication.

While every effort has been made to ensure the accuracy of captions and of the quality of reproduction, the Publishers cannot under any circumstances accept responsibility for inaccuracies, errors, or omissions.

Future Editions

If you would like to be included in the call for entries for the next edition of Typographics please send your name and address to:

Typographics Duncan Baird Publishers Sixth Floor Castle House 75-76 Wells Street London W1P 3RE

e-mail: dbaird@mail.bogo.co.uk

As a collection point has not yet been finalized, samples of work should not be forwarded to this address.

the ashi ypes as' 9 asii void ec(is Si rand ISUa ash